D1327841

# TRADITIONAL EMBROIDERED ANIMALS

SARAH DON

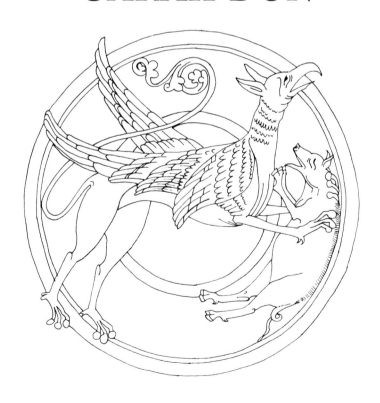

A DAVID & CHARLES CRAFT BOOK

DEDICATION

*To my children, Emily, Oliver and Ottillie,
for sharing this with me.*

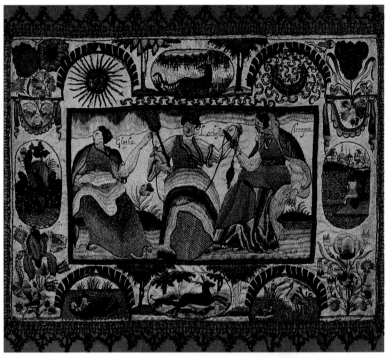

*Embroidered panel showing the Three Fates* (Christie's)

**British Library Cataloguing in Publication Data**

Don, Sarah
 Traditional embroidered animals. – (A David & Charles
craft book).
 1. Embroidery. Special subjects: Animals. Designs
I. Title
746.44

ISBN 0-7153-8967-X

Stitch technique drawings by Ethan Danielson

Typeset by Typesetters (Birmingham) Ltd, Smethwick, West Midlands
and printed in Singapore
by C S Graphics Pte Ltd
for David & Charles Publishers plc
Brunel House   Newton Abbot   Devon

# CONTENTS

# FOREWORD

My interest in the subject of traditional embroidered animals was inspired by the embroideries I studied in various museums during a period of research. Some of the animals depicted on traditional embroideries are enchanting, with child-like qualities. Others are real and fabulous creatures depicted in wondrous settings which seem mysterious and intriguing. And yet others are heraldic, their origins and significances a forgotten subject.

Scenes from classical literature and from mythology in which the adventures of gods and goddesses are shown surrounded by romantic birds and beasts are freely depicted. Animal fables are a favourite subject for embroidery and the Bayeux Tapestry presents the most fascinating and substantial collection of embroidered fables to be seen.

When I realised that the source material that inspired the working of embroidered animals had been neglected by authors on the subject and that the embroideries themselves display a wealth of styles, I determined to make traditional embroidered animals the subject of a detailed study. I hope that this resulting book will prove a valuable source of inspiration and design to fellow embroiderers.

# INTRODUCTION

*Let us not forget that the main object of all embroidery is to give pleasure in some way, to charm the eye or delight the mind, and that this is the principal reason for its existence.*　(A. H. CHRISTIE, 1909)

The finest ecclesiastical embroideries, whose excellence has never been surpassed, were produced between 1250 and 1350, this period of English embroidery becoming known as opus anglicanum. Many animals worked on to embroideries at this time were deliberately symbolic, even when they were not part of the central theme. They were usually depicted as part of a narrative composition or to reinforce the Christian message.

The prominent animal imagery found on sixteenth- and seventeenth-century embroideries led me into the realms of pre-Christian history and classical literature and mythology. The scenes on the seventeenth-century English portfolio illustrated on p2 are representative of the Three Fates, spirits who determined man's destiny at birth. This lovely embroidery, illustrating man's journey through life, becomes even more interesting when the significance of the images is explained. The animals include a salamander (representing fire), birds in flight (symbolising air) and a hunted stag (generally signifying good fleeing before evil). Allusion is also made to the thread of life via the spider and its web.

An important source of imagery were the works of classical writers, historians and poets. An extract from Ovid's *Metamorphoses* is a typical example of the mythical and animal imagery that must have inspired sixteenth-century embroiderers:

Arachne wove a picture of Europa, deceived by Jupiter when he presented himself in the shape of a bull. You would have thought that the bull was a live one, and that the waves were real waves. Europa herself was seen, looking back at the shore she had left behind, crying to her companions, and timidly drawing up her feet, shrinking from the touch of surging waters. The tapestry showed Asterie too, held fast by the struggling eagle, and Leda reclining under the swan's wings. Then the girl added further pictures of Jupiter in disguise, showing how he turned himself into a satyr to bestow twins on fair Antiope . . . she showed Neptune, too, changed into a fierce bull for his affair with Aeolus' daughter. Disguised as the river god Enipeus, he was making love to Aloeus's wife, who later bore him twin sons, and he was deceiving Bisaltis as a ram. The golden-haired mother of the corn crops, gentlest of goddesses, knew him in the shape of a horse, Melantho as a dolphin, and to the snakey-haired princess, who was the mother of the winged steed, he appeared as a bird. All these incidents were correctly depicted, people and places had their authentic features.

Sixteenth-century natural histories also proved popular sources of designs for animal motifs. These natural histories contained well-defined and simple line drawings in the form of woodcuts which readily translated into designs for embroidery, particularly canvas work. Natural histories remain excellent sources of designs even today – facsimile copies of at least two of these books have been published fairly recently.

Emblem books were also used as design sources with many of the pictorial emblems illustrating stories and animal fables. A number of these have been copied directly on to embroideries. An outstanding example of emblematical devices may be seen on the Falkland

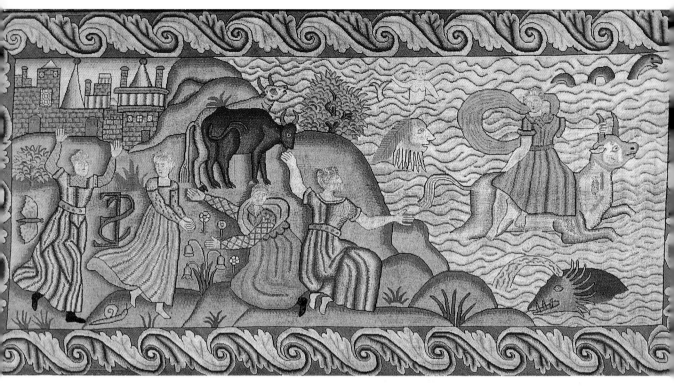

jacket, which is housed in the Victoria and Albert Museum.

Animal motifs derived from these various sources were worked on to a number of different embroidery styles, from Jacobean crewel work to children's stumpwork caskets and mirror frames. Canvas work and blackwork made much use of symbolic and emblematical animal designs, incorporating them into highly allusive and allegorical messages. The applied panels known as the Oxburgh hangings that were worked by Mary Queen of Scots and Bess of Hardwick are

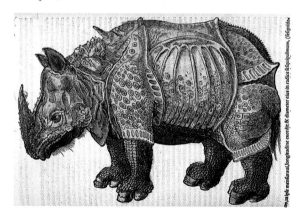

*Konrad Gesner's woodcut of a rhinoceros* (Bodleian Library)

*An English long cushion from Hardwick Hall, Derbyshire, showing the story of Europa and the bull* (National Trust)

a particularly good example of animal motifs used in this way.

During the seventeenth century there was a significant rise in the quantity of engraved patterns that were published especially for embroiderers, patterns which were to become more widely available than ever before. They provided a 'whole view of creation' in which numerous creatures were illustrated in well-defined line drawings. The creatures ranged from flies, worms, snails, beetles and butterflies to birds and fish. Among the real, imaginary and mythological beasts, the lion, unicorn, dragon, horse, camel, elephant and bear were particular favourites.

Eighteenth-century embroidery was inspired by the new Arcadian vision in which animals played their roles in scenes of idyllic rural landscapes and vignettes. Such scenes popularly featured sheep accompanied by lords and ladies masquerading as shepherds and shepherdesses. This period provides today's embroiderer with the greatest source of inspiration, particularly in the choice of techniques and materials.

The style known as Berlin woolwork, which

takes its name from the German city, was introduced during the nineteenth century. Designs included the portrayal of favourite family pets – cats, dogs and parrots – as well as many species of exotic birds, all of which were worked on canvas grounds with brightly coloured wools. Although this period in the history of embroidery has been criticised for the generally poor standard of craftsmanship and the absence of any individual and imaginative pieces, there were some well-designed and well-executed embroideries. A good example is the spaniel illustrated here, the embroidery showing an attractive design that has been finely worked with an excellent use of colour.

As well as the photographs of older embroideries, many woodcuts, engravings and illustrations from early manuscripts have been included in the following pages. They should prove to be a valuable source of design and of inspiration. You may not feel confident about your drawing and design abilities, but you should at least attempt your own designs as soon as possible. Amateur embroideries often exude a sense of warmth and bear the distinction of the embroiderer's individual style. Even amateurs can create animal characters whose personalities reveal charm and a gentle good humour.

A number of drawings are also included from bestiaries, emblem books, pattern books, embroideries and older illustrations of Aesop's fables, in the hope that these will prove useful as design sources for animal motifs. These drawings can be traced off, enlarged or reduced and transferred to the ground using one of the methods described on p125. The charts also included here have been taken from embroideries and older pattern books and are intended for counted threadwork techniques.

*A canvas-work picture of a King Charles spaniel lying on a tasselled cushion* (Victoria and Albert Museum)

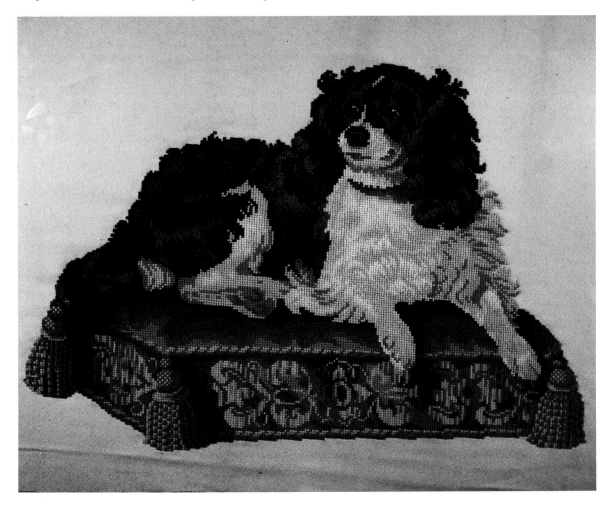

# THE
# BAYEUX TAPESTRY

## ANIMAL FABLES, ALLUSIONS AND SYMBOLISM

The Bayeux Tapestry is both an historic work of art and a monumental celebration of the Norman conquest of England in 1066. The tapestry is one of our most important historic works of art, providing scholars with a unique source of information.

The tapestry measures some 230ft (70m) in length and 20in (50cm) in height and has been embroidered with woollen threads on a coarse linen ground. The richness of the deep earth colours worked on unbleached linen contributes significantly to the tapestry's freshness, beauty and sense of immediacy. This boldness, which even after nine centuries is only slightly faded, perfectly reflects the mood of the story. The relatively limited range of colours includes three shades of blue, two of green, and one each of red, yellow and grey. These were not used in a naturalistic or ordered way; hair, for example, could be green or blue, and the garments of figures making several appearances could be coloured differently each time.

The techniques used were relatively quick to execute, the background being left unworked. Stem and outline stitches (in various colours) were used for all the lettering, the linear parts of the design, and the outlines for the parts to be 'coloured in'. These coloured-in parts were worked with two layers of laid threads, couched to the ground with a third thread. The resulting texture gives depth to the work, greatly enhancing the choice of colours. (Areas too small to be filled with laid and couched work were embroidered with close rows of stem or outline stitch.) Stem and outline stitches were also used to define the folds in clothing and to create the chain-mail, the ground beneath being left empty to create space and the illusion of depth. All the animals are filled completely with stitchery, but many areas of the design, as well as the faces and hands of figures, have been left unworked, creating space within the design – an important factor on such a large and busy work.

The tapestry's style is comparable with that of contemporary illuminated manuscripts in which simple line drawings were filled with flat washes of colour. These are in turn comparable with the designs produced by sixteenth-century embroiderers who used woodcuts and engravings as design sources for many domestic furnishings.

Among the animals depicted in the main narrative part of the tapestry are numerous horses and dogs. Each animal has been beautifully embroidered to create a sense of its individuality and of movement. The expressions worn by the animals have been simply worked with outline or stem stitches. Amid one battle scene a number of horses are shown tumbling over each other in a most dramatic way. Earlier

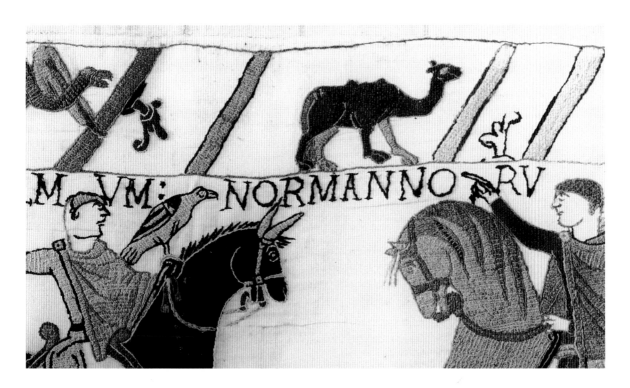

in the story, the tapestry depicts the Normans boarding their horses on to the ships which were to set sail for England.

In a hunting scene, King Harold is depicted with a hawk on his wrist and dogs running before him. Later, the king is shown on board ship sailing to France, accompanied by dogs and a hawk. The bird may have been a gift for William, the Duke of Normandy, but it could also have been depicted as an allusion to the often repeated theme of hunt and capture which runs through much of the work.

# THE BORDERS

In the narrow borders or margins above and below the main narrative are embroidered numerous animals and figures, which most often appear in pairs. These animals may at first appear to be a purely decorative series of simple and naive motifs that have been used to ornament and frame the main narrative. The animals are, however, far from passive. They are highly expressive, full of movement and frequently aggressive, playing a political role in both complementing and commenting on the events as they take place. Many of the lions, griffins, wyverns or dragons, dogs, donkeys, birds, wild

*Detail from the Bayeux Tapestry depicting King Harold* (The town of Bayeux)

boar and deer, among others, are shown in aggressive stances, screeching, screaming or howling, each echoing events in a noisy and violent fashion.

The only silent creatures are the winged lions associated with the triumphs of William. They are depicted proudly preening themselves, as if gloating. Both the griffins and winged lions have been described as 'composite beasts . . . used as symbols of ferocious power'. They were often used to symbolise strength, courage, power and vision – the combined attributes of the lion (as the king of beasts) and the eagle (as the most regal of birds). In Christianity, the griffin symbolised the two-fold nature of Christ: the divine (as the bird) and the human (as the animal). Both these creatures – the griffin with its talons and beak, and the winged lion with its paws and muzzle – have been used to symbolise William's cause, representing his many triumphs.

Animals were undoubtedly depicted to highlight or underline events in the story. For example, a pair of doves look up from beneath Edward's shrouded body, while lively hunting dogs relate to hunting scenes. Two wild boar are shown either biting or sharpening their tusks

against the patterned diagonals that contain them. (The boar may be relating the fable of the fox and the boar and are shown directly above the scene that depicts Harold rescuing Norman soldiers from treacherous quicksands.) A single dog looks up from beneath Edward's funeral procession and howls at the coffin as it passes. A single donkey has been embroidered directly under a knight named Vital and a pair of camels are shown immediately above William greeting Harold who has been freed from Count Guy's imprisonment. (A camel signifies stupidity, stubbornness or pride, although the pair depicted at this point of the story may represent another fable.)

Some of the creatures embroidered in the borders seem to represent astrological signs, including Sagittarius the centaur, Taurus the bull, Capricorn the goat, Leo the lion, Aries the ram and Pisces the fish. Birds are also included – among them ravens, peacocks, cranes, cockerels and eagles – and all have overt symbolic and religious meanings and are also featured in a number of fables.

## FABLES

The repeated allusions to the themes of hunt and capture, betrayal and treachery that are depicted in the Bayeux Tapestry, are emphasised by the inclusion of animal fables, many of which have been identified. They include the fables of the fox and the crow; the pregnant bitch; the wolf and the lamb; the mouse, the frog and the kite; the wolf and the goat; the crane removing a bone from the wolf's throat and the lion and his subjects.

By the Middle Ages, artists had begun to explore the use of decorative frames around narrative pictorial works and they were also using fables to enhance their work. It was through these mediums that medieval artists found the freedom to express their own, perhaps dissenting, views, messages and political comments. Aesop, author of the ancient animal fables, was said to have used his stories for political purposes and fables have been traditionally associated with dissent. It is possible that the designer of the Bayeux Tapestry (probably an Anglo Saxon) who was commanded to record his country's defeat and at such length, used fables as one means of subverting the Normans' view of the conquest by depicting subtle twists to the story.

In trying to interpret the fables as they relate to the story of the Norman conquest, one must decide whether or not the artist intended to show the official Norman story. The artist (probably English) may have been commenting on the illegitimate claim of the French to the English throne by alluding to the untrustworthy animals featured in fables who used flattery, trickery and, if necessary, brute force to obtain what did not belong rightfully to them. The moral to the fables depicted in this part of the tapestry seems to be that those who lose are either innocent and weak, or just foolish. Whatever the case, any satirical comments made by the designer had to be very carefully introduced, and cleverly hidden.

In the fable of the fox and the crow, the vain crow drops his prize after being coaxed by the

*Illustration of the fable of the fox, the crow and the piece of cheese* (The town of Bayeux)

fox to show off his wonderful singing voice. The story has been depicted three times on the tapestry, perhaps alluding to the sacred oath which Harold was persuaded to swear when on a mission to William in Normandy. This oath was a promise to give the English crown to William on the death of King Edward – a promise subsequently broken. The Normans used this broken promise as justification for their invasion.

The fable of the eagle, the kite and the frog (or mouse) also points to broken promises, while that of the wolf and the lamb moralises that the tyrant (perhaps alluding to William) will always find a pretext for his tyranny. The fable of the lion's court has been embroidered above an illustration of Harold who is shown sailing for France on his controversial mission to meet William. Its inclusion at this point is significant, because it may allude either to Harold's foolishness or to the deviousness of the Normans, William being satirised as the lion.

The fable of the wolf and the crane is frequently depicted in various art forms. The crane stretches its neck into the throat of the wolf to remove a bone which has lodged there, the wolf having promised a reward to any creature who would remove the bone for him. Having achieved the task, the crane asks the wolf for his reward. The wolf replies that the crane's reward is the fact that his head has been left intact. This fable has been embroidered twice on the tapestry, first in the illustration of Harold sailing for France, and again on the scene of his return journey. The fable is obviously alluding to broken promises, although whether the ungrateful wolf symbolises Harold or William is open to interpretation – more likely, the foolish crane represents Harold.

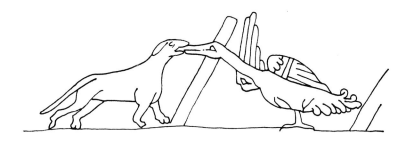

# TECHNIQUES AND MATERIALS

The techniques employed in the making of the Bayeux Tapestry are similar to those used for the couched metal threadwork of opus anglicanum pieces where threads were laid and couched to create textural patterning. On the tapestry this technique proved a very effective method of working, especially where the ground had to be covered quickly. The textural qualities created by the use of woollen threads embroidered on to plain linen are best contrasted with an unworked ground.

Although the use of wool on linen is the most obvious and effective combination of materials, it could be worth experimenting with alternatives such as stranded cottons and perle threads on various types of fine grounds. If wools are to be used, one of the stranded kinds is preferable. Many different sorts of linen are available for embroidery purposes and the choice is one of personal preference.

Designs should be drawn finely on to the ground, using one of the methods described on p125 and remembering that all lines must be covered by the eventual stitchery. Linear details and the outlines of motifs should be worked first, followed by the areas to be 'coloured in' with laid and couched work. Add tiny details such as facial features and eyes last.

All the outlines of the figures and motifs and linear details on the tapestry have been embroidered with either stem stitch or outline stitch. The difference between these stitches has been defined in different ways by different authors. A number of embroiderers would have worked on the making of the tapestry and it was the individual embroiderer's own personal way of working that created the two different stitches. In stem stitch the thread is always kept to the right of the stitching, while in outline stitch the thread is always kept to the left (some authors on the subject say that the opposite is true). Generally, no spaces were left between the stitches and a continuous, perfect line of back stitches was created on the reverse side of the work. Where spaces were left, a finer line was created. A heavier line still was achieved by embroidering

stitches over a thread laid on the ground along the line to be worked.

The couching was worked by the laying down of closely packed rows of parallel threads over the shape that was to be filled. A second series of threads (not necessarily in the same colour) were laid over these, at ⅕in (5mm) intervals, and these threads were stitched down to the ground with the same coloured thread. In this way, very little stitchery actually shows on the reverse side of the work.

The couched threads were laid either vertically and horizontally,

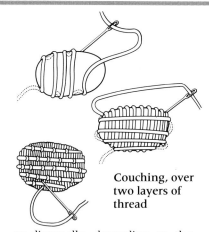

**Couching, over two layers of thread**

or diagonally, depending on the flow and direction of the form. This choice was an attractive one

in the working of animals and birds, adding a further diversion to the textural quality that was created.

Chain-mail was created by the working of a series of circles in stem or outline stitch, while the ground was left showing through. The hands and faces were also left unworked. Tiny areas too small for couched work were filled with rows of closely worked stem stitch.

**Stem and outline stitch**

## PRACTICAL APPLICATIONS

The practical applications for the styles and techniques used on the Bayeux Tapestry lie mainly in the production of larger scale embroideries, perhaps those worked by groups of workers. Embroideries worked to record an important historical occasion or special event within the community are of special value and particularly well suited to the techniques involved in the making of the tapestry. Individual embroiderers, however, may choose these methods for detailed narrative designs – that is, those telling a story using a number of pictorial scenes shown in sequence – in which the ground could be covered quickly on works such as larger panels, pictures and furnishings. Biblical stories, such as that of the flood and Noah's ark, animal fables and scenes from mythology, could be depicted in great detail and in a manner similar to the way in which comic-strip stories are told.

Similar subjects would also suit projects embarked upon by children in schools and by community groups in which embroiderers with even the most basic of skills could be involved in some of the

relatively simple stitchery. Designs should be drawn accurately on to the ground by a proficient artist who should remember that all permanent lines must be covered by the eventual stitchery and that a degree of definition can be lost during both this and the actual embroidery process. Once this has been done, the individual embroiderer can then outline the motifs and other linear elements of the design with outline stitches. You can fill in with stitchery, using colours selected at will from a previously chosen palette. Everyone involved in the project should be encouraged to contribute ideas on how the story should be told – on the content, the use of colour and the final arrangement of the design.

While biblical stories might appeal to church groups, schools may choose to celebrate historical stories or histories of individual animals such as the dolphin, the whale or mythical beasts, such as the unicorn, the salamander, the phoenix, and so on, or perhaps classical stories such as that of Arachne who was turned into a spider. Classical depictions of the cycle of nature, the four seasons and the four corners of the earth, or a calendar showing monthly

seasonal tasks in the countryside, would also prove fascinating projects. Children may choose to tell the stories of extinct and endangered species, of the World Wide Fund for Nature, or the setting up of bird sanctuaries, wildlife parks and zoos, and so on. Narrative embroideries of this kind that are worked by groups of embroiderers are very beneficial to the community, with people working together to provide theirs and future generations with a unique social and historical record.

Designs taken from existing illustrations must be clear, simple and without over-elaborate details. One of the methods described on p125 can be used to transfer the design on to the ground; card templates are very useful for motifs that are worked more than once. The use of a frame is essential and, with a little ingenuity and practical help from a volunteer with carpentry skills, a sizeable frame may be constructed to hold areas or lengths of the ground at a time. The quantity of threads that may be required should be estimated generously. Larger embroideries may need to be worked in sections and sewn together later, although this should be avoided if possible.

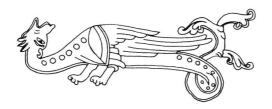

# ANIMALS IN MEDIEVAL ECCLESIASTICAL EMBROIDERY

Opus anglicanum is the name given to the much acclaimed ecclesiastical embroideries produced in England during the medieval period. The beauty and excellence of this work – which reached its peak between 1250 and 1350 – was due mainly to the use of only the best materials, superb craftsmanship and the excellent quality of design. Its production was largely prompted and inspired by the religious and social climate of the time. The extravagant use of costly metal threads, precious jewels and only the finest linen and velvet grounds reflected the importance and power of the church.

The versatile technique of underside couching so characteristic of the opus anglicanum period, together with the use of minutely worked split stitches, which were used to create shading, meant that a high degree of realism and expressiveness could be achieved. These factors, combined with the talents of the finest draughtsmen, ensured that only the highest standard of work, which was to dominate the world of embroidery for two hundred years, was achieved. The production of such superbly executed embroidery is said to have been one of

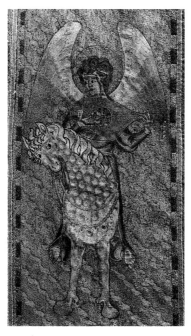

*Detail from the Steeple Ashton cope showing a saint riding a dappled horse* (Victoria and Albert Museum)

England's greatest cultural achievements, with pieces being sought after by church dignitaries, while many items were exported to Europe.

Very little ecclesiastical embroidery has survived from this period, although there is no doubt that the animals depicted on such works had symbolic and religious meanings. One of the earliest pieces of ecclesiastical embroidery to have survived from the opus anglicanum period depicts a pair of lions facing each other, placed inside roundels within a geometric design. The embroidery is worked on what are now only fragments of a vestment, thought to belong to Walter de Cantelupe, Bishop of Worcester (1236–66).

## THE STEEPLE ASHTON COPE
The Steeple Ashton cope, which is on loan to the Victoria and Albert Museum, is one of the richest sources of animal imagery that has been embroidered on an ecclesiastical vestment. Dating from the early fourteenth century, it is a beautiful example of opus anglicanum embroidery and the techniques and style of design employed in its production make it an individual piece.

AGNUS DEI

The numerous animals depicted on the cope include the *Agnus Dei* (the Lamb of God) worked in high relief with silver thread. The lamb is shown supporting the resurrection cross and a banner which bears a black Maltese cross. The Lamb of God (the holy lamb, the paschal lamb) is the principal image used to represent Christ as the Son of God. The sacrificial lamb of ancient near-Eastern religious rites was adopted by the Christians to represent Christ in his sacrificial role: 'Behold the Lamb of God, which taketh away the sins of the world.' The death of Christ is symbolised on the cope by a number of emblems which include the cross and the banner of the resurrection. In primitive Christian art, the lamb is often shown with blood issuing from its chest into a chalice, and the twelve apostles were shown as sheep accompanying the Lamb of God. Other qualities symbolised by the lamb are innocence, gentleness, patience and humility, which appear as attributes of these personifications. Of the four temperaments, the phlegmatic man was also represented by the lamb.

Wild animals were embroidered along the border of the cope. They were depicted chasing each other across its length, perhaps symbolising good fleeing before evil. The creatures depicted include a stag, a hare, a goat, a hog and a rabbit, worked between bands of scrolling leaves and embroidered in gold thread that is couched in different directions. A fascinating representation

of the universe composed around a central seven-lobed shape, in which four fish encircle an eight-pointed star, each with another's tail in its mouth, has also been included. Around this design are four beautifully simple images of a stag opposite a doe and a finch opposite a snipe. The birds have been worked to represent the sky, the fish the sea, and the stag and the doe the earth.

The main panels on the cope illustrate scenes from the lives of the Virgin Mary and of Christ, and the martyrdom of the saints. The depiction of St Margaret's miraculous escape from the belly of a dragon is particularly dramatic. This legendary saint had refused to marry the Prefect of Antioch because she was a Christian virgin. Margaret was tortured and imprisoned for her refusal and, while in prison, it is said that she was visited by Satan, in the form of a dragon, who devoured her. However, she burst free from the dragon's belly, saved by the holy cross she held in her hands. Later, Margaret was beheaded for beseeching God that 'women in childbirth who invoked her might be delivered safely of their child, as she was delivered safely from the dragon's belly'. Hence Margaret was greatly patronised by women in childbirth.

The dragon depicted on the cope has been simply drawn and worked, the resulting image being well-defined and effective. The creature has been embroidered with underside couched

gold threads in four colours in broad bands which follow the contours of its body. The variation in colour was achieved by winding the gold thread loosely around brown, fawn, yellow or green coloured cores.

Also embroidered on the cope are the symbols of the four Evangelists: an angel, an ox, an eagle and a lion. In Christian art, the four Evangelists were represented symbolically by a man's face (Matthew), a lion (Mark), an ox (Luke) and a flying eagle (John). These are said to allude to the four living creatures seated before the throne of God: 'And the first beast was like a lion, and the second beast was like a calf, and the third beast had a face as a man, and the fourth beast was like a flying eagle.' (Rev 4:7). Irenaeus (a second-century Greek Father of the Church) said: 'The lion signifies the royalty of Christ: the calf his sacerdotal office: the man's face his incarnation: and the eagle the grace of the Holy Ghost.'

The Evangelists were symbolised in this way because medieval Christians found suitable meanings and explanations in the gospels. Matthew's gospel begins with the tree of the ancestors of Christ, so Matthew is symbolised by a man's face. Mark's gospel begins with the crying of the voice in the wilderness and the roar of the lion is said to allude to this. Luke's gospel begins with the account of the sacrifice of Zaccharius, his symbol is therefore the sacrificial ox. John, whose vision of God was 'closest and distinct from others', is represented by the eagle because this bird flies higher and closer to heaven than any other.

In the gospels, sinners are likened to goats, and in Christian art, the goat is the symbol of the damned at the last judgement. During the early Middle Ages the goat symbolised Satan. From antiquity, the goat has been a symbol of un-chastity and it has also been used to represent lust, one of the seven deadly sins. In medieval bestiaries the he-goat, 'Hyrcus', was said to be a lascivious animal, 'always burning for coition' and with eyes of 'transverse slits because he is so randy'. The holy goat, however, symbolises the Lord who is 'all knowing', because the goat was said to have such good eyesight that it could tell from afar whether or not people were wayfarers or hunters.

The ass appears on tapestries and embroideries which depict religious scenes, including the

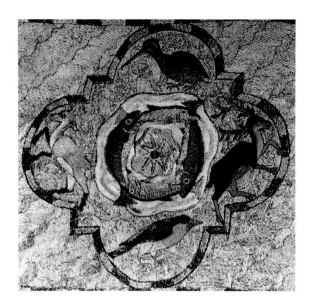

*Detail from the Steeple Ashton cope showing the symbol of the universe* (Victoria and Albert Museum)

nativity and the flight of the holy family into Egypt. (Tradition has it that the dark line which runs down the ass's back and across its shoulders was given when it carried Christ on his triumphal return into Jerusalem.) In religious scenes the ass was the beast of burden and the animal of the poor.

Because of the various stages of its life-cycle, the butterfly symbolised immortality and the resurrection. In antiquity the image of the butterfly emerging from its chrysalis represented

*Caprea the Wild Goat*

*HOLY DOVE*

the soul leaving the body at death. The butterfly as a symbol of the resurrected soul sometimes appears in the hand of the infant Christ. A caterpillar, a chrysalis and a butterfly embroidered together symbolised the stages of a man's life on earth and his resurrection, as did a bird's egg, especially if the shell was broken.

Animals such as the ass, camel, horse, sheep, snake, fox or jackal, as well as numerous species of birds, were all native to biblical lands and were featured in stories from both the Old and the New Testaments. Although all the creatures depicted on the cope have different symbolic meanings, with various interpretations, many of the animals were embroidered with specific meanings in mind. Dragons, lions and serpents were embroidered frequently and there are numerous references to these and other animals in the Bible.

Birds, such as pelicans, eagles, ravens, doves and cockerels, were also frequently depicted. The cock symbolises Christ, the conqueror of 'the powers of darkness and evil spirits. He is the bird that calls men to work in the light of day and the judge who rouses to wakefulness those slumbering in the sleep of the dead.' In the context of St Peter's denial of Christ and then his repentance (it was at the cock crow that Peter felt remorse), the cock is seen as a symbol of penitence and watchfulness. It has also been used to represent lust personified. In the seventeenth century, the cock was said to be 'a warlike ensign of the Goths' and was used in this sense to decorate Gothic churches.

In Christian art, the dove symbolises the Holy Ghost. When seen with seven rays emanating from its breast, the dove symbolises the seven gifts of the Holy Ghost. When shown flying from the mouth of a dying saint, the dove symbolises the soul as it rises to heaven:

And Jesus, when he was baptised went up straightway out of the water; and lo, the heavens were opened to him, and he saw the Spirit of God descending like a dove, and lighting upon him.

Hence the dove is depicted in scenes of the baptism of Christ, the annunciation and the descent of the Holy Ghost.

As symbols of mercy and peace, two doves facing one another signify concord. It was a dove that brought the olive leaf to Noah as a sign of God's mercy after the flood. A dove depicted with a phial (the holy chrism) in its beak is an attribute of Regimus and when shown on a flowering wand it is an attribute of Joseph.

A dove or a pair of doves are the chief attributes of Venus and symbolise love and constancy. Billing doves suggest the fond embraces of lovers, although they were also an attribute of chastity.

The pelican represents an ancient type of Christ 'by whose blood we are healed'. It symbolised the crucifixion and is an attribute of charity personified. When the pelican is depicted standing on her nest with her wings displayed and with her young feeding from her blood, she is said to be 'in her piety' – that is, signifying filial devotion. The idea that the pelican pecks at her breast (vulning) until it bleeds, so that the

*Detail from the Syon cope showing St Michael slaying the dragon* (Victoria and Albert Museum)

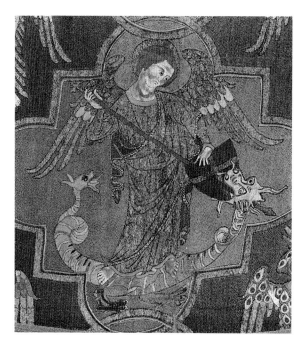

offspring can feed from her blood, is a fallacy and may have arisen because the parent bird feeds the chicks from macerated food in a bag under its bill. St Jerome tells of a pelican reviving young birds killed by their parents and of his own salvation by the blood of Jesus Christ.

Illustrated here is a detail of the Syon cope, which dates from between 1300 and 1320, showing Michael, the Archangel, who symbolises the triumph of good over evil: 'Then war broke out in heaven, Michael and his angels waged war upon the dragon . . . So the great dragon was thrown down, that serpent of old . . .' (Rev 12:7-9). The Church explains this passage as being that of the Christian conflict, Christ versus the Antichrist, represented by Michael vanquishing the devil. Satan is depicted as a dragon or serpent with two heads, one of which is almost human. He is lying prostrate under the feet of the Archangel who is about to slay him. In Christian art, a dragon or serpent chained or trodden underfoot symbolises the conquest of evil (the Latin word *draco* signifies both snake and dragon).

In the authorised version of the Bible, the word 'tan' is translated as 'dragon'. The revised version translates it as 'jackal'. The Hebrew word *tannin* means any great monster of land or sea and it is generally seen as a serpent. It is usually depicted as a fabulous winged creature with the

*Turtur the Turtle Dove*

*THE PELICAN IN HER PIETY*

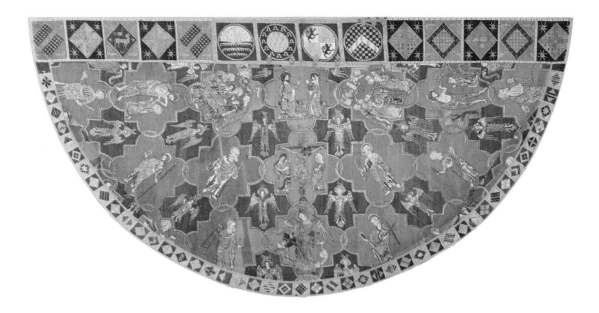

*The Syon cope* (Victoria and Albert Museum)

## SECULAR EMBROIDERIES

tail of a serpent; the dragon or serpent is frequently shown as an amalgamation of the two creatures. In the book of Revelations, Satan is described metaphorically as the great dragon. The dragon in the Middle Ages was a symbol of sin and particularly of paganism. Tales of ladies who were held captive and guarded by dragons' were popular in the Middle Ages and many depictions of St George and the dragon appear on embroideries as well as on other arm forms.

At the beginning of the thirteenth century, early examples of opus anglicanum show narrative scenes with figures contained inside quatrefoils surrounded by birds, animals and curling leaf scrolls.

By the end of the century, however, saints were depicted as secondary subjects, their attributes frequently depicted as animals. The saints' attributes were symbols peculiar to themselves, indicating the instrument of martyrdom, if it was relevant. Those who were not martyrs had attributes that symbolised their particular virtue. For example, the bear was the attribute of St Antonia, the beehive of St Ambrose, the crow of St Vincent, a fish of St Andrew, the stag of St Julian the hospitator, and the swan of St Cuthbert. Other animals, accompanied by birds and foliage, were used as heraldic badges. On the borders of the Syon cope are embroidered the Lamb of God, lions, wyverns and eagles.

Smaller items, such as burses, purses, book covers and seal bags, were also embroidered during this period. Burses were often decorated on one side with the head of Christ, or the crucifixion of Christ together with images of the Virgin Mary and St John. On the other side, the coronation of Mary or the Lamb of God were sometimes worked. These motifs were usually surrounded by rosettes, stars, peacocks and eagles.

The seal bag illustrated overleaf dates from the opus anglicanum period. Measuring 5in (13cm) long the bag originally held a charter, which was dated 1319. It has been embroidered with silver and silver-gilt threads and coloured silks. Underside couching, split, cross and two-sided Italian cross-stitches have been worked on an evenweave linen. The reverse side of the bag is decorated with the royal arms of England together with two wyverns and three crowns; eyelet stitch has been used entirely for the background – an unusual technique for this period. On the front of the bag is worked the figure of St Paul and the coat-of-arms of the City of London.

The Apparels of Albs at the Victoria and Albert Museum are worked on red velvet and embroidered with coloured silks, silver-gilt and silver thread, using split stitch, underside couching, laid and couched work and raised work. They date from the mid-fourteenth century and bear the coat-of-arms of two English families.

Embroidered scenes include those of the annunciation and the life of the Virgin Mary. In the three scenes, the animals have been worked gently and sympathetically, particular care having been taken to depict the expressions on their faces. On the left, the nativity scene shows an ox and an ass looking at each other with wondrous expressions. On the right, the three wise men, bearing gifts and riding dappled horses, travel to Bethlehem to see the baby Jesus. In the centre are shepherds watching their flocks. One of the shepherds is seated, playing pipes, with a dog at his feet. The depiction of Christ and Christians as a shepherd with his sheep occurs in other art forms. The shepherd – young and beardless – would be seated among his flock playing a syrinx or lyre. This is said to have been an image from mythology of Orpheus charming the animals. A goat in the bottom right-hand corner is symbolic.

The Museum houses one of the most substantial collections of embroideries from this period, although the metal threads have now tarnished and the colours faded. Although the original brilliance and splendour that these pieces once displayed can only be imagined, the technical achievements and excellent workmanship are still evident.

*Detail from an embroidery depicting King Charles II as the Prince of Wales standing over the dragon. Silks and metal threads have been worked on a satin ground with straight stitches in a painterly manner. The dragon has been outlined with back stitches and there are also some metal threads and couched work* (Bowes Museum)

haustible source of imagery for contemporary artists, craftsmen and embroiderers, and many animals and their symbolic lore were to be depicted on fourteenth- and fifteenth-century tapestries. One of the most popular creatures was the unicorn which was depicted in many allegorical hunting scenes. Among the best known bestiaries were those of Richard de Fournval, Guillaume le Clerc and Philippe de Thaun.

According to the bestiary translated by T. H.

# THE PHYSIOLOGUS AND MEDIEVAL BESTIARIES

The *Physiologus*, first written in about AD 200 by an anonymous Greek writer, uses a natural history of animals to explain the Christian doctrine. The *Physiologus* was an extremely successful and popular theological treatise and, by the Middle Ages, it had been revised and added to numerous times, having been translated into many different languages.

The *Physiologus* described a large number of animals, birds and fish and gave moral lessons to be learnt from each. Pagan myths, legends and folklore were transformed and integrated into the rich symbolism of the Christian church, with the God of earthly love and the God of heaven co-existing harmoniously.

The *Physiologus* was the forerunner of the popular bestiaries of the medieval period which were intended as serious studies on the natural histories of animals. Bestiaries proved an inex-

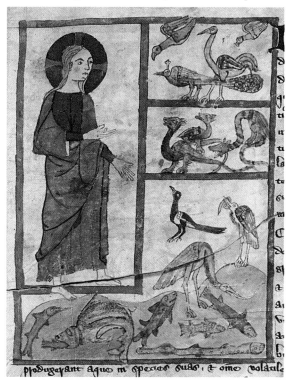

*A depiction of God creating the birds and fishes from a fourteenth-century manuscript* (Bodleian Library)

*This seal bag from the Guildhall in London shows an heraldic design of three lions and two wyverns and is one of the earliest surviving examples of opus anglicanum. The bag holds a charter dated 8 June 1319 (City of London, Guildhall)*

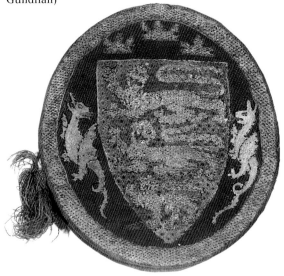

White, the panther is an animal which has small white spots 'so that it can be distinguished by the circled dots upon the tawny and also by its black and white variegations'. It was fabled to have had a peculiarly sweet odour which it exhaled:

*As one who hidden in deep sedge and reeds*
*Smells the rare scent made when the panther feeds,*
*And tracking over slotwise the warm smell*
*Is snapped upon by the warm mouth and bleeds,*
*His head far down the hot sweet throat of her*
*So one tracks love, whose breath is deadlier.*

(SWINBURN, 'Laus Veneris')

*Mouser or Catus*

In the early *Physiologus*, the panther represented a type of Christ. Later, when the savage nature of the beast became known more widely, the panther became the symbol of evil and hypocritical flattery. John Lyly compared the beauty of women to 'A delicate bait with a deadly hook, a sweet panther with a devouring paunch, a sour poison in a silver pot'. The milk-white hind in Dryden's 'The Hind and the Panther' symbolises the Catholic Church, milk-white meaning infallible. The Church of England is symbolised by the panther that is 'full of the spots of error'. 'Without unspotted, innocent within, She fared no danger, for she knew no sin.'

Medieval bestiaries depicted bears bringing forth their young imperfect and deformed, like a lump of raw flesh. The latter was probably the foetal 'bag' or placenta and the female bear would lick her offspring clean as soon as they were born. In the Middle Ages the Church saw the consequent licking of the cubs by the mother as a symbol of the conversion of the heathen by Christianity.

The pard, an animal often mentioned in early writings, is described in T. H. White's *The Book of Beasts* as a 'parti-coloured species', said to have been 'strongly inclined to bloodshed'. T. H. White explains that there are several Latin names for leopard, including *panthera*, *pardus* and *pordalis*, and that confusions between the pard and the leopard (they were thought to have been different animals) arose from this fact, the names reaching England before the animals did. In Greek mythology, the leopard was an animal sacred to Bacchus (as was the dragon) and a pair of leopards were sometimes depicted drawing his chariot. In Christian art, the leopard represents the beast spoken of in Revelations 13 1-8, which had seven heads and ten horns; six of the heads wore a nimbus or halo, while the seventh head was bare, indicating that it was 'wounded to death' – that is, without power.

The salamander was mistakenly believed to be a poisonous creature which could poison all the fruits on a tree and thereby also the people who afterwards ate the fruit. If the salamander fell into a well, its poison could contaminate the water, killing anyone who drank from it. The salamander was the only animal capable of extinguishing flames and was itself impervious to fire.

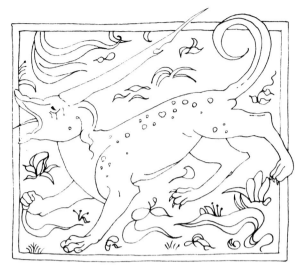

*Unicorn from Qazwini (Iranian) manuscript* (Staatliche Museum Berlin)

The crane is usually shown standing on one leg, with the other raised and holding a stone. According to legend and the medieval bestiaries, cranes take turns to keep watch at night and if the crane on duty falls asleep, the stone will fall from its claws and the bird will awaken. Hence, the crane represented vigilance, one of the virtues required by monarchs and important public figures.

The illustration of a 'mouser' – 'vulgarly called cat' – accompanied by mice and a weasel, is taken from a fourteenth-century bestiary. In ancient Rome the cat was a symbol of liberty because of its independent spirit and loathing of restraint. The goddess of liberty was depicted with a cat at her feet and in ancient Egypt the cat was held sacred and golden statues were made of it. The goddess Bast, who represented the life-giving sunshine, was shown with the head of a cat. Because of the animal's inherent nature, the cat came to symbolise idleness, and the love of ease, coquetry and freedom.

The *Speculum Humanae Salvationis* ('The Mirror of Human Salvation') was a treatise written to simplify the symbolism used by the Church in the early fourteenth century. It was intended to explain, in simple terms, the relationship between the Old and the New Testaments. It consisted of drawings with short explanatory texts in the form of Latin rhymes and proved a successful medium for the teachings of the Church. The treatise became a favourite source of imagery for embroiderers. Copies of *Speculum Humanae Salvationis* from the thirteenth century

and earlier are now extinct, but the Bodleian Library has two later copies, one from the late fourteenth or fifteenth centuries (English) and a French copy dated *c*1430–50. Both show scenes from the Old and the New Testaments.

The *Biblia Pauperum* ('The Poor Man's Bible') first appeared in about 1460. This late-medieval block book depicted scenes of the life of Christ which were taken from the New Testament and were surrounded by their Old Testament prefigurations. The *Biblia Pauperum* used allegory, analogies and symbolism to explain the Bible and seems to have been intended for use by preachers and the lower orders of the clergy. The Bodleian Library has a Dutch or German copy of the *Biblia Pauperum* which has been coloured by hand and is dated about 1470.

## LATE MEDIEVAL EMBROIDERY

Ecclesiastical embroideries continued to be produced after the Black Death (1348–50), although not to the same high standard as those from the opus anglicanum period. During the fifteenth century the practice of covering grounds completely with stitchery was rejected in favour of separately worked motifs which were applied to a ground of coloured velvets or richly patterned Italian brocades. These motifs were surrounded by couched silver-gilt threads to cover the edges of the motif and enhance the work further. Brick, satin and long and short stitches were popular because they were quicker to execute. Surface couching replaced the traditional method of underside couching. Later still, the working of heavily padded motifs in the mood of three-dimensional carvings reflected the strong European influences which were prevalent throughout this period. Designs for vestments usually had a central theme – most often that of the annunciation or the assumption of the Virgin Mary, surrounded by lilies.

Few secular pieces have survived from this period, although descriptions of secular embroideries are frequently mentioned in wills and inventories. These reveal that applied work and woollen embroidery were also being worked. Bed-hangings were very popular and were indicative of the rank and wealth of the owner. In

# CANIS THE DOG

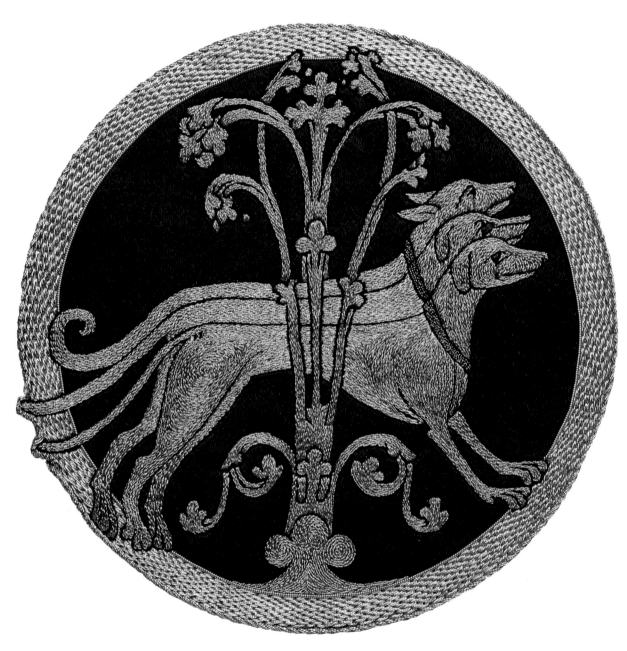

*Canis the Dog* (Author)

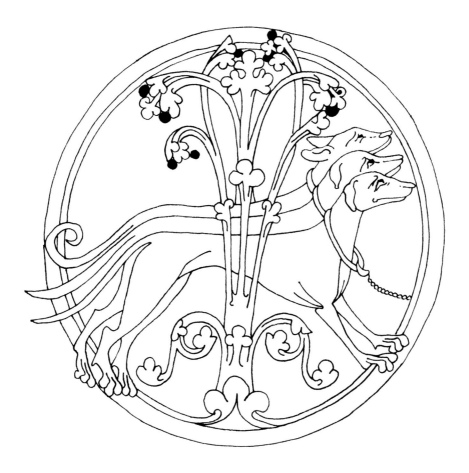

This embroidery was inspired by an illustration in a medieval bestiary translated by T. H. White. The design is simple yet very strong. The lines were first outlined using black stem stitches. The number of techniques and materials have been kept to a minimum, the different areas being filled with just a few highly versatile stitches; stem stitch for the flowering stems and split stitch for the dogs. Choosing the directional flow of these proved difficult and needed more than a little careful planning.

The outer circle has been embroidered with rows of underside couching, following a brick pattern. (Again there were problems, this time in keeping the circle's shape from distorting.) Inside this is a line of couched coarse gold purl. The background is of densely worked straight stitches kept in line by following the weave of the ground. The finished embroidery was cut out and applied to another ground using tiny slip stitches. A line of gold twist cord was applied around the edges, again using tiny slip stitches.

## MATERIALS

The ground is two thicknesses of fine, tightly woven linen. The outlines are worked using 3 strands of Coats stranded cotton in black, 0403. The background is worked using 3 strands of Coats stranded cotton in purple, 0102. The outer circle is of Madeira metal effect yarn, gold, 003, and used whole. Gold purl No 3 is couched to the inner edge of this circle. The plant is of 5 strands of Madeira metal-effect yarn, gold, No 008, the dogs of Madeira metal-effect yarn, gold, No 5012, used whole. The dogs' collars are in Madeira metal-effect yarn, gold and black, No 5014, used whole. The trefoil shape at the base of the plant was worked using Madeira metal-effect yarn in gold, No 501, used whole in stem stitches.

an inventory of Charles V dated 1364, several bed-hangings, including one embroidered with lions, eagles and leopards, are mentioned. All the animal motifs had intentional, often secretive, significances; some motifs were included for heraldic purposes. In 1394 Sir John Cobham bequeathed his bed which was embroidered with butterflies and in 1434 Joan Beauchamp bequeathed her bed which was embroidered with swans and leopards.

Lavishly decorated costumes became increasingly popular, especially during the reign of Richard II, and great extravagance was exhibited in the use of gold and silver threads and precious jewels. Costumes and hangings made during this period were usually decorated with monograms, insignia and animals – all devices of an heraldic or symbolic nature. One of Richard II's favourite cognisances was a white hart and Queen Philippa is known to have had a costume decorated with golden squirrels.

The setting up of the guilds and livery companies brought the enactment of many lavish civic pageants for which occasions the rich city merchants would wear ceremonial garments that had been specially embroidered with symbolic motifs. Finely embroidered funeral palls, some of the finest embroideries to have survived from these times, were used for elaborate public funerals of guild members.

During the fifteenth century, workshops came to depend on mass-produced embroideries.

Large numbers of motifs were made in advance, ready to be applied to appropriate pieces. Orders were gained through travelling representatives, whereas previously, commissions were awaited from wealthy clients. There was strong competition from Flanders where the new, or *nue*, technique was being worked. This method was practised in England later, but it was not particularly successful.

With the introduction of the first printing press in England, which had been set up in Westminster, printed patterns became more easily accessible to a greater number of embroiderers and replaced the illuminated manuscripts, bestiaries and herbals as design sources for embroiderers and craftsmen generally. However, the sources for these printed patterns were at first often the same as they were for the bestiaries. Konrad Gesner's Renaissance pattern book *Historia Animalium* shows woodcuts of animals, some of which can be traced back to the bestiaries of the twelfth to fourteenth centuries.

The Tudor period brought the dissolution of the monasteries and the relaxation of much religious dogma. There followed, at the expense of the Church, an increase in wealth and better conditions for the populace generally. This improvement led directly to the new traditions of amateur embroidery in the sixteenth century. Although the production of embroideries from the professional workshops continued, it can be said that the great tradition of British ecclesiastical embroideries had come to an end.

# TECHNIQUES AND MATERIALS

## TECHNIQUES

**Stitches** Split stitches in fine silk thread were widely used to illustrate the figures, and especially their faces. Stitching in very fine split stitch was begun at the centre of the cheeks, worked outwards spirally, the entire face being carefully taken in as the work progressed. Whorls of gold were further shaped by moulding them gently, giving still more reflection and shaping. It was the intention that light reflecting off these

**Split stitch**

Split stitch worked in close rows following the desired contours, beginning at the outer edges and working inwards

spirals would give a realistic though subtle impression of the three-dimensional contours of the face. The number of other stitches used is relatively small. Stem stitch was occasionally used in place of split stitch. Satin stitch was only rarely used, as was overcast stitch, which was used for smaller details. Cross stitch was used in particular

**Stem stitch worked in rows as a filling**

for heraldic motifs as was tent stitch which was also used for small details. Other stitches include long and short stitch, eyelet, plait and two-sided Italian cross stitch.

**Underside couching** was a way of laying down threads at intervals, a linen thread being used underneath the ground. The thread was taken up through the ground, over the thread to be couched and back down through the same hole in the ground that it had first come up through, the couched thread being pulled through to the back of the work, encircling the linen couching thread. This created a 'hinge' with the gold couched thread, giving the quality of suppleness to the resulting fabric which would otherwise have been stiff. This was repeated a distance further along (it was worked in rows). By changing the position of this 'hinge' (by counting threads of the linen ground), many different geometric patterns were created. Gold thread couched in this way was usually in brick and chevron patterns and later in square and diamond patterns. Gold thread was generally extremely fine and ten threads laid together formed as little as 1/10in (3mm) in width. These grounds were often further embellished with tiny seed pearls.

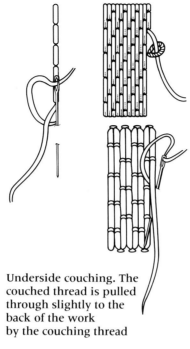

Underside couching. The couched thread is pulled through slightly to the back of the work by the couching thread

Backgrounds of silver-gilt embroidery were the most common, although the Syon cope at the Victoria and Albert Museum has an unusual ground of underside couched with red and green silk.

## MATERIALS

**Jewels** used to decorate opus anglicanum work included seed pearls and cabochon stones and, because of the technical problems involved in drilling these stones, they were set on to mounts which were fitted with loops. A strong thread was passed through these loops to secure the stones to the grounds.

**Metal threads** were mainly of Cyprus gold and were generally a fine flat strip of silver gilt that was twisted on a silk core. Occasionally, thin metal plate was couched in diaper or woven patterns directly onto the ground. There was some plain surface couched work for linear designs. Floss silk was used in a wide range of colours. A wide range of metal and silk threads is still produced today, although they are available only at specialist shops.

**Grounds** Opus anglicanum embroidery was worked through two layers of linen – a fine layer on top and a coarser one, below. The entire ground was covered completely with stitchery, a large proportion of the work being produced in metal threads and embellished with precious stones. For this reason much support was required as the finished article would have been very heavy. If velvet was used, it was tacked with a coarse layer of linen and overlaid with a finer layer. The stitching was worked through all three layers and, when completed, the fine layer of linen on the surface was cut away around the embroidery to reveal the velvet ground beneath.

## PRACTICAL APPLICATIONS

The sophisticated metal threadwork used for the lavish ecclesiastical embroideries of the opus anglicanum period is not beyond the abilities of skilled amateur embroiderers. With practice and determination, embroiderers will become sufficiently proficient in underside and surface couching to create a variety of backgrounds, in particular geometric patterned backgrounds. The variety of colours, textures and reflective qualities of the different threads means that the number of possible patterns is endless.

It is worthwhile mastering the technique of working fine silk or cotton threads in densely packed rows of split stitch. When neatly worked, the technique is an effective way of embroidering animal motifs. Rows of underside couching, following the lines and contours of the design, are similarly effective. Subtle changes of colour can help to give a more realistic effect. An animal design worked entirely in underside couching, even simply in straight rows, can produce stunning results, the effect depending on the materials used. A fine line of couched thread or cord can be sewn around the edges of the design to give a neat finish.

Outlines of designs should generally be worked first, in a stronger contrasting colour to the remainder of the body. The major areas of the design are filled in effectively with the simplest of stitches, the most important factor being a well-designed and simply drawn image in the first instance.

The prick and pounce technique (see p125) is the best method of transferring designs on to a ground of strong linen fabric, preferably two layers. The ground must be firm enough to support the weight of the embroidered metal threads.

The charts included in this book are intended for counted thread-work – principally canvas work – while the drawings can be used both for canvas work and more freely worked styles of embroidery. I have left the choice of stitches and colours to be used to each individual embroiderer in the hope that he or she will draw inspiration from both the older examples that have been discussed here and from the illustrations and drawings from bestiaries and medieval manuscripts. Many heraldic designs may also prove to be a rich and valuable source of animal motifs. Decisions on colours and techniques depend largely upon the worker's own personal preferences, tastes and technical abilities.

Although much ecclesiastical embroidery today is executed by skilled workers and by those from professional bodies such as the Royal School of Needlework, a significantly large proportion is worked by embroiderers from groups such as the local Women's Institutes, parishes, and branches of the Embroiderers Guild. Many churches have been proudly furnished with canvas-work kneelers, which often use basic cross and tent stitches, by such organisations. Kneelers prove ideal projects for the individual embroiderer, with the medium of em-broidery purveying a rich sense of each worker's personality.

Themes that depict animals featured in the Bible present a fascinating challenge for amateur embroiderers. Ideas can be gleaned from the wealth of animal imagery which is featured in stories from both the Old and the New Testaments. Popular images are of Noah's ark, Jonah and the whale, St Francis of Assissi, the shepherd guarding his flock, and scenes from the nativity in which animals watch over the baby Jesus in the stable. Other smaller items of church furnishings include Bible covers and Bible cushions upon which simpler motifs of the Holy Spirit symbolised by the dove, the pelican in her piety, the crane devouring a snake and the sacrificial lamb could be embroidered, as well as depictions of many smaller creatures.

Larger, more adventurous works include pew hangings, altar frontals and lectern cloths. These provide an area large enough to feature more narrative and perhaps more highly symbolic designs, the production of which is probably better suited to professional embroiderers or groups working together. The complicated techniques employed in metal threadwork are, perhaps, more within the realms of the professional embroiderer, but simple designs may be tried. The simpler the design and the technique, the more effective the finished work will be.

All work must be done with the ground held firmly in a frame and, depending on the weight of the final intended stitchery, the ground may need to be lined with a second layer of fabric to support the weight. Transfer designs to the ground by using one of the methods described on p00. As all the ground is covered by the eventual stitchery, this process is less difficult.

*THE UNICORN DIPPLING ITS HORN INTO A WELL*

# SIXTEENTH CENTURY CANVAS WORK

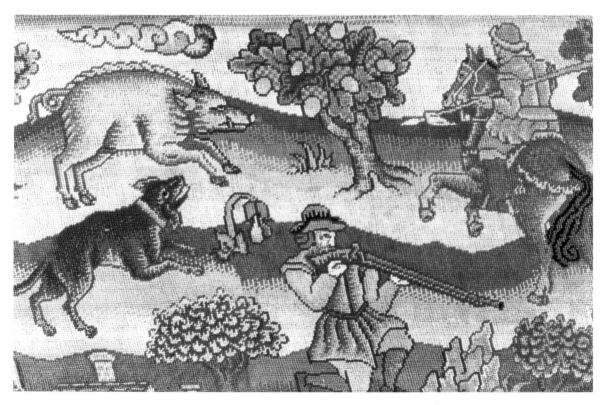

## RURAL SCENES, TABLE CARPETS AND BED VALANCES

*Detail from the Bradford table carpet showing hunters, dogs and boar* (Victoria and Albert Museum/ Bridgeman Art Library)

In contrast to the techniques of the ecclesiastical and opus anglicanum embroideries of previous centuries which employed free stitchery, canvas work became popular during the sixteenth century for the production of domestic furnishings. The style was imitative of the large and luxurious tapestries being made at this time. Tent or cross stitch was worked on fine linen canvas, with either wool or silk threads. It is a technique that remains popular today, although it is generally worked on a coarser canvas. Grounds used by the Elizabethans were fine, with a thread count of between 16 and 20 threads per inch.

The animal motifs worked on the large furnishings of the period were essential to the

genre of scenes that were depicted, and in the rich and dense backgrounds of verdure used as the settings for scenes from classical, mythological and biblical stories. Generally, the animals depicted on such pieces have no symbolic significances, but are merely part of the romantic rural idyll envisaged by the Elizabethans.

Table carpets for covering the plain wooden trestle tables in use at this time were worked with elaborate designs and finished to a high standard. The Bradford table carpet is an example of English canvas work from the late sixteenth century. The carpet measures 13ft × 5ft 9in (4 × 1.75m) and has been worked in tent stitch with coloured silks on a fine linen canvas of twenty threads to the inch. In the centre is a repeating all-over trellis design, with intertwining vines bearing large bunches of grapes. The wide borders include scenes typical of the genre style, showing figures posing within different country settings. The numerous animals depicted here include all the farmyard favourites – ducks, geese, chickens, cows and sheep. Members of the nobility and the wealthier middle classes are shown strolling about their country estates or posing unnaturally before their grand houses.

Brueghel depicted country peasant life through his paintings and is said to have influenced sixteenth-century pastoral scenes, particularly those worked on to tapestries. Unlike embroiderers and tapestry-makers, however, Brueghel was indifferent to the popular concept of beauty. His landscapes and religious scenes are usually crowded with figures and are often satirical, allegorical and morally instructive.

In complete contrast, the Bradford table carpet depicts in detail castles, mills, bridges and farms. Wild and domestic animals are shown in rural settings, shepherds with their grazing sheep, and a wolf stealing a lamb with the shepherd in pursuit. Various breeds of dog, some of which are involved in the chase, are illustrated, while others are shown sitting obediently at their masters' feet. Among other animals depicted are rabbits, squirrels, swans, chickens and, as prospective victims of the shoot, ducks in flight.

Ponds, streams and rivers hold unnaturally oversized fish. Although this lack of proportion may seem absurd, the pictures display a certain charm and naivety, and the inclusion of each animal, bird, fish, tree and flower was more important to the embroiderer than technical accuracy. Such accuracy would have meant the

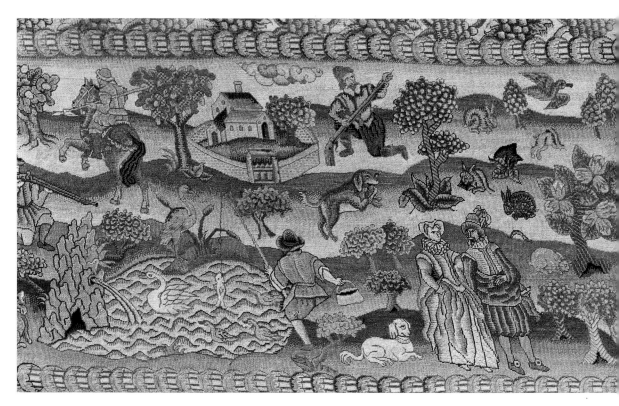

exclusion of many motifs, resulting in the loss of much of the spontaneity and liveliness displayed in the work.

The Gifford table carpet is the earliest example of an embroidered table carpet, dating from the mid-sixteenth century. Worked in tent stitch with coloured wools on a linen canvas, formal designs of interlace are combined with three large medallions edged with floral wreaths. Two of these depict a deer standing behind a strongly stylised oak tree (acorns being their proffered food). The entire carpet has been beautifully designed. The third medallion contains the Gifford coat-of-arms.

A late sixteenth-century table carpet depicts the banquet of Lucretia. Its borders are decorated with animals lying beneath fruiting trees which are occupied by various species of colourful birds, and held within strapwork designs. The design has been adapted from an engraving published by Philippe Galle (1537–1612). The combination of wildlife and trees appeared frequently on many types of embroideries, other examples being those worked on the uncut panels from Traquair House, Peeblesshire.

Owing to their size and the scale of the work involved, many large pieces, such as table car-

pets, hangings and valances, were made in professional workshops and the subject matter indicates that the more complicated designs were worked by professional embroiderers. Wherever size permitted, the opportunity was taken to work larger and more adventurous designs. Classical subjects include the four seasons and the cycle of nature, the virtues and vices, and so on. Popular themes included episodes of stories from the Bible and depictions of the hunt. Others depicted stories from mythology, the most popular being those from Ovid's *Metamorphoses*. On a pair of valances in the Victoria and Albert Museum are a number of episodes from the stories of Adonis and Myrrha. Venus and Adonis are also depicted: when Adonis spurns the company of Venus in favour of a hunting trip, he is killed by a boar. Venus is shown kneeling at his side, while a nightingale laments in a tree. Numerous wild and domestic animals, including sheep, dogs, rabbits and a lion attacking a dog, are depicted in country scenes.

Designs were often taken from popular contemporary paintings and engravings, many of which were Flemish. Engravings by artists such

*The Bradford table carpet* (Victoria and Albert Museum)

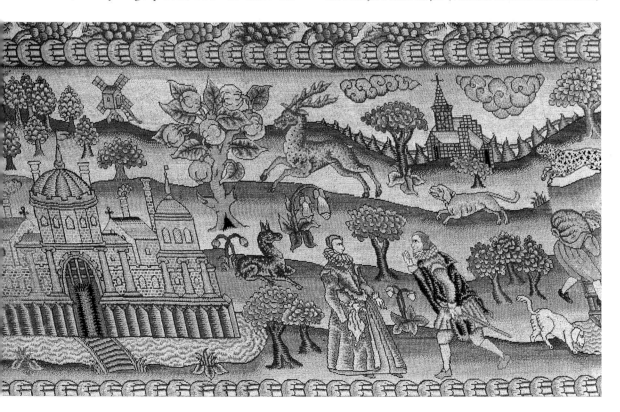

*DOG*

as Martin de Vos and Gerarde de Jode are known to have been copied directly on to embroideries of this kind. In medieval times it was often the illuminators of manuscripts who drew out designs for embroideries. Artists, too, were sometimes involved in this work and in the fifteenth century Cenniro Cennini recorded his instructions for his painters on the techniques and materials to be used. He told how the design should be drawn on to the ground with charcoal and then carefully overdrawn in ink. Subtly graduated shading was achieved by brushing in those inked lines with a soft minerva brush.

Alternatively, a full-size drawing might be made and outlined in black. The drawing was then pinned to the ground and positioned so that light shone through it. Using black or sepia paint and a fine brush, the design would be traced on to the ground. A coloured drawing, indicating where the different colours should be applied, was used by the embroiderers as a guide.

For smaller works on which a fine canvas was used, amateur workers would often transfer designs using the prick and pounce method and printed pages of woodcuts or engravings. This method was probably a major factor in the destruction of early prints and pattern books.

Amateur embroiderers, eager to furnish their homes with rich textiles, often worked bed valances. These were made in three lengths, designed to fit around the tops of four-poster beds. Valances provided long flat surfaces perfect for embroidering pictorial themes in a narrative sequence. Aesop's fables proved a popular theme

that was particularly attractive to amateur embroiderers who embarked on such projects. Such works were accomplished with the help of a professional embroiderer to draw out the design on to the ground, and with the involvement of friends, companions and servants.

A late sixteenth-century valance at the Victoria and Albert Museum is decorated with borders that surround a number of panels featuring animals – a heron with a frog, a dog, a camel and a bird eating a fish. The designs were probably taken from the Renaissance pattern books and emblem books of the period. A set of valances dated 1594 shows scenes from the biblical story of Jacob and Esau and both wild and domestic animals appear in the backgrounds. Various animals, including a dog chasing a fox, decorate the surrounding borders.

The Cooper Hewitt Museum in New York houses a long embroidered panel that was designed to illustrate twelve different fables. It is French, dated c1600, and has been worked in wool with cross stitch, with highlights in silk thread. One of the panels (also surrounded by borders) depicts the fable of the crane and the snake. The image of the crane devouring the snake is said to symbolise good devouring evil; in Christian terms, therefore, the crane as an eater of snakes symbolised the defence of the Christian faith.

Many of the scenes depicted on embroidered valances are set in backgrounds of perfect English landscapes or quaint Elizabethan gardens. The perfect rural scene was rarely depicted

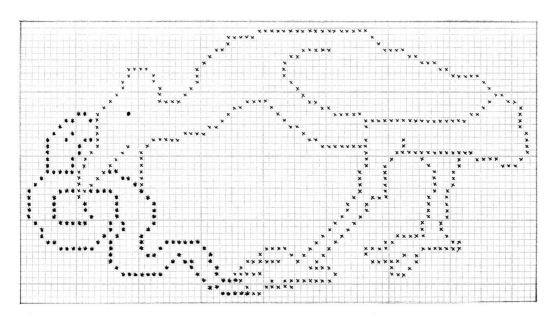

*A STORK EATING A SNAKE*

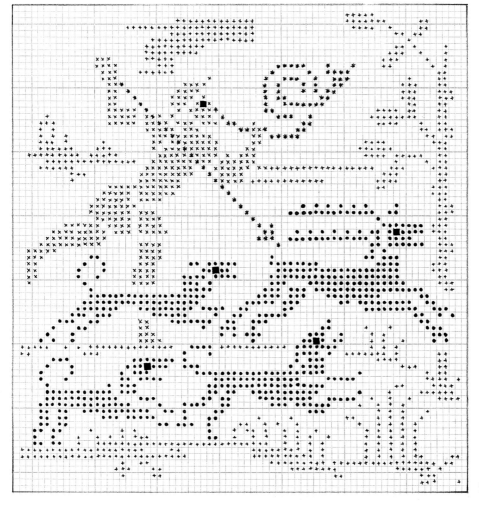

*THE HUNT*

without a contented shepherd and sheep grazing in rich green pastures, and numerous rabbits basking in the sun.

Rabbits were probably introduced to this country shortly after the Norman Conquest. They were difficult to breed and found it difficult to acclimatise. Rabbits were scarce at this time, being highly prized for their meat, which was considered a great delicacy, destined only for the tables of the nobility and the very wealthy. Rabbit fur was also greatly valued and served as the 'poorer' man's imitation of ermine which was used to decorate costumes.

Rabbits were also animals of the chase and hunting rights were tightly controlled. Licences to breed rabbits (known then as coneys) were granted only to the very privileged. In the fourteenth and fifteenth centuries, rabbit-hunting was a lucrative occupation for lords and houses were built especially to protect them against poachers. Rabbits depicted on sixteenth-century embroideries not only typified the English countryside, but symbolised the chase and were status symbols of the rich.

By the seventeenth century, rabbits were well-established in England. The rabbit has also been used in heraldry and in the latter half of the seventeenth century one herald said of them:

Of this little beast it seemeth that men first learnt the Art of undermining and subverting of Cities, Castles and Towers… Though nature hath not given these timourous kinds of beasts such craft or strength as to the former; yet they are not destitute of their succours, in that they have their strong castles and habitations in the earth, and their food ever growing so nigh them, that they need not put themselves into danger except they list.

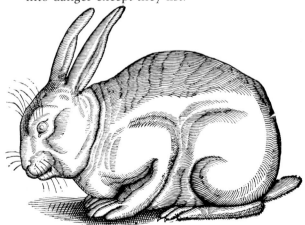

# THE RISE OF AMATEUR EMBROIDERY

It was the enlightening social, political and financial climate resulting from the Reformation that gave the necessary impetus for both the creation of the new middle classes and for the new traditions of amateur embroidery. Until the Tudor period, embroidery had been undertaken mainly by professionals – mostly men and a few noble women. After the Reformation, however, women of the new middle classes began to enjoy working embroideries. With their new-found wealth, expensive materials were more easily affordable. New techniques had been developed that were totally different from those of the opus anglicanum period. The relatively quicker and simpler techniques were enthusiastically adopted by the new amateur embroiderers.

## POPULAR MOTIFS ON ELIZABETHAN CUSHIONS

Cushions, although often quite large, provided amateur embroiderers with less ambitious projects than the table carpets and valances. Cushions were a sign of wealth and were scattered around the best rooms. Long cushions, typical of the Elizabethan period, were made for benches and window-seats. (Square cushions were also worked, but not in such large numbers.) Many cushions had an heraldic character, with the family coats-of-arms or that of a rich city merchant's company being proudly incorporated into the designs. (Only the upper sides were embroidered, the undersides being backed with a plain material.)

The Moreland cushion-cover from the late Elizabethan period shows sophisticated and delicate designs and is a good example of applied embroideries worked on linen canvas. A lion and a unicorn occupy a central position, indicating heraldic intent, other creatures include an elephant, a camel, rabbits and dogs. Coloured silks, silver and silver gilt threads have been worked on a fine linen canvas and the various different creatures have been embroidered mainly in tent stitch. The details of the smaller motifs have been worked in laid and couched work, coral stitches and some button-holing. The insects include dragonflies, worms and caterpillars. The whole

effect is luxurious, the slips having been applied to a ground of black velvet which sets off the colours beautifully. The cushion is backed with green damask and is decorated with a fringe and elaborate tassels.

Another Moreland cushion depicts scenes of labourers, fruit-gathering, hawking and the chase. Canvas-work motifs, which include a turkey and a peacock and pheasants in flight, are applied to white satin and are arranged around three fruiting trees. Butterflies and worms decorate the foreground. The motifs are worked mainly in cross stitch, with a small amount of cross stitching and couching with silk and metal threads. The animals that have been worked – peacocks, rabbits and a dog chasing a stag – are those that frequently appeared in idyllic scenes of country life. Depictions of the chase have been popularly portrayed throughout history and are said to symbolise the flight of the seven deadly sins.

A cushion dating from the mid-sixteenth century bears the coat-of-arms of John Warneford and his wife Susanna Yates which is placed within a design of foliage and flowers. Discreetly worked into these are a number of small creatures and insects. A pair of frogs are accompanied by a snail, a dragonfly and a moth. The moth is said to symbolise those mortals who succumb to temptation. Perhaps this is because it flutters around burning candles 'till the angelic wings of their souls are consumed'. The cushion is believed to have been made professionally, because both the quality of the work and the interpretation of the design are excellent. Tent stitch on a fine canvas has been worked with silk and wool.

A canvas-work cushion from the early seventeenth century shows the coat-of-arms of James I and has been signed 'Mary Hvlton'. Coloured silks, wools and gold thread have been used, worked finely in tent stitch, although plaited and long-legged cross stitches have also been used. The embroidery has been described as an excellent example of early Jacobean work, although the techniques used belong to an earlier period. All the design elements – the flowing stems, stylised leaves, oversized exotic blooms and animals standing on small hills – were to be developed and refined, becoming characteristic of later Jacobean crewel-work embroideries.

A long canvas-work cushion thought to have been worked by Elizabeth of Shrewsbury is a

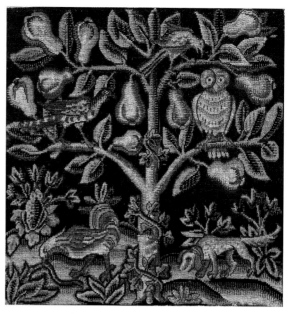

*A canvas-work panel showing a charming design of an owl perched in a pear tree* (Christie's)

naive interpretation of a woodcut by Bernard Salomon that illustrates the story of Europa and the bull. It has been worked in tent stitch with silks, with gold thread worked into the ground. Europa is shown being carried off through the waves by Jupiter disguised as a charming and beautiful white bull. Her attendant maidens watch helplessly from the shore while cattle are also witnesses to the drama. A mermaid and three monstrous creatures are shown swimming in the sea (see p6).

A long cushion from the late Elizabethan period in the Irwin Untermyer collection depicts Adam and Eve. The couple are shown with the tree of knowledge and the serpent, while Constancia, Innocentia, Concordia and Pax are depicted in flight. The animals have been taken from Topsell's *History of the Four-footed Beasts*, while the figures are from engravings by Martin de Vos and Marc Antonio Raimondi.

A square canvas-work cushion bearing the cipher of Mary Queen of Scots is worked with a lattice design of stems decorated with small flowers, lilies, thistles and roses. In the centre and at the four corners are roundels, inside which are embroidered five of Gabriel Faerno's fables (published in 1563). In the centre two frogs are shown sitting on the edge of a well debating whether or not the well is dry – if they jump in and the well is dry, they will be trapped.

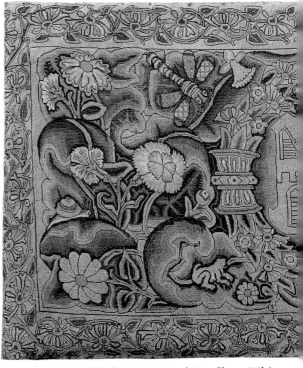

*This long cushion-cover from the mid-sixteenth century bears the coat-of-arms attributed to John Warneford of Sevenhampton, Wiltshire, and his wife Susanna Yates. The arms are worked within a flowering wreath with a background design of flowers and verdure, surrounded by a scrolling floral border. A dragonfly, a moth, a snail and a pair of frogs have been discreetly worked among the foliage. Linen canvas has been embroidered with coloured silks in tent stitch* (Victoria and Albert Museum)

The emblem signified slyness, secrecy and discretion and Mary may have used it to underline her attempt to escape from her imprisonment by Queen Elizabeth.

Other roundels depict Aesop's fables of the crow and the snake, and the cat and the cock. In the first of these fables, a hungry crow saw a serpent asleep in the sun. He flew down and seized him, whereupon the serpent bit him with a mortal wound. The dying crow cried: 'O unhappy me! who have found in that which I deemed a happy windfall the source of my destruction.' In the fable of the cat and the cock, a cat caught a cock and pondered a good excuse for eating him. He told the cock he was causing a nuisance to men by crowing in the night. The cock replied that he did this to call them to their work. The cat replied that, despite the cock's apologies, he would eat him anyway – and did.

*A Moreland cushion with applied slips of animal, insect and plant motifs* (Victoria and Albert Museum)

Another roundel shows one of Geoffrey Whitney's emblems of a cat that is trapped in a cage with mice around it running free. Whitney's moral was that the wicked of the world are free and escape justice. The last roundel holds a galloping horse, symbolising 'our ever-coursing time pursued by its nights and days'.

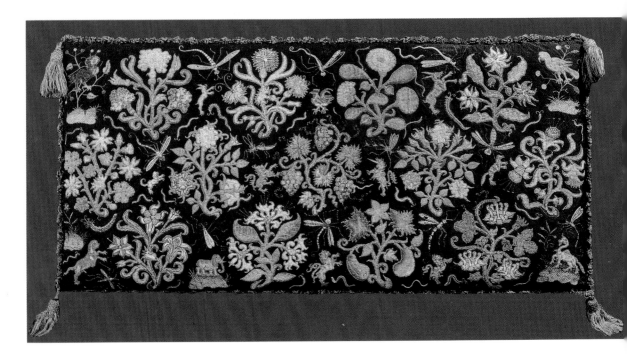

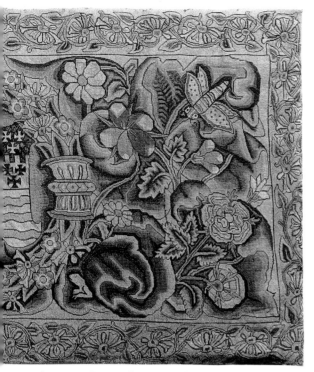

The popular technique of canvas work that began during the Elizabethan period continued into the seventeenth century. The narrative scenes that were depicted on valances and table carpets were worked on pictorial embroideries to be framed and hung on the wall. They were now often worked for no practical use, but purely to exhibit the skills of the needleworker and to decorate walls. Their advent marks a major turning point in the history of amateur embroidery making. When wood panelling was introduced, it became the perfect place to hang embroidered pictures, which became very popular as a result.

Tent and cross stitch continued to be worked but now on a fine canvas and early Jacobean subjects for embroidery were similar to those from the Elizabethan period. Religious and mythological stories were still popular and figures included in these stories were dressed in contemporary costumes and placed in typical English gardens or rural country settings. Illustrated books telling biblical and classical stories served as pattern sources for the embroiderer. Increasingly, amateur embroiderers worked embroidered pictures in which the designs were smaller in scale and less complicated. As with most sixteenth- and seventeenth-century embroidery, little regard was paid to scale and proportion, and animal motifs were popularly used for filling in spaces in designs. Wild and exotic beasts are seen side by side with docile creatures such as rabbits and squirrels, together with colourful species of birds and a profusion of insects.

*A Moreland cushion of applied slips showing scenes of fruit-gathering and hunting* (Victoria and Albert Museum)

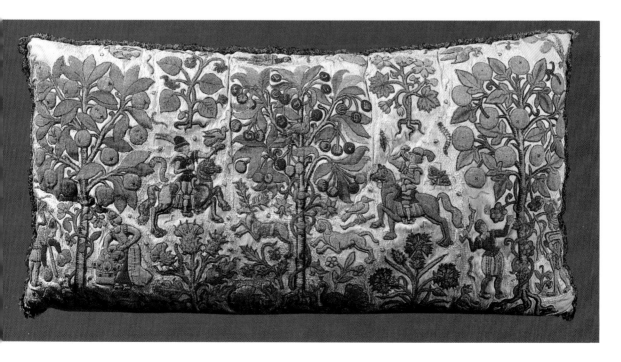

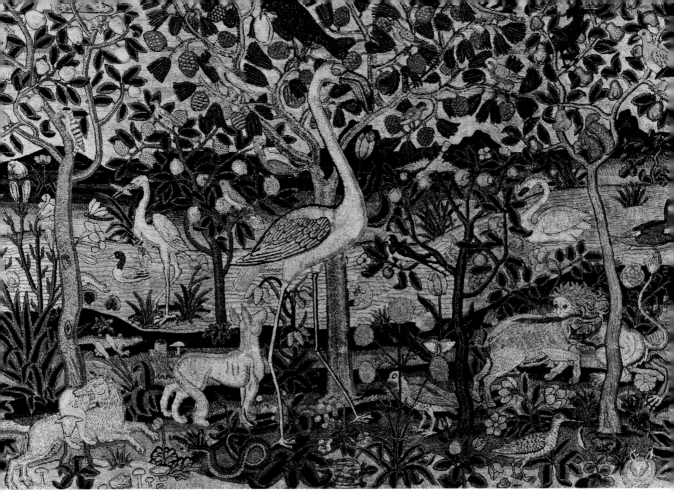

# TECHNIQUES AND MATERIALS

Larger items of canvas work, such as the table carpets and wall-hangings made by the Elizabethans, would rarely be attempted by amateur embroiderers today. Square or long cushion-covers, curtain tie-backs and canvas-work pictures prove to be attractive and less ambitious projects. It is well worth experimenting with various threads and grounds before beginning a piece because the appearance of different stitches, weights of threads

*Detail from an embroidered picture of the early seventeenth century* (Victoria and Albert Museum)

and grounds give various different textural qualities.

Today, most canvas work is done with relatively thick wool on a coarse canvas. The Elizabethans used a much finer linen canvas with a thread count of between sixteen and twenty threads per inch, and they embroidered with silk or fine woollen threads. Relatively fine cotton and linen grounds are widely available today and the use of stranded wools, giving a choice in thickness, is advisable. Canvases, both single and double weave, are also manufactured. Double-weave canvas, generally known as Penelope canvas, is intended for cross and tent stitch whereby stitches are worked over pairs of threads.

The thread count (the number of threads, or pairs of threads, to the inch) of the canvas determines

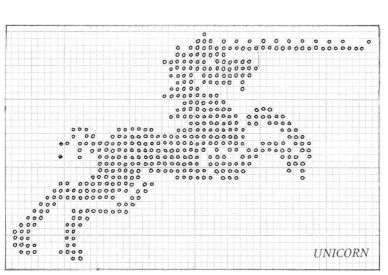

UNICORN

the size of a particular motif and the finished work. The weight of the thread should be matched carefully to the gauge of the canvas – the lower the thread count, the fewer the number of threads to the inch and the larger the finished design.

Needles, too, must be matched to the weight of the work and, as for all counted thread-work,

**Cross stitch**

**Cross stitch worked in rows**

should be blunt-ended. A blunt-ended needle will not pierce either the working thread or that of the ground, thus helping the stitches to lie neatly and evenly. All canvas work should be worked in a strong frame to prevent the distortion that arises when stitches are worked repeatedly in the same direction across the ground. Using a frame may help to eliminate the need for the difficult task of blocking a finished piece.

The main stitches that were

**Tent stitch, worked diagonally or in rows**

used for sixteenth-century canvas work were cross and tent stitch. Generally, the elements of the design – especially the animals and figures – were outlined with a line of stitches worked in a dark colour, the stitches following the drawn lines of the design. The outlined shapes were then filled in with colour that was worked in the chosen stitch.

A number of charted designs for canvas-work motifs have been illustrated in this book, but other methods involve drawing the design straight on to the ground. Because the ground is covered entirely with stitchery, the drawing of the design is not such a harrowing process (see p125). A well-defined outline of the design may be placed behind canvas and traced directly on to the ground, the drawing being visible through the mesh of the canvas.

# APPLIED CANVAS-WORK MOTIFS

The method of embroidering motifs separately on canvas and then applying them to luxurious grounds, such as velvet and damask, became popular during the sixteenth century. Embroideries worked in this way belong to one of the most exciting groups of amateur embroideries from that period, from which many examples have survived, including pieces such as the Oxburgh hangings at Hardwick Hall. Other important pieces are the uncut canvas-work panels from Traquair House, Peeblesshire. Both sets of examples are decorated with motifs of large numbers of different animals, birds and fish, together with flowers, fruit and fruiting trees. Both have retained to a surprising degree their brilliant colours and good condition.

While flowers, plants and trees were copied from contemporary herbals, the principal design sources for sixteenth-century embroiderers of animal motifs were the popular natural history books of the day, together with a number of English and French emblem books which were

also in demand. With improvements in methods of printing and vastly increased circulation, these books became more popular. Their publication coincided with, and complemented, the new and fast-growing traditions of amateur embroidery, providing Elizabethan women with an inexhaustible supply of exciting material upon which to draw for ideas and inspiration.

The colourful and lively collection of bird, insect and fish motifs for the applied work which is shown overleaf, have been worked ready to cut out and to apply to a ground. Coloured silks have been worked with tent stitch on a linen canvas (the small area of background that has been filled in was added at a later date). One of the advantages of working in this way is that the decision regarding the final arrangement of motifs may be made last. The long cushion depicting hunting and fruit-gathering scenes (see p35) (English, 1575–1600) is an excellent example of applied motifs, which have been applied to a ground of white satin and worked in silk and metal threads. The motifs have been arranged around a design of three fruiting trees, with depictions of the hunt, falconry and fruit-gathering. Spaces between have been filled with

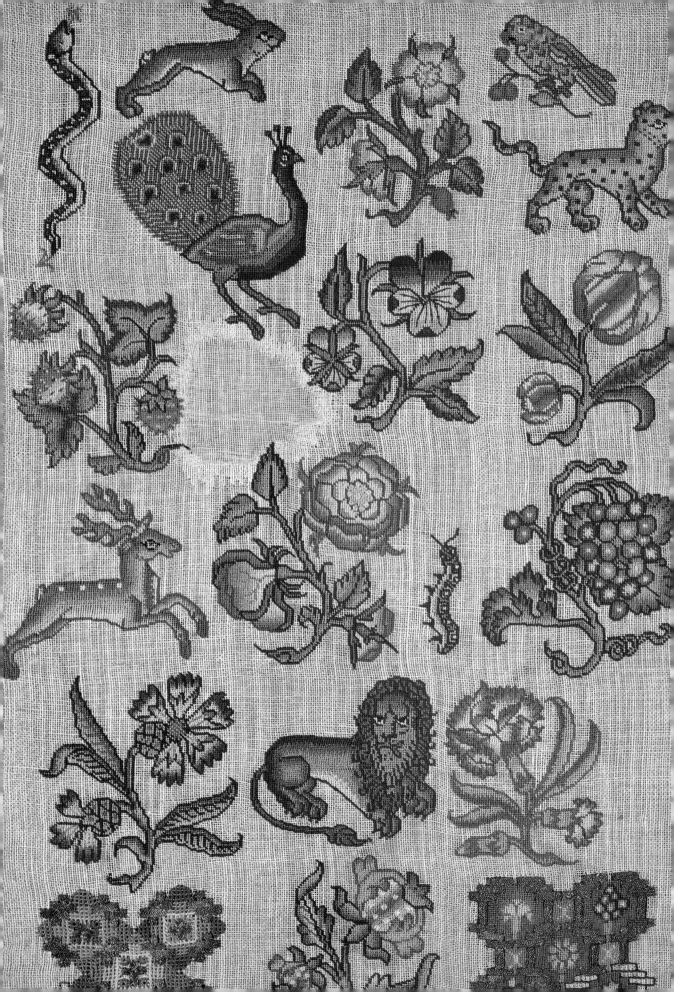

birds, insects, butterflies and caterpillars. A pair of peacocks stand either side of the central tree.

Motifs that are to be applied should be embroidered first on a fine canvas ground and must be worked simply, in one of the most basic of canvas-work stitches. The Elizabethans generally worked in tent stitch with silk or wool. Other simple canvas stitches that may also be used are cross and Hungarian stitch. Sufficient space should be left around the motif or panel to allow for cutting out the piece, and about ¼in (6mm) should be snipped at right angles to the edge to be turned under. Awkward, fiddly shapes can have this edge cut to enable the ground to lie neatly when tucked under. The work is then sewn to the ground with tiny slip stitches and the folded edges concealed with thicker silk thread or cord which is couched down around the design. Details such as insects' legs are embroidered on to the ground afterwards.

The canvas must be fine to avoid lumpy, bulky results. The ground to which the motifs are applied must also be strong. It may be necessary to line lighter fabrics with a further layer of linen underneath for extra support. Furnishing-weight velvet or a tightly woven satin is ideal.

## PRACTICAL APPLICATIONS

Included in this book are a number of charted canvas-work designs taken from sixteenth- and seventeenth-century embroidered furnishings. To work from these charts, each symbol in each square must be read as representing a single stitch worked over one thread (or pair of threads) of the ground. Animal motifs were frequently outlined with stitches in a dark coloured thread (generally black or dark brown) and subsequently filled in with the chosen colours. Outlines can be gently shaded around the contours of the body to give a more realistic impression of form. Many of the drawings also included here may be used for canvas work, designs being traced off and drawn on to the ground with simple outlines (see p125), the method traditionally employed during the sixteenth and seventeenth centuries.

Animal motifs may be taken from any clear and well-drawn illustrations by using the traditional methods of tracing off and drawing. Woodcuts, engravings and etchings are a good source of designs. Although animal motifs are usually worked in landscape settings, they may also be embroidered to stand alone as individual designs, perhaps framed by bands of patterning, wreaths or garlands of flowers, and so on. They may also be placed on grounds of textured stitch patterning, other canvas work stitches being used instead of the basic tent and cross stitches traditionally worked. Grounds might also be filled with small, repeating, geometric or floral patterns.

Today, canvas work is worked mainly on pictures, panels, cushion-covers and curtain tie-backs. Larger items, such as table carpets and valances, would not be considered practical, mainly because of the sheer size and scale of the work involved. Smaller cross-stitch rugs, however, may prove an exciting area for the more patient worker. Portraits of individual animals, worked perhaps in the style of some American hooked rugs on which sheep were especially popular, will be attractive on such rugs. A simple border would be sufficient to frame the finished design.

Pairs of animals or animal fables could be worked within strapwork border designs, surrounding central scenes such as the Creation or Adam and Eve. Ideas and inspiration may be drawn from many areas, including scenes from mythological and biblical stories such as Orpheus charming the animals or the animals entering Noah's ark. There are numerous possibilities involving farmyard scenes, rural landscapes and gardens.

Cushions need not be embroidered on both sides – they may be worked on one side only and backed with plain furnishing fabric. Cushions may also be made from embroidered panels applied to a ground of rich fabrics, such as velvet, brocade or satin. Different shapes, both of cushions and applied panels, provide a good visual mix, as well as stimulating ideas on designs to be held within these various shapes. Such shapes may be octagonal, round, square, hexagonal, oval and cruciform, as on the panels of the Oxburgh hangings. The long cushion, so popular during the Elizabethan period, could make a welcome return, offering ample scope for pictorial and narrative designs. Curtain tie-backs provide small areas well suited to smaller animal motifs, such as dogs chasing deer, rabbits or hares, decorating their lengths. A pair of creatures could be placed either side of a flowering sprig or tree, which has always been a popular and useful design element.

*A sampler from the first half of the seventeenth century showing motifs for applied work* (Victoria and Albert Museum)

# CANVAS WORK HERON

This leafy canvas-work panel of a heron standing in a dark pool was inspired by a contemporary screen print by Caroline Hughes – another source of design ideas for canvas work. I was so attracted by the bright modern colours that I asked if I could re-work it as a cushion cover.

Appleton's crewel wools have been used on a single mesh canvas of 18 holes to the inch. The wool is used double, worked entirely in tent stitch, though cross stitch is an obvious alternative. Tapestry wool, stranded silks or cottons could also have been used.

| | |
|---|---|
| / | Yellow 331 |
| // | Dark yellow 472 |
| × | Green 525 |
| ● | Red 947 |
| . | Grey 922 (bird) |
| . | Dark grey 965 (border) |
| ▽ | Blue 821 |
| □ | Brown/Black 588 |

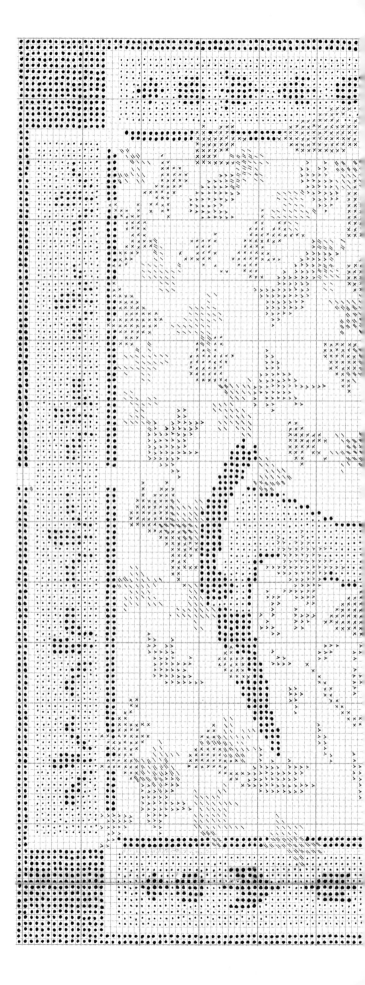

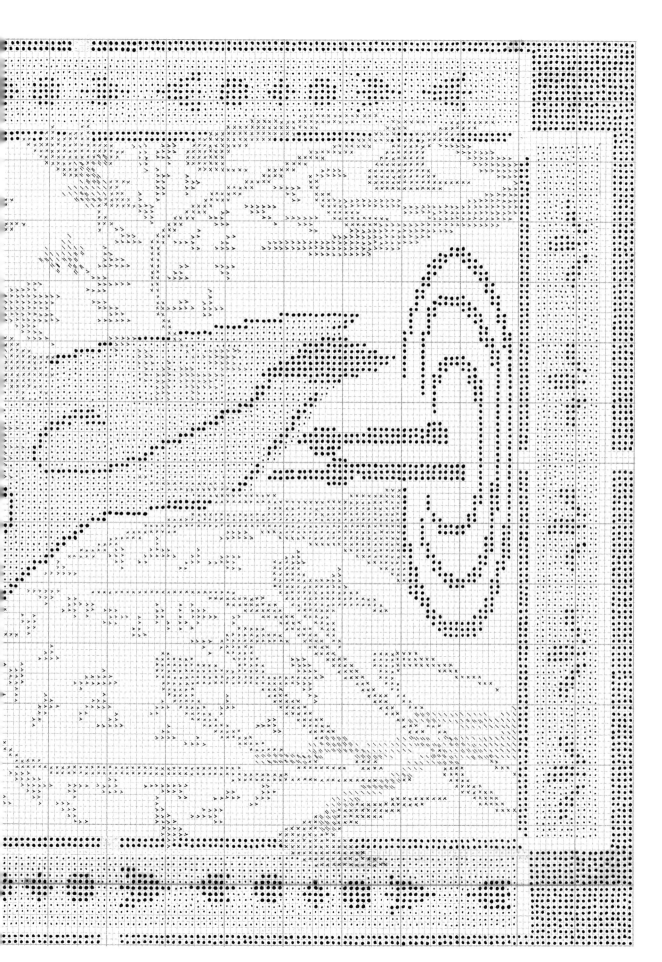

# ELIZABETHAN CREATURES

Natural history books were intended as serious studies of animal life rather than as source books for craftsmen and embroiderers. The numerous woodcuts that were included in these works were conscientious renderings of different species of animals, birds and fish, many of which displayed a characteristic unnaturalness. Those that are obviously not drawn from life appear somewhat distorted and those that are perhaps copied from less capable drawings have become stylised, being more decorative in quality. While many animal motifs from the sixteenth century might be considered naive today with our extensive knowledge of the animal kingdom, such depictions were probably very attractive to Elizabethan embroiderers. Animal motifs from this period possess a timeless quality so that they remain attractive centuries later and are still easily workable using the same techniques. Counted threadwork is as popular a method of working today as it was in the sixteenth century when silk was worked on fine linen canvas; today, the working of wool on a heavier, more open canvas is generally used, probably because the work progresses more quickly.

The most popular natural history book that was used as a source of reference for animal motifs was written by Konrad Gesner, a humanist and a doctor. Gesner wrote on medical subjects and also compiled a full catalogue of contemporary authors, which earned him the title of 'The Father of the Bibliographies'. It is, however, for his four-volume compilation entitled *Historia Animalium* that he is remembered

*Elephant from Konrad Gesner's* Historia Animalium *(1551)* (Bodleian Library)

A further publication used as source material for embroiderers was a compilation by Edward Topsell (died 1683). This was entitled *The History of Four-Footed Beasts and Serpents*, which included *The Theatre of Insects*, and was published in London in 1668.

The strong linear quality of these illustrations meant that motifs could be copied easily, enlarged or reduced and drawn on to the ground ready for working. This was usually done professionally. The motifs were then outlined with tent or cross stitch with a dark coloured thread, usually black, and then filled in with the desired colours. The infilling was done on a fine canvas with basic stitches such as tent and cross stitch. Simple shading gave a slightly more realistic impression. It is a technique similar to today's painting by numbers or children's colouring-books.

This simplistic method of working left the embroiderer free to concentrate on the design content. She could involve herself with the various motifs to be worked and the messages that could be conveyed through clever use of allegory and symbolism – perhaps including

today. He gathered information from Greek, Roman and medieval writers and his books are illustrated with over a thousand woodcuts of all species of animal life. Some of the illustrations were drawn especially for the books, while others were submitted at random by Gesner's travelling correspondents. Others still were based on material that was already published, such as Albrecht Dürer's famous woodcut of the rhinoceros.

Gesner's illustrations were very popular with embroiderers who copied them exactly. His strange and often wondrous creatures appealed directly to people's imaginations. Gesner seems to have had a particular fascination with the different species of fish, although his illustrations were drawn more from the imagination than from scientific observation.

*La Nature et Diversité des Poissons*, written by Pierre Belon and published in Paris in 1551, was another natural history book used as a source of information for embroiderers. Also published in 1551 was Pierre Belon's book on birds, *L'Histoire de la Nature des Oiseaux*.

*Boy riding Frog, from Gesner*

Latin mottoes. The task of drawing out the design would have most often been carried out by a professional, but the choice of content was entirely that of the embroiderer. The choice of colours was also hers, with professional advice at hand should it be required. As a result, some very colourful and vibrant embroideries have been handed down to us. The more sophisticated and experienced professional would not have dared to use colours and motifs in such a way and consequently these amateur embroideries show a wonderful freshness and immediacy.

## PRACTICAL APPLICATIONS

Both Gesner's and Topsell's natural histories have been republished recently in part and are available to the modern embroiderer as an exciting source of animal designs. A wide variety of real and fanciful, wild and domestic, birds, animals, fish and insects are shown as large, bold black and white illustrations. Any one of these would translate readily into charming embroideries, particularly for canvas work. The designs may be traced off easily and transferred to the ground by using one of the methods described on p125. In the same way, many other illustrations with clear and simple outlines may be used, as they were in the past. Many such illustrations were subjected to the prick and pounce method of transferral (see p125) which contributed to the destruction of many sixteenth-century natural history books, resulting in their scarcity today.

Many of the designs from natural history books would also suit more freely worked styles of embroidery as well as counted threadwork. Raised and padded techniques may be used where the forms and contours of animals can be indicated. Motifs may be worked separately, cut out and applied to the ground afterwards (see p39) and many of the insects and birds may be worked by using the more painterly techniques of surface stitchery with straight satin and long and short stitches. Subtle shading may be achieved by using

**Straight satin stitches**

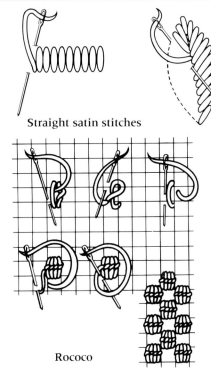

**Rococo**

several shades in various colours. Designs can also be interpreted by using any of the techniques employed in the making of stumpwork caskets (see p83), where much use was made of detached stitches to embroider animal motifs, which again were often raised and padded. In short, designs taken from natural histories adapt readily to almost any technique and are therefore a valuable source of animal designs for today's embroiderer.

Many of Gesner's and Topsell's animal designs were copied directly by Bess of Hardwick and Mary Queen of Scots on the panels of the Oxburgh hangings, which illustrates the ease with which these simple, well-drawn designs translate into embroideries. By using the simplest of techniques and a basic but charming colour-scheme, the results achieved are at times naive and childlike, but also most effective and appealing. These natural history woodcuts present a perfect challenge to amateur embroiderers of any standard.

# THE OXBURGH HANGINGS

The embroidery panels worked by Mary Queen of Scots on the famous Oxburgh hangings are good examples of applied canvas-work panels that use animal designs from sixteenth-century natural history books. The panels were worked by Mary and Bess of Hardwick, wife of the Earl of Shrewsbury, in whose care Mary had been entrusted during the majority of her nineteen years of imprisonment. Mary worked a large number of embroideries during her captivity, some of which were intended as bribes, others which were ostensibly gifts that often carried secret messages.

These messages were combined with the symbolic and enigmatic meanings of numerous exotic, domestic and fabulous beasts, birds, insects and fish.

It is known that Mary was an accomplished needlewoman, but the relatively poor standard of the work illustrated here perhaps emphasises the fact that she was so involved with the content of her designs that her workmanship suffered. Embroidery proved to be one of Mary's few methods of communication, through which she indicated her burning sense of injustice and her courage in the face of adversity.

Mary's final place of imprisonment was at Chartley Hall and the Chartley inventory made in 1586 of the queen's possessions listed large numbers of embroideries. There were many unmounted or unfinished embroidered canvas-work panels of individual animal motifs. A total of 240 birds, 16 four-footed beasts and 52 different fish were listed as separate pieces. These, together with other items of needlework, add up to an astonishing amount and it is questioned whether or not it was possible that all these pieces could have been Mary's work. Only those bearing her name, initials or cipher can properly be said to have been made by her.

It is generally believed that the Oxburgh hangings, now at Oxburgh Hall in Norfolk, were made after Mary's execution. The hangings were made with a large number of panels embroidered by Mary Queen of Scots and Bess of Hardwick and applied to a ground of green velvet. This is said to have been done professionally by a 'tapissier'. The ground has been further decorated with a scrolling design of couched silver thread/silk cord.

Three of the hangings are on display at Oxburgh Hall; a fourth has been cut up and a number of fragments are now housed at the Victoria and Albert Museum; three other panels are housed at Holyrood House in Edinburgh. The panels are carefully arranged on the ground, the centre-piece being a large square. Around this square are placed four octagonal, and a number of cruciform-shaped, panels. These have been embroidered with silk thread in tent and cross stitch on a fine tabby weave linen of eighteen threads per inch. Chain or braid stitch (Ceylon stitch) have been used to highlight small areas. The outlines of the motifs, worked in black silk, have been filled in with shading. The choice of colours was probably that of each embroiderer, the range of colours limited to those that were available (Mary is known to have made numerous requests for threads in various colours and quantities).

## THE MARIAN HANGING

Of the three surviving hangings, the Marian hanging bears most of the panels that are 'signed' by Mary Queen of Scots. The centre square is worked with a highly symbolic design and bears the motto 'Virtue flourishes by wounding'. The focal point is a hand that reaches down through clouds in the sky between two fruiting trees. The hand is holding a scythe or pruning hook and appears to be cutting down the unfruitful branches of a vine. This was one of Mary's secret messages that was worked into a design on a cushion-cover and sent to the Duke of Norfolk. The duke was involved in a possible plot to free Mary, and it is believed that the design on the cushion signifies the following: 'The unfruitful branch of the royal house [being Elizabeth, always reluctant to marry] was to be cut down. The fruitful branch [Mary who already had a son] would be left to flourish and bear more fruit.' The Duke of Norfolk was captured, tried and executed in 1572 for treason.

Tiny birds fly in the sky, while a butterfly, a running stag and hare appear in the foreground. The entire panel has been framed in red damask and outlined with yellow cord. At the corners are two embroidered marigolds (the flower adopted by Mary as her own symbol) and two thistles (the flower of Scotland).

Three of the four octagons at the sides of the square bear a motto. At the top there is an

# ELEPHANT

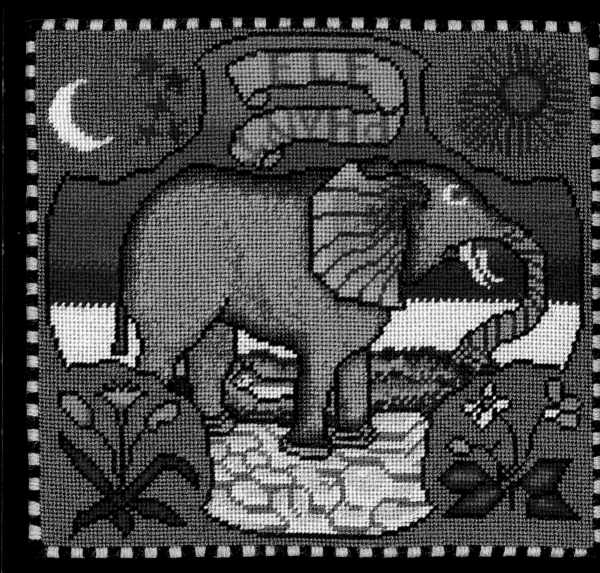

This design is taken from a panel on the famous Oxburgh hangings, with the colours slightly changed to suit my own tastes. I have also shaded the elephant's form rather more than the original, often using two different colours mixed together to give a wider range of shades. The corner motifs have been changed, the rather weak birds being replaced with my own renderings of the sun and moon. Appletons crewel wools and Coats stranded cottons (whole strands) have been used on a canvas ground of

18 holes to the inch. Tapestry wool, stranded silks and even beads would give different effects. The main stitch is tent stitch, cross stitch being an obvious alternative. The finished size is 8 × 7.5in (20 × 18.5cm).

Any of the Gesner or Topsell woodcuts included in this book could be used for contemporary designs. Work the outlines in black stitches, then carefully add shading and colouring.

## COLOUR KEY (see chart)

**Appletons crewel wool**

| | | |
|---|---|---|
| □ | Green 403 | |
| / | Dark green 647 | |
| C | Red 947 | |
| O | Dark red 227 | |
| // | Dark pink 755 | |
| n | Pink 754 | |
| g | Pale pink 753 | |
| ● | Black 993 | |
| Y | Yellow 474 | |
| ÷ | Blue 823 | |
| w | Dark blue 825 | |
| + | Blue 464 | |
| s | Pale blue 821 | |
| | Grey 974 | |
| z | Dark grey 976 | |
| | Pale grey 282 | |
| ∝ | Beige 988 | |
| ▽ | Grey 922 | |
| t | Beige 141 | |

**Coats stranded cotton**

| | | |
|---|---|---|
| * | White 926 | |
| . | Pink 892 | |
| L | Yellow 293 | |

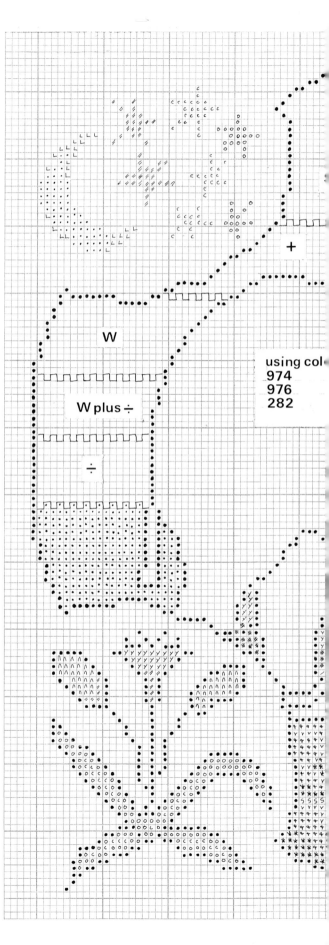

W

W plus ÷

÷

+

using col
974
976
282

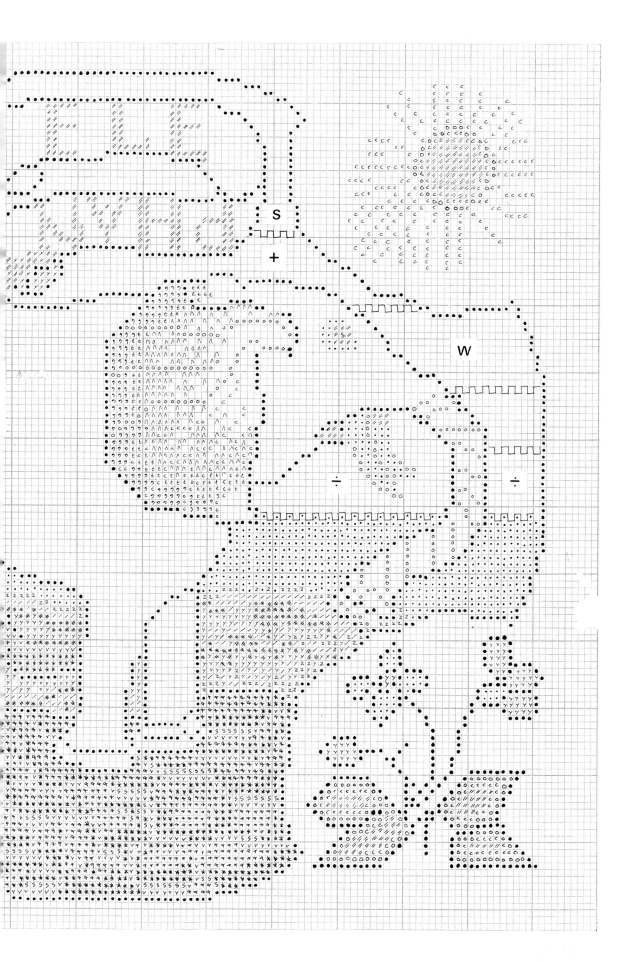

*A panel from the Oxburgh hangings which depicts a 'phenix' (Victoria and Albert Museum)*

anagram motto which uses the letters of the name Maria St Vart, *Sa Virtu Matire*. On the right 'The bonds of virtue are straighter than that of blood', and on the left 'Be it given to the fairest'. Around these are worked a large number of cruciform-shaped panels and four more octagons. Their positioning was of some significance. Directly above the central square and the octagon bearing Mary's cipher is a panel worked with a phoenix rising from the flames anew. This has been worked in an heraldic fashion and does not appear to have been copied from any natural history book. Apart from any symbolic significances that may have been implied, the phoenix was also the impresa of Mary's mother, Marie de Guise. (A crowned salamander was the badge of Francis I.)

At the top left-hand corner of the central square is a unicorn and on the right a lion. This is the order in which they appear on the royal arms of Scotland (on the royal arms of England, their positions are reversed). The pelican, which also occupies a prominent position on the hanging, represents an ancient type of Christ 'by whose blood we are healed'. The pelican was used to symbolise the crucifixion and as an attribute of chastity personified. On the Marian hanging, the pelican has been depicted 'in her piety', that is, standing on her nest, wings displayed and feeding her young chicks from her

blood. The pelican in her piety symbolises filial devotion, the Roman word *pietas* signifying devotion to one's parents, as does the bearing of a pelican on coat-armour.

Of the four octagons which decorate the sides of the hanging, the top-left panel bears the motto 'Not followeth lower things' and another symbolic design that depicts Mary's favourite flowers, marigolds turning their faces towards the sun shining down through the clouds. The bottom two octagons have mottoes which read 'A snake lurketh in the grass' and 'Trust not over much in appearance'.

The numerous smaller cruciform panels contain most of the animals and these were chosen carefully for their symbolism or personal relevances. Mary seemed to have had an affection for toucans, for not only has one been worked on the hanging (under the title 'A Byrde of America') but she also collected feathers of many kinds. Another panel, once part of the Oxburgh hangings, has a design that includes feathers falling from an armillary sphere, although the symbolic meanings behind these seem indecipherable today. It has been suggested that the panel's design is a play on the words *peane*, *plume* and *peine* – grief. Mary's toucan was copied from Gesner's *Historia Animalium*, as were the 'lyon', 'phesant', 'once', 'sneiles' and 'sea moonke'. The tiger also appears among Topsell's woodcuts.

Other creatures worked on the hanging that have been 'signed' by Mary include the 'phenix', turtle dove, dragon, an eagle and a hare, 'unicorne', 'pellican', 'cockatrice', 'zyphwhale', 'harte', 'delphine', butterflies and 'canker' (worm), together with a yellow rose and caterpillars. The unsigned panels depict the 'solen goose', jay, bees and beehive, 'scolopender', horse, rhinoceros of the sea, 'thorne back', 'troute' and a she dolphin, together with another fish.

The leaping 'delphine' (dolphin) represented Mary's first husband, the Dauphin, whom she married in France in 1558 and of whom she was very fond. The inclusion of royal beasts such as the lion is predictable, as was the working of those such as the horse and the unicorn. The cockatrice, which is heraldic in character, is also

*Panel from the Oxburgh hangings depicting the fable of the thirsty Jackdaw (Victoria and Albert Museum)*

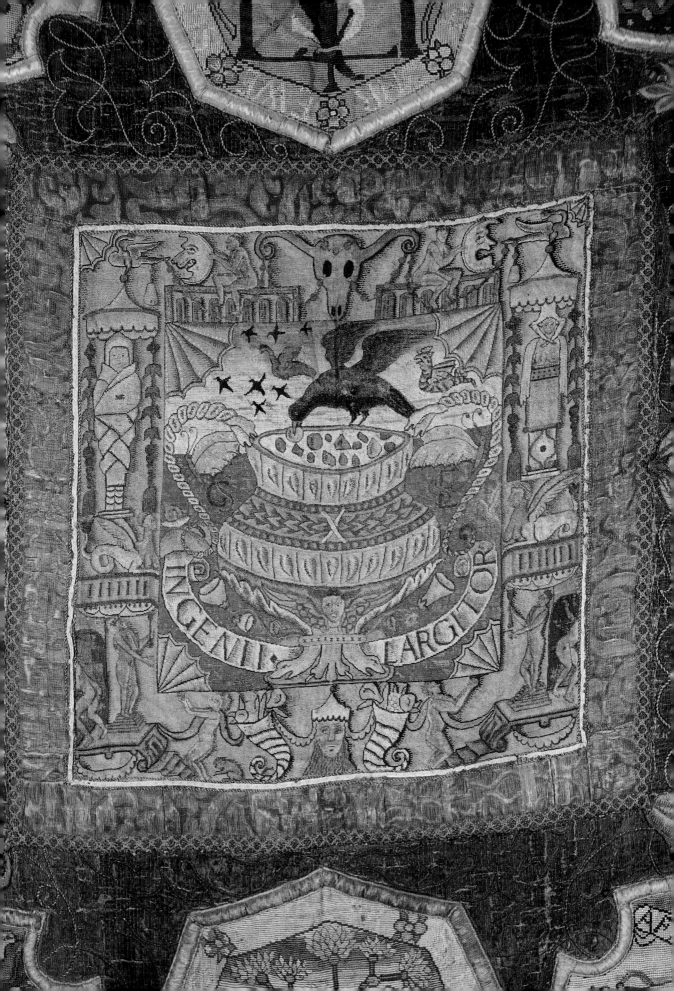

INGENII LARGITOR

*'Sea moonke', from the Oxburgh hangings. Konrad Gesner's illustration of this creature was used as a design source* (Victoria and Albert Museum)

symbolic. An unpleasant beast, in heraldry the cockatrice signified an insidious treacherous person intent on mischief. It was also compared with witches who were said to work the destruction of small infants and neighbours' cattle, because they envied their prosperous estates.

The panel of three butterflies resting on flowers has the initials MR worked in red. Because of the different stages of its life cycle, the butterfly is a symbol of the resurrection and of immortality, and Mary may have worked them to symbolise her Christian faith. Traditionally, the image of the butterfly emerging from the chrysalis represented the soul leaving the body at death. The butterfly symbolises playfulness, joy and pleasure; because it flits from flower to flower, it also symbolises inconstancy.

The snails depicted by Mary were also copied from Gesner's woodcuts. The snail was a popular small motif on sixteenth- and seventeenth-century embroideries used to fill in spaces on embroidered stumpwork pictures, caskets and mirror frames. In heraldry, the bearing of snails signified that much deliberation was to be used in all matters of great difficulty and importance, 'for albeit the Snaile goeth most slowly, yet in time, she ascendeth the top of the highest tower'. Mary's imprisonment gave her plenty of time to consider her problems and she may have borne

in mind the fable of the snail and the hare.

The panel that depicts the eagle and the hare, and the rose and the marigold, may well refer to the two queens, Elizabeth and Mary, and the fable of the eagle and the hare. One interpretation of the moral at the end of the fable is as follows: 'This Fable is a warning against holding anyone in contempt. You must remember that even the feeblest man, if you trample him in the mud, can find a way some day to pay you out.'

Not all of the animals were chosen by Mary to convey symbolic and emblematical messages. On another of the hangings she worked a sentimental design of one of her much loved pet dogs, which she was allowed to keep during her captivity. It is entitled 'Jupiter' and was probably drawn by herself as it is crudely worked, differing significantly from other motifs copied from woodcuts. Another panel (a more competent drawing) shows a similar naivety in the working of a tiny tortoise that is climbing up the trunk of a palm tree. The tortoise represents Darnley, Mary's second husband, and symbolises his attempt to climb in status through his marriage to the Scottish queen who is symbolised by the palm tree. The motto reads 'Glory gives strength'. The large woodcut of a cat, copied from Gesner's *Historia Animalium*, with the addition of a tiny gold crown, was worked by Mary in ginger thread (Queen Elizabeth's hair was said to be red.) A small mouse was also included which represents Mary herself.

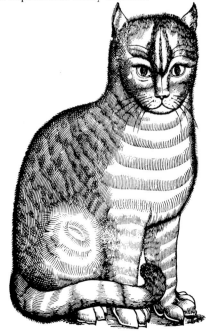

# THE CAVENDISH AND SHREWSBURY HANGINGS

The Cavendish and Shrewsbury hangings are generally associated with Bess, Countess of Shrewsbury. Bess was married and widowed four times and the embroidered panels repeatedly refer to all her husbands, and in particular to her grief on the death of Sir William Cavendish.

The main panel on the Cavendish hanging shows an emblematical design of tears that are falling on to a bed of quicklime. The motto which reads 'Tears witness that the quenched flame lives' may have been included at Mary's suggestion as a fitting epitaph for the countess' much-loved deceased husband. The borders of this square are decorated with numerous motifs that reflect Bess's grief – broken mirrors, a broken chain and a glove (used as a symbol of fidelity and faithfulness) cut in two. Three rings, one for each of her husbands, are linked together but with a break in each.

The snake (as the Cavendish serpent) was a badge of George Talbot, the sixth Earl of Shrewsbury, as were the Talbot dog and the Hardwick stag. A pair of knotted serpents have been worked in a cruciform-shaped panel at the bottom right-hand corner in an intricate and well-designed arrangement embroidered in brilliant colours. The snake or serpent has many different symbolic interpretations: it can be a symbol of prudence personified (in Matthew 10:16 'be wary as serpents'), but it can also symbolise rebirth and healing. This latter significance probably arose because the snake sloughs its skin. The snake is also depicted wrapped around the rod of Asclepius, the Greek god of healing and medicine.

Of the birds worked on the Cavendish hanging the 'estrich' (ostrich), 'gleade' and turkey cock have all been copied from Gesner's woodcuts. The ostrich has been endowed with some extravagant plumage with fluffy curling feathers. An ostrich is depicted with a horse-shoe because it was believed that the bird could eat iron. The 'gleade' (the Scottish name for a kite) is shown with its newly hatched chicks and an observant frog looking on. Other birds include a 'favconet', a 'swalloe' and a second bird of America. The most charming of the animals depicted on this

hanging include a leopard worked in an heraldic pose illustrated walking over a diamond-patterned floor. The tiger is similar in style and is shown walking on a chequered floor. The camel is also charming as is the 'mold warpe' (the mole). The fish worked in a cruciform panel at the bottom left-hand corner has probably been copied from Gesner's woodcut of 'a type of shark' with a similar spotted skin.

The central square of the Shrewsbury hanging has as its motto 'Bestower of Wit'. This was also the title of a fable by M. Claudius Paradin from which this design was taken. It illustrated the fable of the thirsty jackdaw who was unable to reach water in an urn. The resourceful bird filled the urn with pebbles to raise the level of the water so that he could then drink from it. In this embroidery, the urn has been further decorated and the handles changed to those of twisted snakes. Two butterflies, a cockatrice and some small flying birds are also depicted.

The borders of this square are worked in a classical style with a number of naked figures and the skull of what may be either an ox or a bull. Underneath an illustration of what may be representations of Bess and her late husband each swathed in burial cloths, are two sphinxes. These beasts have their origins in Egypt as guardians of tombs and temples. Their very appearance was supposed to frighten away evil spirits and wicked demons. In Greek mythology,

it was the sphinx who devoured those people who could not answer the riddles it set for them, and perhaps was included for its relevance to the riddles set by Mary and Bess in their embroideries. At the bottom of this panel are two cornucopias overflowing with fruit, signifying friendship. This horn of plenty was also an attribute of the figure of Hospitality who holds her hand out to a pilgrim, and again, of Ceres the goddess of agriculture. This may well have been relevant, Bess being a farmer as well as a merchant and builder of houses.

Among the birds worked on the Shrewsbury hanging are a cock, a 'byrde of paradyse' and a crane, all copied from Gesner's woodcuts. The pye of Persia also comes from Gesner's work in which it appears under the title of 'a pa, a bird of prey reported from Madagascar'. Other birds include a 'sterling', a robin sitting on a hurdle and a stork of the 'montaynes'.

The animals copied from Gesner's woodcuts are a 'fyrete' chained and feeding from a bowl, a milkmaid milking a reindeer and a 'chamel of Indye'. The latter is similar to a rendering of Gesner's 'camelopardel' – a cross between a camel and a leopard – but which in reality was probably a giraffe. Other animals include a crocodile, an ass, a dragon and a bull being speared from behind a tree. The image of a boar standing beside a sprig of holly (each associated with Christmas) was also used on coat-armour. With regard to the Oxburgh hangings, fewer panels were worked by Bess than they were by Mary.

Bess was responsible for the building of Chatsworth House and Hardwick Hall, both in Derbyshire. Bess furnished these houses with great care and, as well as the collection of embroideries that are housed at Hardwick Hall, a number of large French tapestries from the sixteenth and seventeenth centuries are on display. The famous Devonshire hunting tapestries are also believed to have originated from Hardwick Hall.

## PRACTICAL APPLICATIONS

The most popular items of embroidered furnishings today are probably canvas-work cushion-covers. It is in this area that designs from the early natural histories are most appealing. The working of applied shaped panels to a ground of rich furnishing fabric is an attractive proposition because it takes less time to make the panels than it does to work the whole surface of the ground on which strong and simple illustrations translate readily into designs for canvas work.

Illustrations from the natural histories also included here can be

CROCODILE

**Eye stitch**

**Algerian eye**

**Hungarian stitch**

**Diagonal stitch**

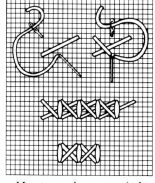

**Montenegrin cross stitch**

**Rice stitch (worked over plain cross stitch)**

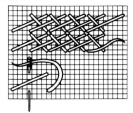

**Long-armed cross stitch**

traced off and transferred to the ground by using one of the techniques described on p00. Tent and cross stitches were those traditionally used and these designs are still best interpreted by using one of these basic stitches. It may be worth experimenting with other stitches, however, which may provide textural interest either for the animals themselves or for the backgrounds. Suitable stitches include rice, Hungarian, diagonal, Florentine, rococo, Algerian eye, eyelet, and various varieties of cross stitch.

The panels have been applied to a ground of green velvet which has been decorated further with a scrolling design of red and silver threads, the decoration providing another element of design with which you may care to experiment. The use of braiding, cord and heavier styles of stitchery worked on a variety of rich materials, such as silks, metal threads, and so on, and stitched around the edges of applied panels, adds to the variety of textural contrasts. Once panels have been applied to the ground, the edges may be decorated by means of a number of techniques, including cord or braid couched to the ground, or raised and padded satin stitches worked over lines of threads, cord or other forms of padding. Stitches such as braid, plaited braid and varieties of buttonhole stitch are other alternatives which, when worked using heavier threads such as gold and silver, can be effective.

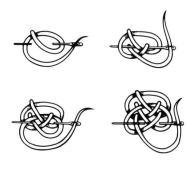

**Plaited braid**

The use of cruciform and octagonal shapes provides further visual variety; other shapes, such as oval, round, hexagonal and oblong, could be interesting and the possibility of creating a 'window' effect could be explored. The shape should be drawn on to the ground first and the design worked into this afterwards. The use of a card template to transfer the outline of the chosen shape to the ground is probably the most efficient method.

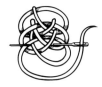

**Satin stitch trailing**

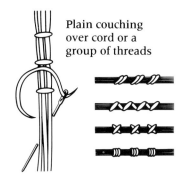

**Plain couching over cord or a group of threads**

**Various couching stitches**

# KNOTTED SERPENTS

This design comes from a panel on the Oxburgh hangings, originally within a cruciform shape. Here, it is placed within a border – also taken from the hangings. (The Latin motto is a personal touch.) Though wool is usually chosen for contemporary canvas work, this design has been worked using whole stranded cottons. (Another alternative would be stranded silks.) The finished piece is 9in (22.5cm) across.

Any of the woodcuts illustrated in this book would make good motifs and can be traced straight off the page. The backgrounds should be kept simple, limited almost totally to the earth and the sky, perhaps with careful shading of colours to give perspective and depth.

## COLOUR KEY (see chart)

**Coats stranded cottons**

| | |
|---|---|
| × | Green 0212 |
| * | Dark green 0876 |
| . | Yellow 0886 |
| / | Dark yellow 0891 |
| O | White 0926 |
| SKY | Blue 0940 |
| SKY | Dark blue 0941 |
| SKY | Mid blue 0399 |
| SKY | Light blue 0398 |
| GROUND | Beige 0393 |
| C | Red 039 |
| ● | Black 0403, plus gold twist cord, No 6, which is couched around the edge of the border. |

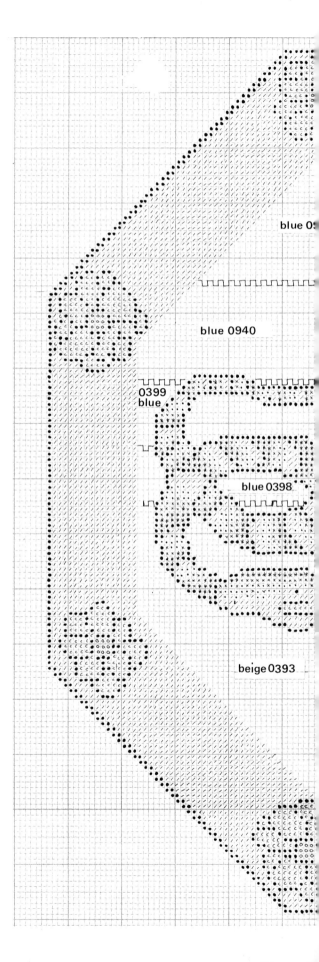

blue 0940

0399 blue

blue 0398

beige 0393

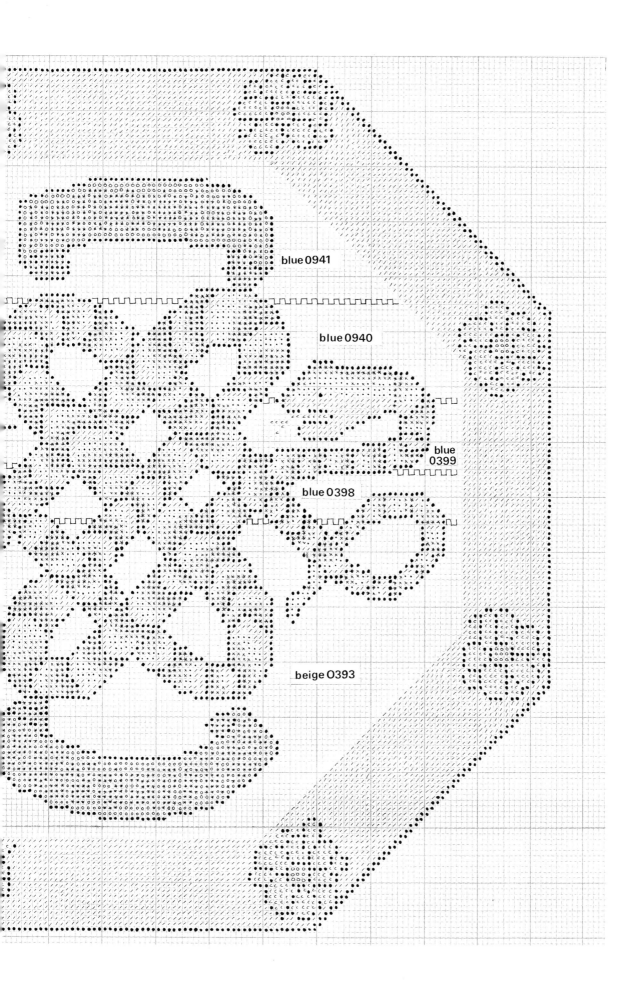

blue 0941

blue 0940

blue
0399

blue 0398

beige 0393

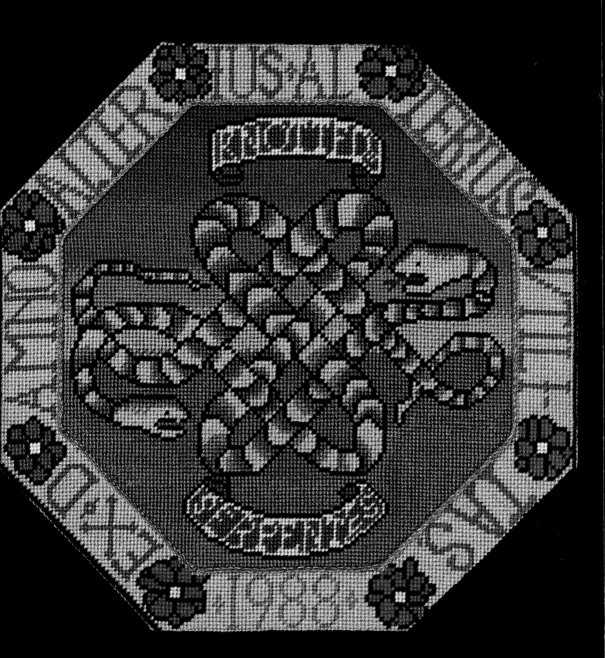

*Knotted Serpents* (Author)

# EMBLEMS
# AND
# EARLY BLACKWORK

Emblem books were an important source of animal designs for embroiderers during the sixteenth and seventeenth centuries. These books were similar to the medieval bestiaries but they were not concerned with the study of animal life or the teaching of religious or moral precepts. Rather they used narrative compositions to tell popular stories. Parallels have been drawn between the emblems that appeared in these books and the works of writers such as Shakespeare, Chapman and Jonson, and it is true to say that emblem books did, indeed, have a significant influence on the cultural and artistic life of the Elizabethan era.

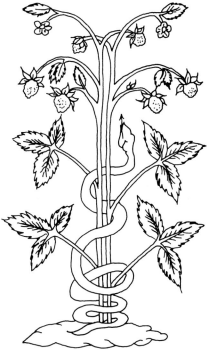

One of the most popular emblem books during this period was Geoffrey Whitney's *A Choice of Emblems* which illustrates at least thirty of Aesop's fables, including the story of the dog in the manger, the ant and the mole, and the fox and the grapes. Many of Whitney's emblems are witty anecdotes while a number of the non-narrative emblems are heraldic. Some of these devices were taken from the works of Claudius Paradin, whose book *Devices Heroïques* was first published in Lyons in 1557. The latter was also a popular source of designs for embroiderers.

*The Fables of Gabriel Faerno,* written in Latin and published in Rome in 1563, was another source of designs, many of the fables being worked as illustrations for embroideries. Faerno's fables were well respected and popular. The Oxburgh hangings, the Shepeard's Buss panel (later discussed in the section on blackwork, see p60) and the Falklands jacket, are all worked with designs that were taken from Faerno's fables.

In his book *Elizabethan Embroidery* (1963), George Wingfield-Digby includes in full a letter written to Ben Jonson by William Drummond of Hawthornden. In it is described a bed believed by the writer to have been embroidered by Mary Queen of Scots. The bed (which has not survived) was worked in gold and silk and covered with a large number of emblems, impresas and mottoes, many of which used animal designs that were allegorical and symbolic. Some of the decorative work referred directly to Mary's imprisonment: a lion captured in a net with hares jumping over him; a bird caught in a cage with a hawk flying above; a porcupine among sea rocks; a lion and her young whelp (symbolising Mary and her son); two flutes and a peacock; a salamander crowned and a phoenix in flames.

## PRACTICAL APPLICATIONS

Pictorial emblems provide both attractive, well-designed animal motifs and complete compositions for embroiderers who are less able to design or to draw their own

illustrations. The black and white motifs provide a valuable source of designs, while leaving plenty of scope for creativity in the use of colour and technique. Again, many pages of emblem books were subjected to the prick and pounce method of transferral (see p125), itself a pleasing task.

Almost any technique can be used, to work these motifs, from blackwork and monochrome embroidery to canvas work, applied motifs and the raised and padded techniques employed in stumpwork and heraldic pieces (many emblems were heraldic).

*Ox and Toad*

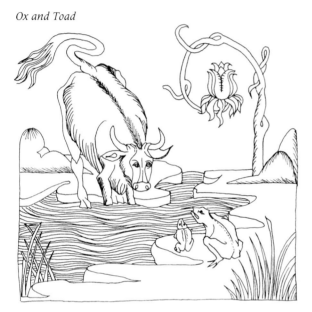

*Stag watching his own reflection in a pool*

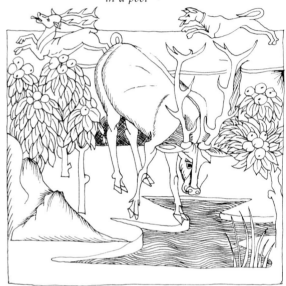

# BLACKWORK AND MONOCHROME EMBROIDERIES

New embroidery techniques were introduced during the Elizabethan period and traditions of monochrome embroidery, commonly associated with Henry VIII and illustrated in Holbein's portraits, were further developed. Monochrome embroidery later became known as blackwork which was used to decorate household furnishings, hangings, pillow- and bed-covers, as well as costumes and accessories. Blackwork was also a popular method of decorating ruffs, cuffs, collars and frills on which the stitching was reversible.

In Tudor times the linear style of embroidery was worked in double running stitch (Holbein stitch) and was popular throughout Europe in the earlier part of the sixteenth century. During the Elizabethan period, silver and silver-gilt

threads were used to highlight stitchery. A much greater variety of stitches was also used and backgrounds were often 'powdered' with precious stones. Geometric and floral 'filling in' patterns gave added depth to designs. Strapwork patterns (as on Jane Bostocke's famous sampler at the Victoria and Albert Museum) had a strong Moorish quality and designs of curling plants and tendrils often had smaller motifs of different creatures worked into every available space.

The crisp and effective linear character of blackwork probably owes its popularity and development to the engravings and woodcuts that were used as design sources. Many motifs were copied from popular emblem books of the period – herbals, natural histories and pattern books. The Shepeard's Buss panel features a number of devices that were copied directly from Claudius Paradin's *Devices Heroïques* (Lyons, 1557). The panel dates from the late sixteenth century and has been worked with black silk on

linen. Back and satin stitches have been worked together with speckling to create shading – in this instance with only one colour – and couched work. Tiny straight stitches were worked at random – close for darker areas and further apart for lighter areas.

The design on the shirt illustrated here, although simple in its conception, is very attractive. It has been embroidered entirely in pink silk with stem stitch on a white linen ground. The seams have been skilfully covered with a fine line of cross stitch and the collar and cuffs have been trimmed with bobbin lace. Among the numerous tiny spot motifs – which include snails, owls, cockerels, butterflies, cats and rabbits – four have been taken from an early pattern book published in 1624. This famous pattern book, entitled *A Schole-house for the Needle* and written by Richard Shoreleyker, has in its introduction the following description of its contents: 'Sundry sortes of spots, as Flowers, Birds, and Fishes, etcetera . . . to be wrought,

*Motifs embroidered onto a sleeve of the Falklands jacket* (Victoria and Albert Museum)

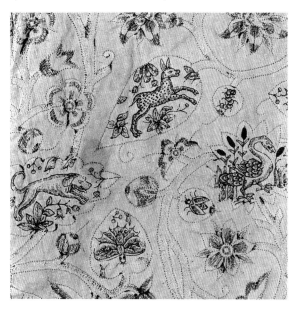

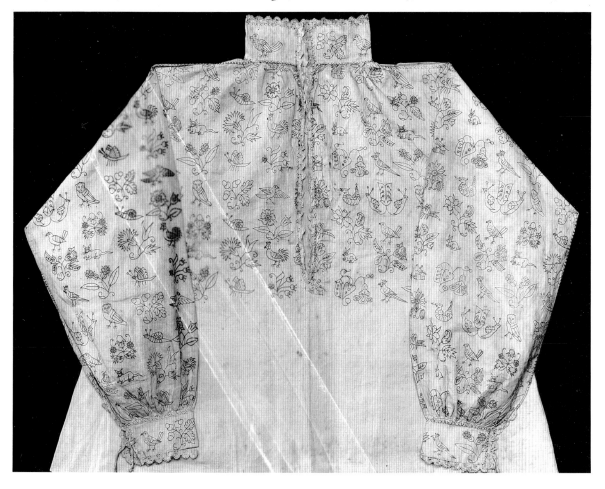

*Embroidered shirt* (Victoria and Albert Museum)

some with Goulde, some with Silke, and some with Crewell, or otherwise at your pleasure.'

The Falklands jacket, now in the Victoria and Albert Museum, is famous for its use of emblematical devices. The piece illustrated, which is unfortunately in poor condition, shows an all-over repeating design of coiling stems, flowers and leaves. Emblematical designs of animals, birds, fish, insects and figures have been worked within the leaves. A significant number of the designs have been copied from Geoffrey Whitney's *A Choice of Emblems*. Black silk has been embroidered on linen, and stem, back and running stitches have been used to outline the design which is infilled with tiny speckling stitches.

The many different creatures depicted on the jacket include an eagle, a peacock, a swan, a goat, a unicorn, a lion, a monkey, a squirrel, a leopard, a lion, an owl, a stork, a dog, a phoenix, a pelican, a hippocamp, a butterfly and a griffin. Other illustrations depict Bacchus playing a drum, the boy Hercules killing snakes and riding a crocodile, a man playing pipes to an ape in a tree, a lion watching a house and Actaeon and the hounds. (In Greek mythology, Actaeon was a huntsman who surprised Diana, goddess of hunting and of the woodland, while she was bathing. In anger, she turned him into a stag who was subsequently torn to pieces by his own hounds. As the stag, Actaeon symbolises husbands whose wives are unfaithful.) Whitney's emblems were also used to decorate the borders of the set of the four seasons tapestries at Hatfield House. At least one third of the emblems that make up these borders have been traced directly back to Whitney.

Embroidered costumes often reflected the Elizabethans' love of symbolism and allegory and everyday wear, as well as ceremonial and festive

*'Take away the prickles of pleasure'*
(from the Shepeard's Buss panel)

FOUR BIRDS

# THE RIVAL FISHES

*The Rival Fishes* (Author)

This design has been taken from a wonderfully strong and lively woodcut illustrating the story of The Rival Fishes (*Dialogus creaturarem*), Lyons 1509). The design was first enlarged and then transferred to the ground with the aid of a lightbox and transfer pencil. The lines were embroidered using black cotton perle. The fishes were worked in whipped back stitch with details in fly and straight stitches; the waves are in whipped stem stitch to give a slightly stronger line. These have also been edged with lines of stem stitch in gold thread on either side. The ground is a heavy cotton twill in white, dyed with a light wash of blue. The threads are DMC cotton perle in black (310) and five strands of Madeira metal-effect yarn in gold (004).

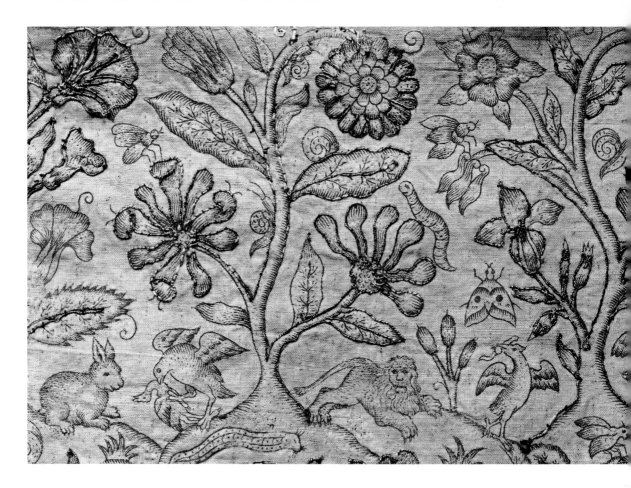

costumes, was frequently decorated with symbolic and emblematical devices. The 'Rainbow Portrait' of Elizabeth I, which can be seen at Hatfield House, made much use of political symbolism. In the portrait, the queen is wearing an elaborate dress, the skirt of which is decorated with heavily embroidered eyes and ears (signifying her ability to be 'all-seeing' and 'all-hearing') and the highly elaborate embroidered serpent on her sleeve symbolised her wisdom. The ermine painted at her feet alluded to her purity (the ermine was believed to be an animal that would rather die than get its coat dirty). In another portrait, the pelican jewel decorating the queen's neck was believed to represent her virginity.

Gloves, which were popularly presented as tokens of affection, were often embroidered with a verse that accompanied relevant motifs, such as rows of phoenixes symbolising love reborn in the ashes. Embroidered costumes and accessories were often embellished with precious gems, pearls, spangles, sequins, silver and silver-gilt thread. Gowns, petticoats, shirts and jackets, mantles and purses were usually made professionally and were often presented as highly treasured gifts.

The popularity of blackwork continued into the seventeenth century, although it became generally heavier and more elaborately decorated with metal threads and spangles. A woman's bodice from the 1630s has been decorated with animal motifs worked in red crewel wool. Different outline stitches, including stem, long and short and coral stitches, which have then been shaded in with speckling stitches, have been used to define the motifs. The ground is a cotton, linen twill weave which proved stronger than the linen previously used. The traditions of crewel work that used stronger fabrics for grounds embroidered with wools were just beginning, although the design sources initially remained the same.

A pillow-cover from the collection of the Marchioness of Waterford in the Royal Ontario Museum is worked with a striking lattice design, within which are a number of different species

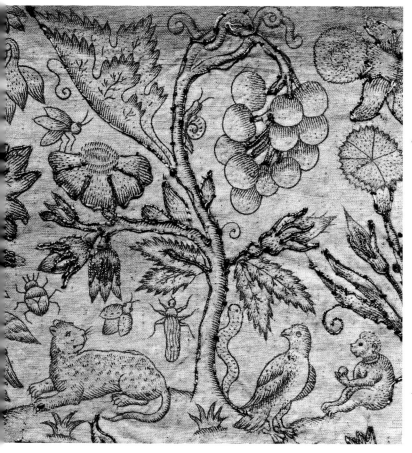

*An early seventeenth-century English blackwork coif on which flowering sprigs and animal motifs have been outlined with silver thread on a linen ground. Other techniques include couched work with speckling stitches to fill in the designs* (Victoria and Albert Museum)

Below left: *Pillow cover* (Victoria and Albert Museum)

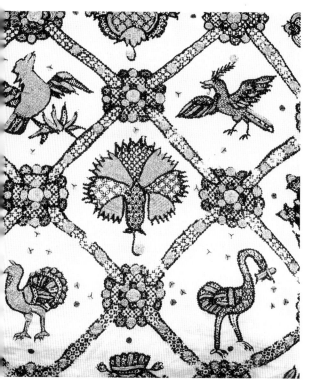

of birds. One theory is that these represent the four elements – fire, water, air and earth. The birds, however, may also be representative in other ways – for example, the dove is symbolic both of peace and of good tidings (the dove is shown here with a leaf in its beak). In the Middle Ages the phoenix was an attribute of chastity personified as well as being a symbol of Christ's resurrection. The crane represented vigilance and filial (or parental) devotion. The pillow-cover of white linen has been embroidered with black floss silk and silver gilt threads with plaited braid, chain, interlaced four-legged knot stitch, detached buttonhole, stem and double running stitch.

A Jacobean coif which dates from the first half of the seventeenth century (only partially worked) has been embroidered with an elaborate design of a profusion of flowers, birds, animals and insects, worked in silks with silver gilt thread and spangles. These docile menageries include exotic beasts from foreign lands, which exist peacefully with more typically English

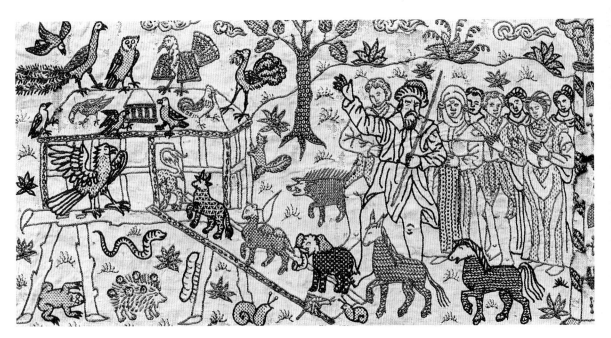

*Long pillow-cover from the early seventeenth century*
(Victoria and Albert Museum)

creatures such as rabbits, squirrels, snails, worms, butterflies and beetles. This profusion of flora and fauna is characteristic of seventeenth-century pictorial embroidery and of the three-dimensional stumpwork that was popular between 1630 and 1680.

The design worked on the coif illustrated on p64 is said to have been printed straight on to the ground from an engraved plate and was probably an early example of this method of transferring designs. Silk has been embroidered on to a linen ground with plait, back, chain and double running stitches. The design has been highlighted with silver-gilt and spangles. The triangular forecloth dates from the early seventeenth century and has been embroidered in a way that has been described as 'the flecked manner'. Black and white threads are used together (wrapped) as a single working thread, in this case with long and short stitch. This cloth has probably been cut from a larger embroidery, the motifs disappearing at the edges.

The illustration of the long pillow-cover, dating from the early seventeenth century and one of a set of four covers, shows a narrative design with four episodes from the life of Noah. The detail (see illustration) shows the animals entering the ark, while the other three scenes depict Noah's drunkenness, his sacrifice and the flood. The animals depicted entering the ark include a lion, a frog, a snail, a boar, a squirrel, a horse, a caterpillar, a snake, a cow, a turkey, a

peacock and an ostrich. A hedgehog is depicted with apples stuck to its spines in accordance with an old wives' tale that questions whether the hedgehog deliberately rolls upon the apples or whether they fall on him accidentally. Red and blue silk and silver gilt thread have been embroidered on linen with stem, back, eyelet and chain stitches, with decorative fillings and speckling.

The blackwork embroidery depicted on a panel from the Burrell Collection in the Glasgow Art Gallery and Museum illustrates the story of the disobedient prophet from the Book of Kings: 'A lion met him by the way, and slew him: and his carcase was cast, in the way, and the ass stood by it, the lion also stood by the carcase' (Kings 1:13, 34). The story is set within wide pictorial borders that depict a romantic rural landscape enhanced by two of the favourite animals of the time – a cheetah and a camel. The female figures in the corners represent the four elements.

The proportion of the different motifs did not receive a great deal of attention, but the balance and arrangement of the designs were worked carefully. Every convenient space was filled with a favourite animal, insect, bird or flower. Many of the motifs were taken from printed books and were probably copied to scale.

# THE FOX AND
# THE GRAPES

*The Fox and the Grapes* (Author)

The design for this embroidery has been taken directly from a very beautiful woodcut illustrating Aesop's fable of The Fox and the Grapes. The fox finds a tempting bunch of grapes to be out of his reach and claims that they cannot be worth bothering with, they must surely be sour! The woodcut has a wonderfully clever sense of perspective which I could not resist. I have worked it entirely in stem stitch using black coton à broder on a white cotton-twill ground. The stitchery has been kept simple in order to portray something of the crisp angular lines of this surprisingly delicate design. There seemed no need for further elaboration, though it may be quite tempting to completely 'colour in' the whole embroidery, perhaps with long-and-short, or straight satin stitches. Finished size 7 × 9in (18 × 22cm).

# TECHNIQUES AND MATERIALS

**Grounds** traditionally used for blackwork were soft, evenly woven linens, thin cambric, or fine lawns in white or cream. An even-weave ground is essential where regular counted stitchery is to be worked. Many types of even-weave fabrics are available, among them glenshee even-weave linen, linen scrim, even-weave cotton, Penelope and hardanger, and they come in various weights and colours. The fineness of old ex-amples of blackwork grounds may seem rather daunting, although coarser grounds can be worked and just as effectively, provided that the embroidered threads are compatible in thickness and weight to those of the ground.

It must be remembered that the thread count of the ground will govern the actual finished size of any design. The higher the thread-count (that is, the greater the number of threads to the inch) the smaller the stitches and therefore the embroidered design. Penelope and hardanger fabrics have their warp and weft woven as groups of two or more threads. This makes counting much easier (with stitches worked over one or two sets of grouped threads) and these would be ideal grounds for begin-ners. For surface stitchery, grounds can range from very fine in weight (muslin, and so on) to heavier cottons and linens, and stitches are worked freely follow-ing the lines drawn on to the ground.

**Threads** Black silk was tradi-tionally used during the sixteenth and seventeenth centuries and was available in a small number of different qualities. A few surviving examples used soft muted shades of blue and pink, and, according to one report, green. Later, red silk was used. By the 1630s, this had

been succeeded by red crewel wool embroidered on heavier grounds of linen. Heavier pieces of blackwork were often embroid-ered with coloured and gold threads that were worked into the outline stitches with weaving or interlacing techniques.

Ideally, threads should be single rather than plied, and they should be smooth and lustrous rather than glossy and slippery. Threads should also be of a compatible weight to the ground, so that the stitching does not distort or pull the ground in any way (too fine a thread will not give a sufficiently dense effect). A wide range of threads and crewel wools is avail-able and the following is a sug-gested list of the most suitable ones:

Burmi lana no 12
Zwicky's pure silk filofloss
coton à broder
cotton perle
stranded cotton
stranded silk
Decor no. 6
marlitt

**Needles** must be compatible with both the ground and the sewing thread – too large a needle will distort the ground. Blunt-ended crewel needles are preferable, so that you avoid piercing both the threads of the ground and any previous stitchery.

**Frames** The use of a frame or hoop is advisable. It should be large enough to take the whole design, thus avoiding the need to roll up the work.

**Transferring designs** Designs were traditionally drawn directly on to grounds either by profes-sionals or by amateurs using the prick and pounce method. Designs can be drawn on to graph paper and then translated into a stitch diagram by marking in the stitches/squares over the drawn

design. These should be indicated by straight lines that follow the same direction as the drawn line and that of the embroidered stitch. Work one stitch (mostly worked over two threads of the ground) per single square of the graph paper. This is by far the easiest method of transferring designs for regular counted threadwork.

The difference in scale between the design drawn on to graph paper and the finished embroidery must be considered. If stitches are to be worked over two threads of the ground, count the number of squares down and across the graph paper design and multiply this figure by two. The result will give you the total number of threads required for the design. To find the final size in inches or centimetres, divide this figure by the thread-count of the fabric used for the ground. (The thread-count is the number of threads per inch or centimetre and this is shown on the roll of fabric in the shop, for example twenty-six threads to the inch.)

Designs transferred using the prick and pounce method had more freely flowing lines, as did designs printed directly from en-graved plates. The difference in character between these methods and regular counted threadwork from charts is striking and the decision regarding your choice of technique should be considered carefully. A relatively fine fabric can be used if you draw the design directly on to the ground. For the less experienced embroiderer, counted threadwork should be tried first.

Guidance on using the prick and pounce method is given on p125. The lines of pounce (charcoal powder) can be painted over with a fine wet brush. Remember that any lines drawn on to the ground must be covered completely by stitchery and that therefore all lines must be fine and accurate. Do

not use a soft pencil as the lead will colour the ground and the threads will be pulled through the drawn lines.

**Stitches** Although many extravagant and luxurious pieces of blackwork were made using a wide range of stitches, animal motifs of the sixteenth and seventeenth centuries were generally worked using very simple examples of the technique. Motifs were first outlined with linear stitches and were then shaded in with minute speckling stitches which were to become so characteristic of crewel work. On some embroideries, animal motifs were filled in with stitch patterns. These were composed of small straight stitches worked in different directions to form endless varieties of floral and geometric filling patterns. On many blackwork embroideries, pattern darning, buttonhole stitches and the technique of pessante (double pattern darning) were also used for fillings.

Other suitable outline stitches include coral and pekinese stitch. Running stitches, back stitch and

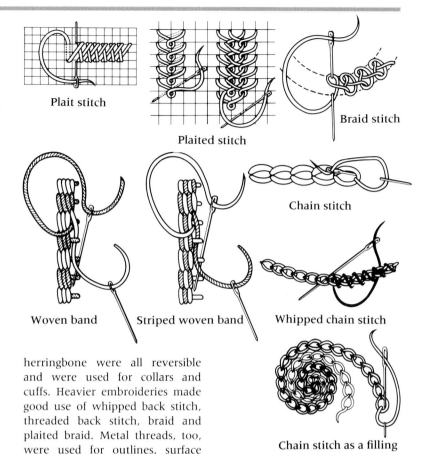

Plait stitch

Plaited stitch

Braid stitch

Woven band    Striped woven band

Chain stitch

Whipped chain stitch

Chain stitch as a filling

herringbone were all reversible and were used for collars and cuffs. Heavier embroideries made good use of whipped back stitch, threaded back stitch, braid and plaited braid. Metal threads, too, were used for outlines, surface woven-through straight stitches or laid and couched to the ground. Stems of flowers were often

worked in chain or plaited stitches with metal threads, the flowers being worked in bright colours.

## PRACTICAL APPLICATIONS

Monochrome and blackwork embroidery was used traditionally for the decoration of costume and it is for this purpose that the techniques involved remain most suitable. Monochrome and blackwork embroidery can be worked both on light grounds, such as muslin and cotton, and on heavier fabrics suitable for more complex stitchery. This versatile and interesting technique, which is still very popular, can be worked on pictures and panels and on a variety of different grounds. Suitable

grounds for beginners working counted-thread designs include hardanger and other even-weave fabrics on which threads are woven in groups of two or more, as well as single-weave grounds.

Blackwork embroidery remains a valid and attractive technique for decorating items of clothing, particularly those worn on special occasions. Hems, collars, cuffs, frills and shaped yokes of dresses are all suitable for decorative embroidery. (These areas are also well suited to cut and drawn work and hollie point.)

Projects such as these also provide the ideal opportunity for

working gold and silver threads into interlaced, whipped and threaded stitches, and for the inclusion of beads and spangles for further embellishment.

An embroidered shirt from the Victoria and Albert Museum is decorated with a large number of animal and plant motifs, worked in pink silk on a white ground, as isolated and carefully arranged spot motifs. The seams have been covered with tiny cross stitches. The result is very pretty and although the design is simple, it is also attractive. White or cream grounds embroidered in a single colour using this linear style of

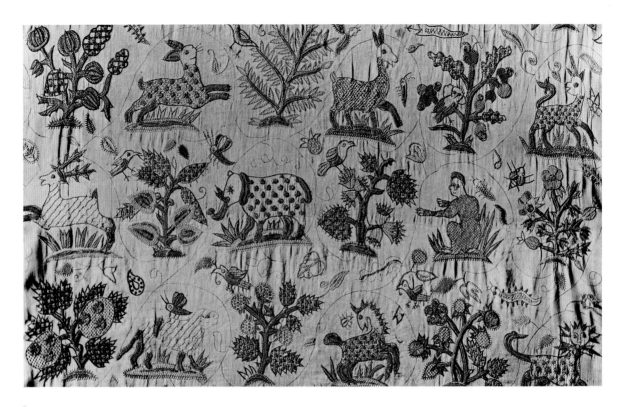

embroidery are always most effective. You need not limit yourself to the use of black on white: pink, red, green and blue can also be used, and try using different shades from pale pastels to darker colours on various colours and types of grounds.

Animals held within floral, strapwork or lattice designs have been worked on to older pieces of blackwork, the study of which can provide inspiration for ideas and designs. On the Falklands jacket the animals are placed inside the leaves of coiling stems within an all-over repeating floral design. The pillow-cover from the Royal Ontario Museum depicts birds contained inside the spaces created within a pretty lattice design. The study of sixteenth and seventeenth century natural histories, pattern books and other etchings, woodcuts and engravings can also provide a great deal of inspiration because their monochrome illustrations translate so effectively into blackwork embroideries.

Suitable projects include the

embroidering of items such as children's quilts, linen for baby's cribs, quilts, pillow-covers and decorative frills. You can fill in outlines with various geometric stitch patterns, using the basic back or running stitches. Textures can also be introduced by the use of knots and interwoven, whipped and laced stitches. Favourite nursery animals such as cats, dogs, elephants, bears, rabbits, butterflies, lions, tigers, zebras, camels, cows and donkeys could all be worked, perhaps at random or held within an overall design. Depending on the styles and materials used, the results could be either charming, beautiful or just fun. In a move away from the traditional colours, bright primary coloured threads and grounds are worth some experimentation.

The traditional use of black threads on a white ground still proves as exciting and as effective as it did in the past. The technique is particularly suitable for renderings of cats, dogs, sheep and zebra, any of which could be selected as

*An English embroidered hanging from the early seventeenth century. These naïve depictions of beasts and birds have been worked with coloured silks, silver gilt and silver thread on a linen ground with a large repertoire of stitches. The most interesting feature of the embroidery is the way in which the animal designs have been outlined with different linear stitches and filled with a variety of techniques, creating a great deal of textural interest (Victoria and Albert Museum)*

the main theme of a design. The animals' bodies can be stitched, using materials and techniques carefully chosen to represent the texture of each creature's coat. You could experiment with strong diagonal patterning for zebras and tigers; spots, circles or large spaced knots for leopards, cheetahs and dogs; and the popular knots and pile or loop stitches for fleeces, tails and manes.

# PATTERN BOOKS
## AND
# CREWEL WORK

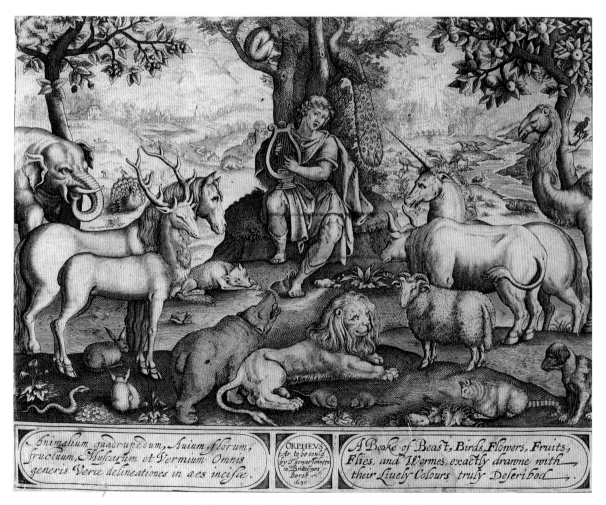

*The title page of 'A Booke of Beast . . .' published by
Thomas Johnson in 1630. The illustration shows Orpheus
playing his lyre to the animals, all of which have been
skilfully drawn* (British Museum)

Important sources of design material for embroideries during the latter part of the seventeenth century included books and large numbers of printed sheets that were published especially for use by embroiderers and craftsmen. From about 1660 onwards, Peter Stent and John Overton were publishing engravings of animals, plants, flowers, fruits and scenes from classical literature.

The titles of these books and sheets are interesting, although rather long-winded. They include such titles as *A Book of Beast, Birds, Flowers, Fruits, Flies and Wormes . . . A booke of beasts lively drawn, A New and Perfect Book of Beasts, Animalium Quadrypedum liber secundus, the second part of Fower-Footed creatures.* An early children's reading book was entitled *A New Book of all Sorts of Beasts Or a pleasant way to teach young Children to reade almost as soone as speake.* The illustrations included 'A leopard and lyon, a Lion leying downe, a strange coney [rabbit], another Lion and a monstrous Tartar' (the word 'tartar' probably relates to Hell – 'Tartarus' – and was used to signify a savage or severe nature).

These books would have been available to the young embroiderers who worked stumpwork embroideries (see Chapter 7). Robert Walton, the publisher, printed engravings for embroiderers. One of his publications was entitled *The whole view of creation in Eight Parts; being a Book of Beasts, Birds, Flowers, Fish, Fruits, Flyes, Insects, containing a hundred and thirty half sheets of paper neatly cut in Copper . . .*

The book with the long title of *Four Hundred new sorts of Birds, Beasts, Flowers, Fruits, Fish, Flyes, Worms, Landskips, Ovals, and Histories etc. Lively coloured for all sorts of Gentlewomen and School Mistresses Works* was published in 1671. It reveals that these publications were also intended for use in schools where needlework was considered the most important part of a girl's education. It was at this time (between 1650 and 1680) that young girls were producing stumpwork embroideries and many of these published patterns would have been available to them.

Animal engravings were not necessarily new. Plagiarism among print-sellers and engravers was rampant and in fact many illustrations were taken from other printed pattern books – many from the earlier bestiaries and natural histories. Some engravings were the work of skilled draughtsmen, others were drawn rather poorly,

and others still were straight copies of existing prints. A number of prints were of complete scenes, a popular one being the Garden of Eden or 'A View of the Creation'. These scenes were often rather fanciful, engravers taking the opportunity to portray fabulous animals as well as real ones. Apart from the numerous depictions of Adam and Eve, there was a scene depicting Orpheus charming the animals, the four cardinal virtues, the four complexions and the seven liberal arts. Peter Stent also published a version of Hollar's *Theatrum Mulierum . . . 52 habits of the female sex.* These titles indicate the subjects popularly covered by both embroiderers and craftsmen during the latter half of the seventeenth century. The favourite animals were the stag, the lion, the unicorn and the leopard. These well-respected motifs were borne on coats-of-arms.

On an English portfolio from the first half of the seventeenth century are embroidered the three Fates (see p2). These were spirits who, it was believed, determined a man's destiny and his path through life. Clotho is depicted holding the distaff and Lachesis the spindle. The most terrible of the Fates, Atropos, holds the scissors in readiness to cut the thread of life. Further allusions are made via the spider that sits in a web in the top left-hand corner of the border. When shown in art form, the depiction of a spider or spider's web usually alludes to Arachne, who was turned into a spider in anger by the goddess Pallas following a competition between the two ladies to weave the most beautiful tapestry.

Symbolic vignettes depicting various scenes also decorate the borders. A stag hunt representing the chase and good fleeing before evil, is illustrated at the bottom. Other vignettes, which

may have been worked to represent the four elements, depict a salamander and fishermen. If the stag represents earth, the salamander, believed to be impervious to fire having the power to extinguish flames, can be said to represent fire, as it was so used in art. The fishermen on their boat obviously represent water and the birds symbolise the element of air.

The sun and the moon, embroidered in raised metal threadwork, are also depicted in the borders. The sun is an attribute of truth personified as 'all is revealed by its light'. A crescent moon was the attribute of the virgin huntress Diana, although in pre-Greek times she was an earth goddess who watched over and cared for wildlife. Later, she was identified with the moon goddess and worshipped by the Romans as Luna (sky), Diana (earth and Hecate (the underworld). Perhaps as goddess of the underworld, Hecate is alluded to by the appearance of the salamander amid the flames, like the everlasting flames in hell.

The portfolio was embroidered mainly with satin stitch with silk threads and the raised work was embroidered with silver thread and was further embellished with silver foil and seed pearls. The whole piece has been edged with a border of silver lace.

# JACOBEAN CREWEL WORK

The word 'crewel' was used by the Elizabethans to describe any work that was executed with worsted wool threads. Nowadays, the word is used to describe Jacobean crewel embroidery that is worked on larger items of household furnishings, such as curtains and bed-hangings. It was a fashion that became highly popular during the reign of James I (Jacobus Rex) and survived until the beginning of the eighteenth century. Worked in both monochrome and polychrome colours, the designs developed a characteristic oriental style, with subtle Indian and Chinese influences. This development occurred mainly because of the increase in travel and the exchange in trade between East and West.

Flowing designs of coiling stems bearing large flowers and oversized leaves were often decorated with animal and bird motifs filling every available space. The creatures that were worked on to the generally exotic backcloth included

*Detail of a crewel-work stag from the Curzon-Hemmick bed-hangings* (Bowes Museum)

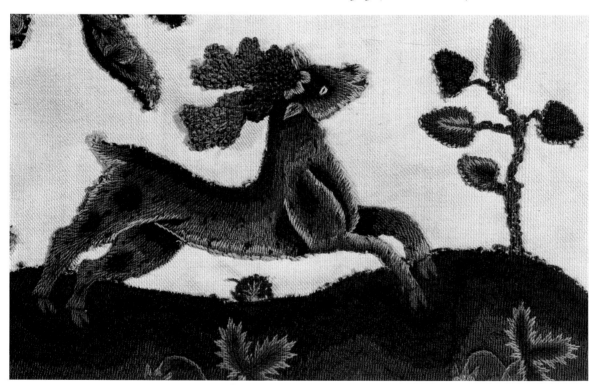

both real and mythological creatures, such as dragons, griffins, lions, unicorns, leopards, camels, stags and elephants, and various species of birds. Many of these animal designs were worked on to contemporary stumpwork embroideries and they often shared the same design sources.

A certain amount of 'crewel work' was executed in one colour only – generally red – which again echoes the style of woodcuts in a similar way to blackwork. The straight stitches and geometric patterning worked inside the flowing lines of leaves and flower petals proved a striking and effective combination. During the seventeenth century, the style of crewel embroideries developed still further, mainly through a desire for an economy of stitchery. The basic designs that were worked repeatedly with many variations, benefited greatly from the resulting refinement of line and space. They evolved into bold, colourful and stunningly beautiful designs that have stood the test of time throughout constantly changing fashions. These designs remain both familiar and popular with embroiderers to the present day.

The stitchery on crewel work was basically freely worked as opposed to the stitchery of canvas work that was employed previously for domestic furnishings. The number of different stitches used in crewel work was fewer than those worked for raised or stumpwork. In crewel work, the lines were defined by stitches, such as stem, back or chain, and were combined with coral, feather and herringbone stitches. Raised areas of French knots or pile stitches were also worked, while others were decorated with a variety of filling stitches and patterns. These included cross stitch and laid and couched work. Other areas were filled using satin and long and short stitches (the most popularly used). An astonishing number of different shades of the same colour might be used to create shading, and the predominant use of reds and greens is one of the main characteristics of crewel embroidery.

Abigail Pett's crewel-work bed-curtains are typical of the period and feature a number of birds and animals among the trees and flowers. Many of the creatures are similar to those that appear on contemporary stumpwork embroideries. A dragon or griffin has been copied directly from a print by John Overton, one of an enormous number of prints that were published during this period especially for embroiderers and craftsmen.

Abigail Pett was an amateur embroiderer whose renderings of animals display a charming naivety. A humorous childlike interpretation of a worried lion shows him confronted by a diminutive hunter who is aiming a gun at him. A monkey sits in a tree and a squirrel in a nut bush. Other animals include a leopard, a camel, a running stag, Chinese cranes and phoenixes. The aerial view of a pond which contains fish seems out of place. Wool has been worked on a cotton-linen twill weave with long-and-short stitches, split, stem, satin, feather and herringbone stitches, and with some laid and couched work and cross-stitch fillings. The fillings have been worked in a wide variety of stitches and patterns, including spots, checks and diamonds.

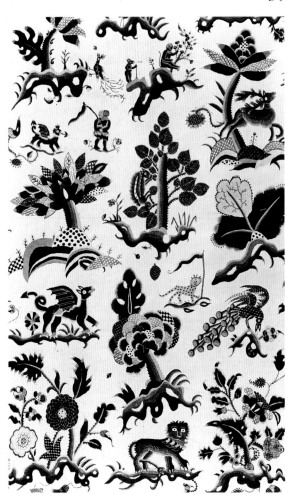

*Detail from one of Abigail Pett's crewel-work bed-curtains* (Victoria and Albert Museum)

# CREWEL WORK PANEL

*Crewel Work Panel* (Author)

The dragon on this panel has been drawn directly from a seventeenth-century engraving by John Overton, also used by Abigail Pett for her famous bed hangings. The design has been enlarged and traced onto the ground with the aid of a lightbox and transfer pencil.

This panel is to be used as a cushion cover, but the design could easily be lengthened to make a decorative edging for a pelmet or curtains by adding further beasts, birds and trees. Appleton's crewel wool has been used double on a linen scrim ground. The repertoire of stitches includes stem, long-and-short, buttonhole and satin stitches, couching, speckling and French knots, as follows.

**The lion** (light to dark) 693, 694, 695, 696. The body is worked in long-and-short stitch, the face in stem stitch and the mane and tail in French knots.

**The dragon** (light to dark) pinks 755, 945, 946, 947, 948, 227; greens 401, 402, and yellow 693.

The body is worked in long-and-short stitch, the face in stem stitch and the wings in stem stitch and satin stitch.

**The grass** (top to bottom) 407, 404, 402, 401, 253, 311, 695, 313, in densely packed rows of satin stitch.

**The tree** yellow 474 in split stitch, the leaves green 404 in stem stitch and the cherries pink 946 in long-and-short stitch.

**The flowers** white 881 and yellow 695 using stem stitch.

**The leaves** green 403 in loose stem stitch.

**The birds** green 313 in stem stitch.

**The strawberries** pink 946 couched to the ground using a single strand of green 253.

**The snail** outlined in stem stitch using brown 975, filled with satin stitches using green 831 and beige 763.

**The butterflies** an assortment of those colours already in use, and French knots, speckling, buttonhole, satin, stem and long and short stitches.

## TECHNIQUES AND MATERIALS

**Transferring designs** Any of the methods of transferral on p125 would be suitable for drawing designs on to the ground, but remember that any permanent lines should be covered by subsequent stitchery.

**Grounds** used for crewel work were usually strong twill linen with a linen warp and a cotton weft. The ground was originally home-spun, which was less expensive than the imported variety. Many types of suitable fabric are available today.

**Threads** These were crewel wools, a fine-spun, two-ply worsted yarn which was available in extensive colour ranges. A number of makes are readily available today.

**Colours** Crewel work was originally worked in a single colour. Later, a second colour was included and the range of stitches grew. Eventually, polychrome became popular, with a variety of different shades of a single colour being used to create shading and the variety of stitches increasing still further.

**Stitches** At first, the number of stitches used for crewel work was limited, but it became more extensive as designs developed. The lines of the design were outlined with stitches such as back stitch and running stitch. Variations on these, such as threaded back and whipped running stitch, were also used. Other stitches used for this purpose include stem, chain, buttonhole, feather, herringbone, vandyke and cross stitch. Again, different variations of these were also worked.

Leaves, flowers and animal motifs were usually shaded and filled in with satin stitch and long and short stitches. Such areas were also filled in with laid and couched patterns, seed stitches (which could also be worked to create shading), pile stitches, or knots such as coral, French or bullion. Areas of flora and fauna were often filled with linear filling patterns that were also associated with blackwork and could be further embellished with whipping or couched threads. The areas of the ground around the design were always left unworked.

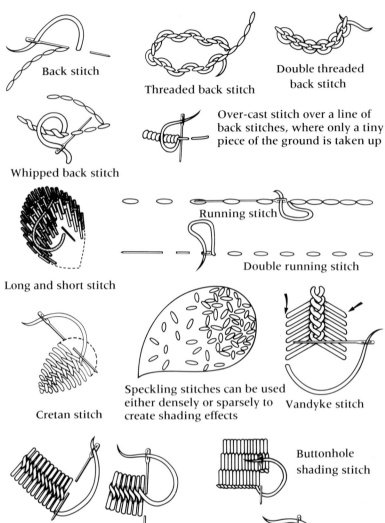

Back stitch

Threaded back stitch

Double threaded back stitch

Whipped back stitch

Over-cast stitch over a line of back stitches, where only a tiny piece of the ground is taken up

Long and short stitch

Running stitch

Double running stitch

Cretan stitch

Speckling stitches can be used either densely or sparsely to create shading effects

Vandyke stitch

Roumanian stitch

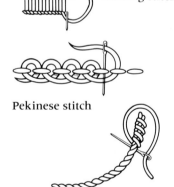

Buttonhole shading stitch

Pekinese stitch

Whipped stem stitch (worked over back stitch)

Basic buttonhole stitch

## PRACTICAL APPLICATIONS

The practical applications for crewel embroidery remain firmly within the realms of embroidered furnishings, although crewel work has been used to decorate items of clothing. The materials tradition-ally used also remain those most suitable for the interpretation of crewel designs. The working of crewel-work curtains may at first seem daunting, but after consider-ing the speed at which the work progresses, they may be seen as worthwhile projects. A bed-cover would take no more time to make than one that was made with pieced patchwork and would prove a much admired and trea-sured heirloom, being decorated with exotic birds and creatures inhabiting leafy gardens of coiling stems, with various species of large fanciful blooms and grassy hill-ocks.

Cushions, which provide too small an area for large floral designs, do present, on the other hand, the ideal opportunity for depicting animal and bird motifs. A cushion can depict a solitary beast standing or lying on a grassy hillock, or a bird in flight, or a bird perched on a sprig with a cherry in its beak. Animal motifs can also be placed in pairs either side of a central tree, itself an ancient and well-used design element. Your favourite animal fable could be illustrated, or the hunt with a hound running after a leaping stag, or a dog chasing a rabbit or a hare.

Traditionally, however crewel-work animals and birds were exotic creatures – lions, camels, elephants and fanciful birds – many of which were copied from contemporary pattern books. This 'Dragon' (see illustration) was copied by Abigail Pett and depicted on her bed-hangings which are now housed in the Victoria and Albert Museum. The illustration

comes from a book by John Overton entitled *Animalium Qua-drypedum liber secundus, the second part of Fower-Footed creatures*. Whenever possible, embroiderers should use these engravings as design sources because they prove far more inspirational than most contemporary designs. Many of the more exotic beasts and birds illustrated here, especially those from the seventeenth-century pat-tern books, could be translated into designs for crewel work. (The designs can be transferred to the ground using one of the tech-niques described on p125).

*'Dragon': detail from a plate published by John Overton in the seventeenth century. This print was used directly as a design source by Abigail Pett for her crewel curtains (British Museum)*

CHAPTER 7

# STUMPWORK
# AND
# BEADWORK

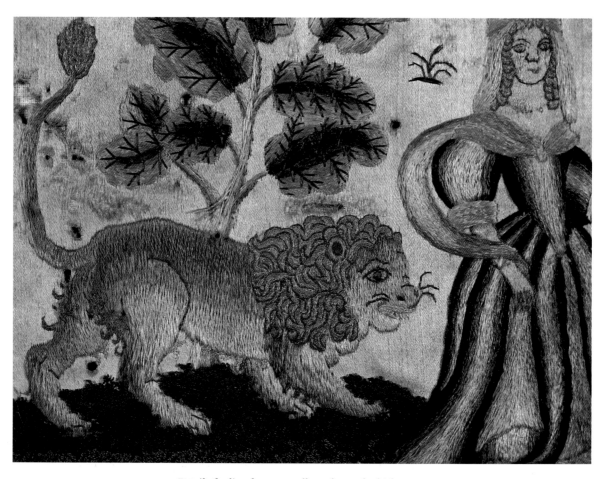

*Detail of a lion from a needlework panel which was
probably intended for a casket. It is English and dates from
the second half of the seventeenth century. The lion has
been outlined and filled with straight stitches, while the
hillock on which it stands has been embroidered with
densely worked knots* (Bowes Museum)

78

Stumpwork developed between 1650 and 1680. The technique produced complicated and elaborate three-dimensional embroideries that were used to cover caskets and mirror frames, and to decorate the interiors of cabinets and caskets. These might contain quilted trays, a miniature three-dimensional flower-bed or even a complete garden. It is believed that kits, comprising all the required materials and grounds and with the designs already printed on them, were available for stumpwork.

Stumpwork was an exaggerated and elaborate form of raised work. It involved the use of darned silk pile, padded and applied motifs and a wide range of different stitches. Details such as flowers were worked in detached buttonhole stitch, only partially attached to the ground, or worked on fine flexible wire that was totally covered in stitchery. These three-dimensional details stood away from the ground. Tiny hands and faces of figures were often modelled from wood or ivory and their facial features were painted on.

The name 'stumpwork' probably came from the carved wooden 'stumps' often used to form the arms, legs and faces of figures. Other stumps were formed of wool or hair that was stitched over and over until the required relief and colouring was achieved. Stitchery was further embellished with pieces of mica, chips of minerals, pearls, beads, coloured spangles, and even peacock feathers and tiny seashells.

Grounds were generally ivory-coloured satin or silk. Metal thread, silk and wool were used for the stitchery. Horsehair or wool were used for padded motifs which were covered with a wide variety of stitches, including detached buttonhole, Ceylon satin and hollie point. Others included French and bullion knots, rococo, seeding and couched work. Canvas-work motifs were embroidered, cut out and applied to the ground.

Designs for stumpwork depicted either a biblical or mythological story, with different episodes being worked on the sides and top of the box. Popular subjects included David and Bathsheba, Solomon and the Queen of Sheba, Isaac and Rebecca, and Venus and Adonis. Others were of figures representing the five senses, the four seasons, the four elements and the four continents. These might be worked on mirror frames or at the corners of cabinets.

Mirror frames decorated with stumpwork were often fitted with doors which opened to reveal the mirror behind. On one excellent example in the collection of Lady Richmond a design has been worked which shows an English or European man with a squirrel standing opposite the figure of a negress who is smoking and accompanied by a parrot. The animals depicted in the corners are a leopard, a lion, a camel and a unicorn or horse.

The figures — allegorical characters dressed as contemporary kings and queens — tell the story. This characteristic was shared by other embroideries, sixteenth-century valances in particular representing mythological and biblical characters who were dressed in contemporary court costumes. The figures on stumpwork embroideries are frequently flanked by regal beasts, such as the lion, the stag, the horse and the unicorn, many depicted in heraldic poses. Seventeenth-century embroiderers were familiar with the

*Detail of a sheep from a panel for a casket. It has been worked in high relief with metal purl which has now tarnished badly. The sheep's face has a self-satisfied expression and has been worked with straight stitches which are outlined by back stitches in a darker colour* (Bowes Museum)

heraldic significances of these beasts. Although none of the rules employed in the science of heraldry have been strictly followed regarding poses and positioning, the heraldic nature of the creatures is inescapable and their inclusion was undoubtedly patriotic.

The lion was seen as a noble and royal beast and was a highly esteemed bearing on coat-

*Unicorn from an early sixteenth-century manuscript* (Bodleian Library)

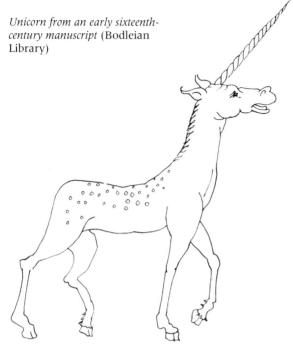

armour. The stag was a royal beast of the hunt. The unicorn, with its association of symbolism and pagan mythology, appears on heraldic pieces and on many art forms as well as on needlework. It was depicted popularly on allegorical works, one notable example being the set of French tapestries that depict the hunt and capture of the unicorn which was used to symbolise chastity.

Both embroiderers and heralds failed to draw a correct distinction between the lion and the leopard. It was a confusion further promoted because the French name for the heraldic lion was 'leopard'. According to a seventeenth-century herald, the leopard was 'portrayed with black spots and a great head, and nowhere shaggie'. The camel, said to be rivalled only by the horse, 'to whom he is a hateful enemie', popularly signified humility, obedience and swiftness. During the Middle Ages, the camel was an attribute of obedience and represented Asia, one of the four parts of the world. The camel was also one of the ten animals that Mohammed allowed to enter Paradise.

The elephant has been treated with much respect and admiration throughout history. Listed among 'whole footed beasts', it was known for its valiance, strength and resolution. Its wisdom was also acknowledged and in a Roman story of a little boy who 'pryed up an elephant's proboscis', 'the enraged elephant picked up the child and cast him up to a great height, but caught him in his trunk, setting him down again gently, considering that a childish prank was worth only a childish fright and that this was revenge enough'. The elephant is a popular bearing in heraldry, denoting greatness, wit, wisdom and strength. Occasionally only the trunk is shown to illustrate its enormous strength. Apart from their heraldic uses, rele-

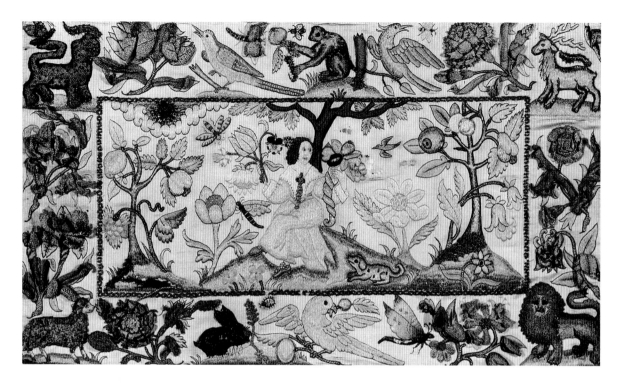

vances and any inherent symbolism, the Tudors and Stuarts considered elephants to be wondrous creatures.

The ever-popular exotic and domestic creatures were all depicted. The inclusion of snails, caterpillars, parrots, bullfinches, peacocks and turkeys seems to have been a prerequisite of stumpwork embroideries. Many different birds, often with fish in their beaks, were also depicted. Illustrations such as the one depicting a dog chasing a hare, appear repeatedly – this design fitting perfectly along the narrow borders on the tops of embroidered caskets.

The space between larger creatures and figures were filled with a variety of flowers and other smaller creatures. Butterflies, often worked as raised motifs over wire shapes, were popular, as were rabbits, swans, worms and numerous different species of bugs, beetles and flies. These creatures were colourful, quick to work and extremely useful for filling in smaller areas of the design. All motifs were disproportionate to each other and no attention was paid to size, distance and perspective.

Water was depicted as tiny horizontal patterns, indicating waves and reflections, sparkling with tiny pieces of minerals. Fountains sprinkled water and nearby rocks were drawn with vertical patterning. Mermaids were depicted sitting in

*An English needlework panel dated between 1630 and 1650. The central scene depicts a woman seated and holding a cornucopia of flowers. Both raised and flat work have been used with silk and metal threads on a silk ground. The delicate birds have been embroidered with straight stitches in a painterly manner, while the stag, lion, cheetah and sheep in the corners of the wide borders have been worked with raised-work techniques (Bowes Museum)*

pools where oversized fish leapt around in water with ducks and swans. The wings of the swan shown overleaf are strips of card, wrapped with silk thread, then folded and sewn in place.

A popular source of motifs, together with the printed sheets which were published by Stent and Overton in the latter half of the seventeenth century, was *The Needle's Excellency*, published by James Boler. Source books were published especially for embroiderers and needleworkers, although many of the designs can be traced back to earlier sources, including the natural history books discussed in Chapter 4.

Many stumpwork embroideries were worked by young girls – needlework having become the most important part of a girl's education by the seventeenth century – which accounts for the charming naivety and dreamlike quality of the compositions. Here is depicted a child's perfect world where the sun always shines and the

*Detail from a needlework panel. The large range of stitches used for this piece include tent and long and short stitches, knots and raised and padded work. The wings of the swan have been represented most attractively, strips of folded card having been wrapped with silk thread* (Bowes Museum)

water is always clear and glistening. These young embroiderers were the children of wealthy and privileged Stuart families and their designs reflect both their social status and their environment. Biblical and mythological scenes were depicted in settings of idyllic rural countryside typified by the English garden. The designs reflect the contemporary fashions in gardens — mazes, knot gardens, arbours, fountains, and pools filled to overflowing with large fish.

The gardens that were depicted and the three-dimensional effects that were employed reflect the popularity during the seventeenth century of topiary, or 'shaped shrubs', where animal shapes were painstakingly sculpted from trees and shrubs. The following description is of a Renaissance garden in Italy where a wide variety of shaped shrubs included the following:

. . . heraldic beasts, monkeys, dragons, centaurs, camels, horses, donkeys, cattle, dogs, stags and birds, bears and wild boars, dolphins, jousting knights, archers, harpies, philosophers, the Pope, cardinals, Cicero and more such things . . .

One amusing, though cynical reference to the continuing fashion for topiary in the eighteenth century, comes from Alexander Pope's essay entitled 'Verdant Sculpture', published in the *Guardian* in 1713:

St George in box: his arm scarce long enough, but will be in condition to stick dragon by next April.
A Laurustine bear in blossom, with a juniper hunter in berries.
A pair of giants, stunted, to be sold cheap.
A quick set hog, shot up into a porcupine, by being forgot a week in rainy weather.
A lavender pig, with sage growing in his belly.

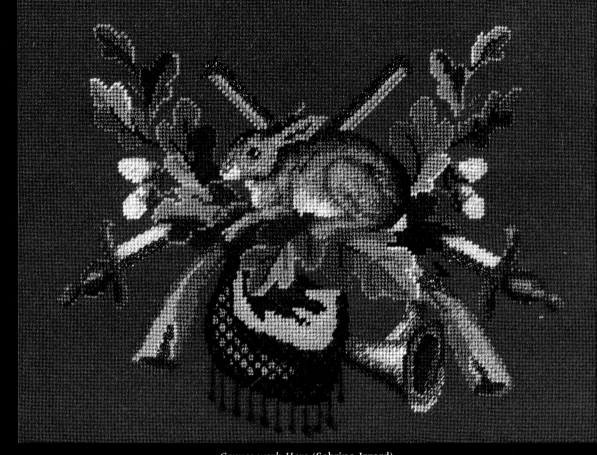

*Canvas-work Hare* (Sabrina Izzard)

This design has been taken from a canvas-work shoulder bag in the Pushkin Summer Palace (outside Leningrad). The bag dates from the time of Catherine the Great (1729–96). It was embroidered in cross stitch using wool on a heavier canvas, with areas such as the horn, the swords and highlights on the guns in coloured beads. Unable to find sufficient beads in suitable sizes and colours, I substituted Madeira special-effect yarns quite successfully. The original bag was

fringed with elaborate tassels, echoed in the bag worked within the design itself.

I have used a finer canvas ground of 18 holes to the inch, and Appleton's crewel wool used double. The hare has been shaded using more shades than the original, often using a strand each of two different colours to achieve a slightly softer and greater range. Tent stitch has been used throughout.

## COLOUR KEY (see chart)

**Madeira special-effect yarns (used whole)**

| | |
|---|---|
| / | White/pearl 480 |
| l | Blue metallic 370 |
| h | Silver 3010 |
| r | Gold 004 |
| # | Black metallic 5011 plus 1 strand black wool 588 (worked together) |

**Appleton's crewel wools**

Blues     647,     644,     642,     641

Greys     974,     972,     971,     975,     976
(one strand of each worked together),     181,
    973 (one strand of each worked together)

Yellows     692,     311,     695,     694,     763,
    851 (one strand of each worked together)

Browns     588,     581,     956,     905,     903,
    696,     185, 956

Greens     255,     548,     348

White     991

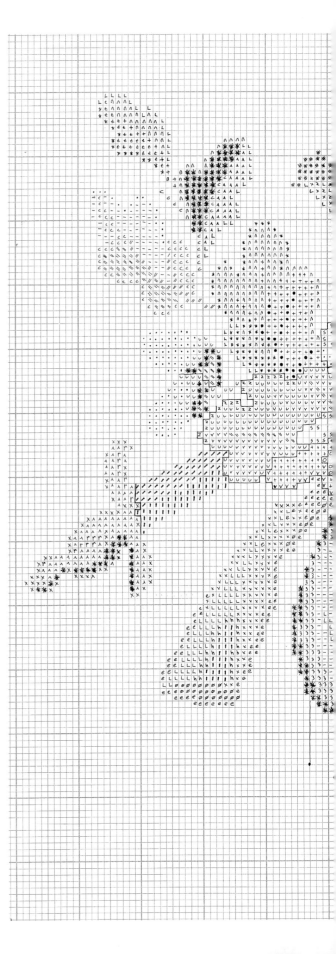

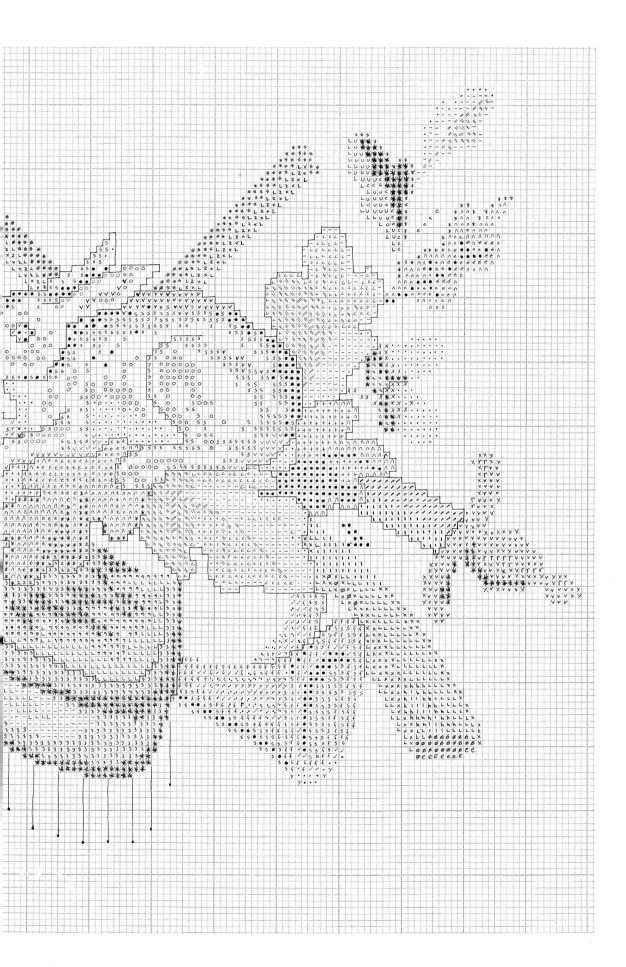

The fascination the Elizabethans had for animals continued to be felt by avid gardeners during the eighteenth century. There was already a tradition for royal palaces to have their own real-life menageries of wild beasts from foreign lands. During the reign of Henry I, a garden in Woodstock, Oxfordshire, had 'Lyons, leopards, strange spotted beasts, porcupines, cammells and such like animals'. The porcupine also appears in heraldry and the impresa of Louis XII (1462–1515) includes a porcupine which was sometimes crowned and sometimes had its spines separated from the body. (It was once believed that the porcupine could shoot its spines at its enemies.) The motto *cominus eteminus* – 'hand to hand and out of hand's reach' – alluded to alternative ways of fighting. The fascination for wild and exotic animals continued into the seventeenth century and the menagerie in St James' Park established by James I was enlarged by Charles II who introduced the famous pelicans. In Tudor and Stuart times, bear gardens and bear-baiting were popular entertainments and the fascination for strange, new and exotic animals persisted.

# TECHNIQUES AND MATERIALS

## TECHNIQUES

**Covered wire shapes** were completed before they were attached to the ground. The ends of the wire were pushed carefully through the ground and sewn firmly to the linen backing with small stitches. It is advisable to do this when the remainder of the work is as near completion as possible. Detached buttonhole stitches were popularly used to cover these shapes. (Wire can be bought from specialist embroidery suppliers in different weights.)

**Applied motifs** can be of a light fabric – silk, calico, fine linen, and so on. If motifs are to be covered with stitchery (such as French or bullion knots) they should be embroidered before you apply them to the ground. All applied shapes or motifs should be cut out slightly larger than the finished size. Embroidered motifs should be cut out and a narrow border should be left around the stitchery. (Awkward shapes can be carefully snipped around this border at right angles to the embroidery.) Edges should then be turned under and the motif applied to the ground with very small slip stitches. If the motif is to be padded, leave a small opening. Using a stiletto or needle, push the stuffing through and then finish sewing the motif to the ground. Some type of animal wool is the best form of padding.

Raised motifs can also be padded with felt. Cut the desired shape first, then cut out successively smaller shapes. Sew the smallest shape to the ground, then sew the next smallest shape to the ground directly over the first shape, and so on. Apply the first and largest shape that you have cut out to the ground last. Apply a final layer of fine fabric and cover the motif with stitchery. Motifs may be covered with layers of satin stitch (each layer worked in a different direction) to give the required contours.

**Applied canvas-work slips** Embroider these slips first, then cut them out and apply them to the ground using the same method as for applied motifs. All applied and raised motifs can be outlined with laid or couched threads or stitching which conceals the edges and provides further embellishment. Canvas-work slips should be made with relatively simple stitches such as tent, cross or Hungarian stitch and worked on a fine canvas.

**Stitches** Detached buttonhole stitch was the most popular stitch for covering raised shapes and motifs. Hollie point, Ceylon stitch and padded straight stitches were also used. Other stitches used for stumpwork include split, back, satin and long and short stitch. Areas were also filled with seeding, rococo and tent stitch, bullion or French knots. Knots were also used to represent human hair and trees and were worked in silk, human hair or metal purl. Stems of flowers were often worked in plaited gold thread and silver,

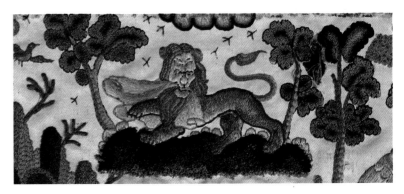

*Detail of a lion from a needlework panel which was probably intended for a casket* (Bowes Museum)

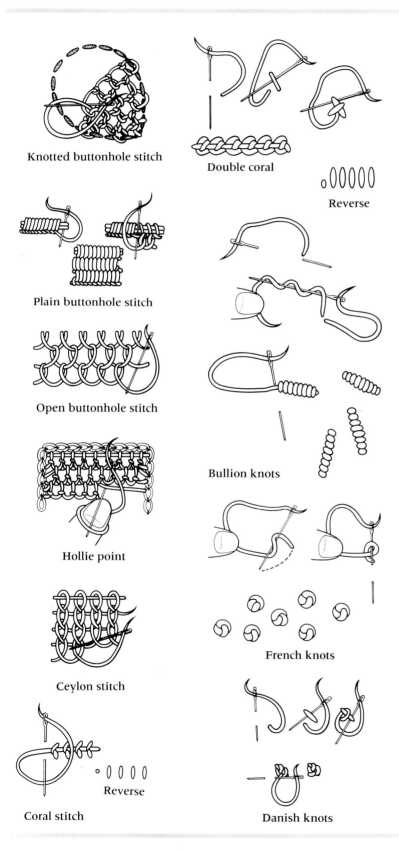

Knotted buttonhole stitch

Double coral

Reverse

Plain buttonhole stitch

Open buttonhole stitch

Hollie point

Bullion knots

Ceylon stitch

French knots

Reverse

Coral stitch

Danish knots

silver-gilt threads and wire being couched and laid to the ground. Flat areas of embroidery, particularly on backgrounds, were worked in satin, split and long-and-short stitches.

Human figures were made separately and may have had paper pasted on to the back before they were attached to the ground. A line of cord was sometimes couched to the ground over the joins. Figures were dressed in costumes made from needlemade fabrics and lace. Picots, characteristic of cutwork and whitework, were used as edges to costumes. (Scraps of fine fabrics, ribbons and lace could prove useful substitutes.) The faces were sometimes covered in wood or wax, their features being painted on later. Some were reportedly stitched with tiny smooth split stitches, with features outlined in stem stitch. Hands were of wood or bone, and fingers were usually worked with silk-covered wire.

Darned silk pile (similar to chenille in texture) represented fur. Sheep were made by using a series of knots. Clouds were also often worked in knots but these were more usually embroidered with metal purl. Caterpillars might be depicted in plumules of peacock tail-feathers. Acorns were sometimes constructed from wooden balls that were covered with tiny buttonhole stitches.

## MATERIALS

**Transferring designs** Where no professional help was available and designs were not obtained ready printed, designs were generally transferred to the ground by means of the prick and pounce method (see p125). The resulting charcoal lines were painted in with a fine wet brush and this remains a good method today (see p68). Any permanent lines that were drawn on to the ground

must eventually be covered by subsequent stitchery.

**Grounds** used for stumpwork were of ivory-coloured satin (many raised-work techniques can, however, be worked on canvas). The satin grounds for stumpwork were always backed with linen to give the necessary support.

**Raised motifs** and shapes were worked over wooden stumps or those constructed from wadding, hair or animal wool were stitched over and over again until the required shapes and contours were achieved. The final covering was of silk or satin. Stumps can be carved from soft balsa wood or made from modelling clay (available at craft shops). Modelling clay hardens in contact with the air or when it is dried in a slow oven.

**Threads** included slightly twisted and soft floss silks, chenille, cord and a variety of metal threads. Silk floss was sometimes couched in floral or geometric patterns to line interiors of caskets. Silk floss is still available but is difficult to use and perhaps should be avoided by the less experienced needleworker.

(Stranded cottons are popular alternatives to silks.) Chenille is also still available, as are a wide range of cords. Twisted cords should be couched to the ground, the needle being passed carefully between the plies.

**Metal threads** were used in a number of different forms and there are many modern alternatives. Metal plate is in the form of a flat strip and is strongly reflective. It is usually confined to surface couching. Purl is a tiny metal spiral in the form of a hollow spring and is available in many colours, varieties and sizes (on most stumpwork embroideries the purls have become badly tarnished with time). The types of purl includes shine purl (a bright wire coil), chequered purl, bead, badge and jaceron. Pearl purl resembles a string of very shiny beads, while lizardine is a crimped pearly purl.

Jap gold should always be couched, whereas passings (made of round fine threads) pass easily through the ground. Wavy passings are slightly textured. Crinkles are coarser forms of wavy passings that are made from two or more threads plied together. Gimp, or quimp, is made from flattened spirals generally used for edgings. Lace, or orris lace, is made from flat metal braidings and ribbons of different widths, and is used for edgings or is couched in geometric linear or interlacing designs. Before beginning a stumpwork embroidery, it is a good idea to write to suppliers and request as many samples of threads as possible as weights and colours vary considerably.

**Jewels** were generally used in settings or with pierced metal mounts with loops for attaching them to the ground. Sequins (called laminates) were small reflective shapes of perforated precious metals. Beads were of a variety of materials, including floral glass, amber, turquoise, precious metals and lustrous pearls. Seed, baroque and freshwater pearls have all been popular for embroidery during different periods, although eventually they were replaced by mass-produced artificial pearls. Coral was also used, and mica (a transparent reflective mineral laminate) was used for windows on stumpwork embroideries.

## PRACTICAL APPLICATIONS

Stumpwork was a fashion peculiar to a span of just thirty years of the seventeenth century and is unlikely to be revived by amateur embroiderers today in exactly the same form. However, the many and varied textural qualities of the different styles, stitches and materials provide the modern-day embroiderer with a wealth of ideas and inspiration. The practical applications now, as in the past, would be on decorative pictures, panels, frames and perhaps even boxes.

The various types of detached stitches are well suited to animals, as are beads and spangles, metal threads and purl, used with raised and padded work as frequently employed in heraldic embroideries. The method of embroidering animal and bird motifs separately before applying them to the ground, is also an attractive technique, especially when the final arrangement of motifs comes at a later stage.

Fur, fleeces, lion's manes, tails and other such details are depicted with knots, pile or loop stitches, metal, purl, chenille, and so on. Birds and smooth-haired creatures can be worked with satin and long-and-short stitches over padding, giving some impression of form over the contours of the animals' bodies. Detached stitches can be used for those creatures with thicker hides – elephants, rhinoceros, boar, and so on.

The endless possible combinations of stitches, materials and colours can provide creative embroiderers with many exciting challenges. Choose your materials carefully to suit each individual creature – a sampler is a perfect ground for experimentation before you move on to the final work. Detached motifs worked over wire

frames, such as birds, butterflies and other insects, are difficult to make – these are for deft fingers only. The stitches used here include detached buttonhole which is well worth the trouble and time it may take to master.

The materials used in the seventeenth century are not always available today, although there are many suitable alternatives. (Num-erous sorts of beads, spangles and sequins are commercially pro-duced and are available at special-ist needlework and craft shops and at craft fairs. A number of shops in larger towns and cities specialise in beads. Here, too, suitable alterna-tives for mica may be found. It is worth writing to specialist sup-pliers and requesting a range of sample threads and grounds. Suit-able satin fabrics for grounds can be difficult to find, although I have been successful in this respect. Again, it is well worth finding out exactly what is available before you begin your work.

If a major project such as a casket or mirror frame is to be attempted, it may be wise to find an upholsterer or picture-framer to help make up the finished item.

# BEADWORK

Small areas of beadwork can be worked by sewing each individual bead to the ground with back stitches. Work covered entirely with beads requires different methods. The first method is to couch the beads in rows: thread them first in rows and then, with a second thread, couch them to the ground (between each bead, or a number of beads). The second method uses the tambour hook: thread the beads in rows on a continuous thread at the front of the work. Pull the thread between each bead through to the back of the work to form a loop. Pull a second loop between the first and second bead, through to the back of the work and through the first loop, and so on. This produces a chain stitch on the reverse side and on the front side a line of back stitches that hold the beads to the ground. Some seventeenth-century beadwork baskets were made with wire constructions as a frame-work. Wire covered with finer decorative coils of wire was threaded with beads, several at a time, in rows.

When you follow a charted design, work your coloured beads in rows. Each square represents one bead that takes the place of a single stitch in the colour indicated. The work must progress in rows, each row in turn being threaded carefully with colours in the correct order.

Grisaille is the name given to a particular kind of nineteenth-century beadwork. Black, grey, white and opaque-coloured beads were worked and a classical 'architectural effect' was intended. Geometric patterns, as well as other designs, were worked, for which backgrounds were filled in with wool or silk stitchery.

A typical Victorian beadwork picture, worked entirely in tiny coloured beads, depicts a King Charles spaniel lying on a tasselled cushion. The ground has been filled with blue wool in tent stitch, the whole work measuring less than 6 × 8in (15 × 20cm). Beads too small to be threaded with a beading needle should either be threaded with very fine wire or the ends of the working thread should be waxed and threaded directly through the bead. The Victorians preferred the method of sewing each individual bead separately to the ground, as opposed to couching, which was considered the lazy way.

The English basket illustrated dates from the mid-seventeenth century and is worked in bright coloured beads. The figures have silk faces and the windows of the house have been made with mica. The lady in the central design and the figures worked within the borders represent the five senses. Also in the border, are worked a unicorn, a camel, a leopard and a dog accom-panying one of the ladies. The main design incorporates motifs of birds sitting on sprigs, a stag, a lion, a caterpillar, snails and a beetle.

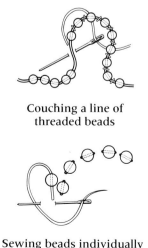

**Couching a line of threaded beads**

**Sewing beads individually to the ground**

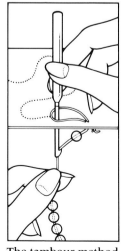

**The tambour method**

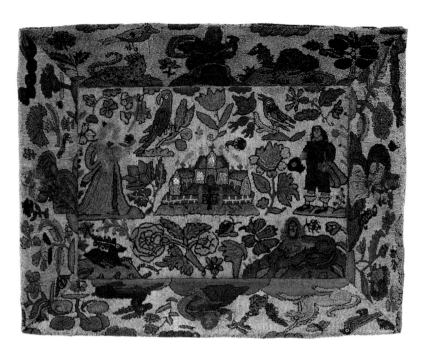

*An English beadwork basket from the mid-seventeenth century.*
*The basket measures 15 × 19in (38 × 48mm) (Christie's)*

## PRACTICAL APPLICATIONS

Pictures, frames and smaller items, such as purses, bags and covered boxes, remain the most suitable items for beadwork today. Any of the charted designs for counted thread work can be used for bead-work – each symbol of the chart should be read as representing one bead of a particular colour. A finer canvas ground can be used if you wish, and each bead should be sewn over one or two threads of the ground.

You should choose small, simple designs and keep the range of colours to a minimum. Simple depictions of solitary creatures shown seated on a cushion, stand-ing on a grassy mound, and so on, can be surrounded by patterned borders or wreaths of flowers. If backgrounds around these are to be filled, they are most effectively worked with wool in simple

stitches such as tent or cross stitch. The cockatrice worked by Martha Edlin on her casket is an excellent example of a very effective but simple design, worked with a limited colour range on an unfussy ground.

You can also use finer grounds and work designs that have been previously drawn on to the fabric. Many of the drawings illustrated here would be suitable for larger pieces, with animals worked as spot motifs placed carefully around the ground. Other ele-ments can be introduced to pro-duce an overall design – sun-bursts, clouds, rainbows and rain-drops, flowering sprigs and tufts of grass, and so on.

Later, wool or silk canvas-work pictures often had areas such as eyes, centres of flowers and the white patches on spaniels high-lighted by the use of beads. Such highlighting can be both effective and pretty. It is best to use subtle colours for such items – clear,

black and pearl beads are the most successful, especially when they are incorporated into blackwork designs. They can then be worked into the centres of coiling stems, and strapwork and lattice designs, or into leaves and petals of flowers. Some later beadwork pieces showed simple geometric patterning which is effective when worked on border patterns.

Smaller, regularly sized glass or ceramic beads with a central hole are the most suitable for the work described here. These beads come in clear and opaque colours, some with tiny patterning on them, others with a pearly sheen and others with a matt quality. It is worth experimenting with long bugle beads, to vary the textures for different animal motifs or when you are working geometric patterns. You may be surprised by the quantity of beads necessary – make sure you buy enough to finish the work as your chosen beads may not be available again.

# HERALDRY

Animals were considered by far the most worthy subjects for armorial bearings. Their characteristics, habits, virtues and vices were all carefully matched to the bearer and his family with great deliberation on their history and military achievements. The presentation and positioning of the animals borne, whether they were shown *couchant* (lying), *passant* (walking with one paw raised), *gardant* (looking forward), or *rampant*, and so on, was also very important.

Initially, these images were used as instantly recognisable symbols on the battlefields, at a time when the majority of the population was illiterate. One visual record of the use of early heraldic emblems can be seen embroidered on the Bayeux Tapestry. A number of soldiers' shields bear the images of various animals, among them a raven, an eagle, a griffin and a number of wyverns (the latter being exclusive to

the Norman soldiers). At this time the assignment of insignia was not properly organised and it was not until the thirteenth century when armorial roles first appeared, that the science of heraldry became properly organised.

The simple, clear and precise black and white illustrations found in heraldry books must have been attractive and appealing as design sources, although heraldry books may not have been readily available to many embroiderers. The illustrations here have been taken from *A Display of Heraldry* (1660) in which hundreds of crea-

*An Elizabethan canvas-work long cushion which bears the coat-of-arms of the Hardwick family. The arms are supported by the Hardwick stag and the Talbot dog. The design of wandering flowering trees is a forerunner of the later crewel-work styles. Different varieties of flowers are shown growing on the same tree and birds are depicted perched in the branches* (National Trust)

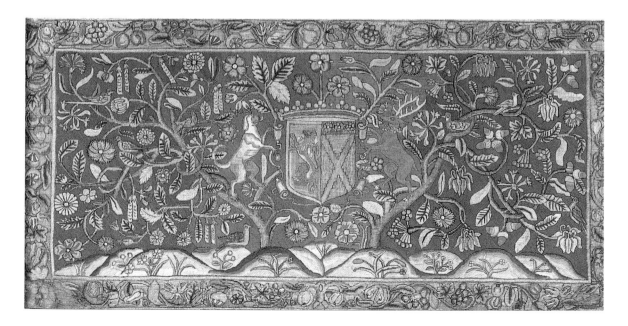

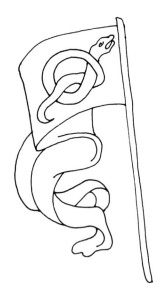

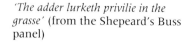

'The adder lurketh privilie in the grasse' (from the Shepeard's Buss panel)

tures used in heraldry were shown and discussed in great detail. These drawings prove to be an excellent source of inspiration and design even today. A much later publication, *Clark's Heraldry* by J. R. Planche which was published in the early nineteenth century, shows animal illustrations for armorial bearings that are remarkably similar to those of the seventeenth century.

Embroidery was one of the most usual methods of decorating clothing, banners, flags, coat-armour and streamers, and was worked by men in professional workshops. Although little in the way of heraldic embroideries has survived, it is believed from written evidence that the technique and craftsmanship employed were of a high standard. Precious metal threads of gold and silver were worked using appliqué and raised and padded techniques. The aim was to impress and to provide as much splendour as possible.

The Valois Tapestries provide a visual record of animals in heraldry and sixteenth-century French festivals. Depicted on the Whale tapestry, on a barge carrying guests across the water, are a number of shields bearing creatures such as a lobster, an oyster, an eel and a whelk shell. The tapestry depicts a musical water spectacle with soldiers attacking a mock whale. This represented the overthrow of the monster of war, alluding to the desired peace between France and Spain.

Heraldic embroideries were also produced for the lavish ceremonies and pageants of the livery companies of the City of London. Funerary palls were embroidered for the splendid funerals of deceased members of the companies. Horse trappings, barge decorations and heraldic devices worked on to official burses, crowns, book-bindings, bags, purses, gloves and sweet bags, were all decorated in the heraldic style.

During the Middle Ages, as the feudal system began to crumble and the new middle classes were born, members of the gentility applied to the crown for, and were granted, coats-of-arms. Heraldic motifs, insignia, emblems and family coats-of-arms were proudly embroidered on to a variety of household furnishings. Embroidered devices were also worked on to costumes and by the sixteenth century shields had become central to many designs on table carpets, hangings and cushions.

The Gifford table carpet (1550) bears the coat-of-arms of the Gifford family depicted in a central medallion, a shield bearing three lions with a crest and antlers above.

The stag was a royal beast of the chase, a sport reserved for kings and their honoured guests. In heraldry, the stag was considered a coward unwilling to assail its enemy. However, there were two occasions when he would supposedly

turn on his enemy rather than flee. The first was when in pursuit of love, when he would fight to the death the 'hinderer of his hot desire'; and the second was when he had been chased to the point of exhaustion and was unable to run further.

The stag was also described by heralds as 'a goodly beast, full of state and view', and endowed with wisdom. On coat-armour, the stag signified 'a man who is wise and politicke, who well forsees his times and opportunities, endowed with exceeding speed of foot, to flie from danger when it approacheth'. The stag also represented the sense of hearing because of its excellent hearing abilities. All members of the deer family were believed to be fond of music and the hart can represent 'a man skilful in musicke, or one who takes felicity and delight in harmony'.

The canvas-work cushion overleaf, from the early seventeenth century, depicts the coat-of-arms of James I and has been signed Mary Hvlton. The arms are flanked by a pair of lions, dogs and birds. Several caterpillars and a pair of snails appear, both creatures that were to become very popular as small motifs on sixteenth- and seventeenth-century embroideries. The caterpillar appears on the impresa of Charles I and was worked on many early samplers and stumpwork pictures. It was useful as a motif to fill smaller areas of the ground.

As an heraldic device, the lion was reckoned to be the king of beasts, signifying the most eminent person, the person in the highest position. It was a fierce and noble beast that possessed resolution, strength and the greatest courage. Listed among the beasts that possess many claws, the lion was described as fierce and ravenous, of one colour, shaggy-breasted, with a certain 'tuft of haire in his traine'. When shown *rampant* (that is, bolt upright, his mouth wide open as if roaring and his claws extended) he was at his most noble and fierce.

Greyhounds were ancient and frequently used motifs decorating coat-armour. Also used on coat-armour were the alanda – a large hunting dog with short ears – and the talbot – an heraldic creature with the body of a mastiff, the head of

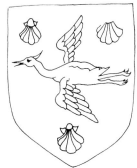

*STAG*

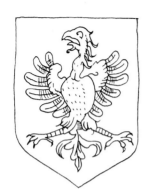

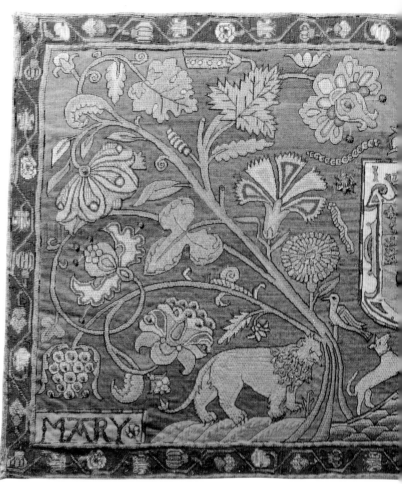

a hound and the long drooping ears of a bloodhound. Dogs of all kinds were frequently and fondly worked on to many amateur embroideries of the period.

Heraldry was prominent in church decoration, and ecclesiastical furnishings often bore coats-of-arms, particularly funeral palls. The coats-of-arms of wealthy patrons of the church were embroidered on covers of prayer-books and Bibles. Animals from the Old Testament used symbolically in Christian art and church decoration, were frequently used as armorial bearings. The Syon cope at the Victoria and Albert Museum has coats-of-arms, including the Lamb of God, worked into its border. In Christianity, this was the sacrificial lamb 'by whose blood we are healed' and was representative of Jesus Christ 'who taketh away the sins of the world'. In heraldry, the lamb was used to signify a brave and resolute spirit who undertakes a war for Christ's cause. In Christianity, as in heraldry, the

pelican symbolises piety, charity and devotion to one's parents, the dove symbolises peace and mercy and the phoenix represents immortality. In heraldry, the leopard was described as a misbegotten beast wanting in courage, being 'naturally enemie to the Lyon'. The shape of the leopard was said to 'betraieth his unkindly birth . . . portrayed with black spots and a great head, and nowhere shaggie'. This was the beast of seven heads and ten horns and referred to in Revelations: 'And the beast which I saw was like unto a leopard, and his feet were as the feet of a bear, and his mouth as a mouth of a lion'.

In Christianity, the cock generally symbolised God's providence; for heraldic purposes it was a noble bird of courage and great importance was placed on the courageous qualities demanded of those fighting for their king. The eagle was said to allude to a queen, the swallow or wagtail to a lady and the cock was termed the knight among birds.

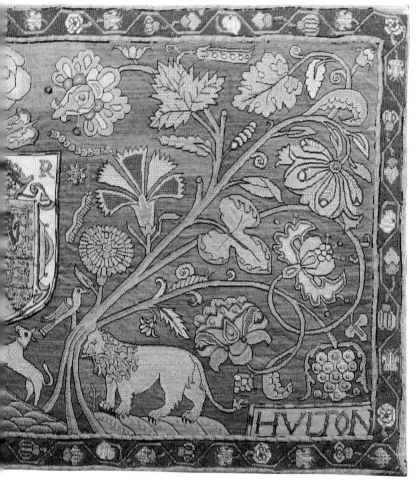

A canvas-work cushion dating from the early seventeenth century and signed Mary Hvlton, which depicts the coat-of-arms of James I. Coloured silks and wools and silver thread have been worked with tent, plaited and long-legged cross stitches on a fine linen canvas (Victoria and Albert Museum)

In *A Display of Heraldry*, animals are classified into groupings that will be unfamiliar to the modern reader: whole-footed beasts, cloven-footed beasts and those with many claws. Then come less harmful beasts and reptilia, or egg-bearing animals. Smaller creatures are placed in groups such as creeping things, gliding animals, fowles and insects that live above the earth, and then watery creatures. A separate section deals with monsters and this section is, perhaps, the most fascinating.

'These monsters cannot be reckoned those good Creatures created before the transgression of Adam . . . for they had in them neither accesse nor defect, but were the perfect workmanship of God's creation. If man had not transgressed the Law of his Maker, this dreadful deformity (in likelihood) had not happened in the procreation of Animals, which some philosophers do call errors in Nature.'

Some monsters were purely heraldic inventions, while others were derived from mythological stories, the Bible, the *Physiologus* and the early bestiaries. The long list of imaginary creatures includes the alphyn, a monster of 'unsettled form', and the enfield, described as being of 'doubtful origin and antiquity', with the hind-quarters and tail of a fox, the body of a dog and the claws of an eagle. The bonacon was a bull-like monster whose horns curled inwards and were inadequate to defend itself. The bonacon was said to defend itself by shooting its burning excrement at its enemies. The chatloup had the body of a wolf, the face of a cat and the horns of a goat, and occasionally was depicted white with brown spots.

The camelopardel was an amalgamation of various animal descriptions given by travellers and was probably the giraffe. Confusions of more exotic and less well-known animals were commonplace, and many other examples were found

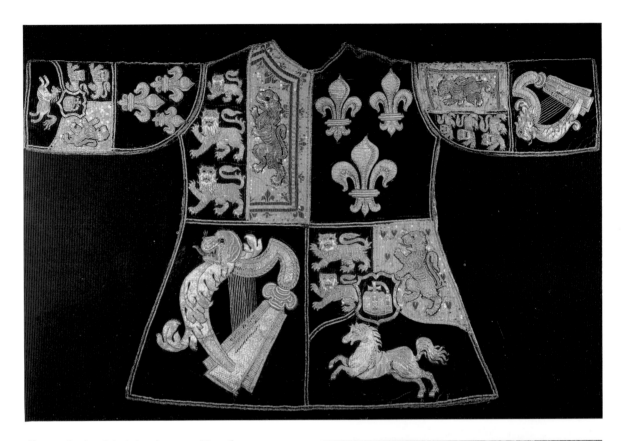

Above: *A tabard depicting the garter king of arms*
(Victoria and Albert Museum)

Right: *Detail from the Syon cope showing the Lamb of God*
(Victoria and Albert Museum)

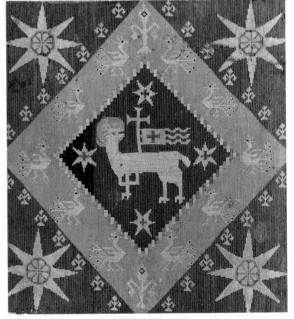

in Gesner's and Topsell's sixteenth-century
natural histories. The basilisk (from the Greek
*basleus*, meaning king) was the fabulous king of
serpents, frequently confused with the cocka-
trice. It was said to have been hatched from a
cock's egg and to be able to kill a person by fixing
his eyes on them. It also featured in Spenser's
*Faerie Queene*:

'The Basilisk . . .
From powerful eyes close venim doth conveay
Into the lookers hart, and killeth farre away'.

The wyvern was used to decorate coat-armour
from the earliest history of heraldry and was also
one of the most frequently used. It appears as a
winged dragon with a barbed serpent's tail.
When the tail is bowed, it is shown intricately
knotted with numerous foldings in the manner
of a fret. The cockatrice became known for its
pestiferous and poisonous aspect 'wherewith he
poysoneth the Aire'. The creature was likened to
devilish witches who worked the destruction of
innocent infants and their neighbours' cattle
whose prosperous estates filled them with envy.

The griffin was a fabulous monster from Greek

mythology. With the head, shoulders and wings of an eagle, and the hind-quarters and tail of a lion, the griffin recurs frequently in heraldry. The animal was used to signify watchfulness, fierceness and courage – the qualities of the eagle and the lion combined. In Christianity, the griffin symbolised the two-fold nature of Christ: the divine being was represented by the bird and the human being was represented by the animal. The griffin was a popular bearing held in great esteem. The unicorn was also likened to a valorous soldier, one who would rather lose his life than undergo any form of bondage or servitude. In heraldry, the unicorn represented both the quality of strength and of courage, as well as a virtuous disposition and the ability to do good.

Numerous creatures were used for heraldic purposes. The most prominent and familiar of heraldic animals are the lion, leopard, stag, eagle and horse – all noble beasts, although it seems that admirable qualities could be found in even the humblest of creatures such as the tortoise, hedgehog, mole, rabbit, snail and even the ant.

Ants were called emmets or pismires and were used to signify a man of great labour, wisdom and providence. While emmets were described as simple, feeble and silly creatures, they were praised for preparing their meat in summer and for gathering their stores in the autumn, in spite of their lack of any guide, governor or ruler. Emmets were considered an excellent example to the slothful man.

Like the ant, the grasshopper was praised for going forth 'all by bands', despite the absence of a king. Comment was also made regarding the males who spent all summer singing while the females were silent. The ant who worked while the grasshopper sang, taunted their slothfulness thus: 'you who sing all summer may go shake your heads in winter'. In Athens, grasshoppers were held in great esteem and, according to Pierius, Athenians wore golden grasshoppers in their hair to signify their nobility. Grasshoppers also appeared on the signboards of London goldsmiths and bankers to commemorate the crest of Sir Thomas Gresham (1519–79), founder of the Royal Exchange. The grasshopper still forms part of the crest of Martin's Bank in England. The creature also featured on sixteenth- and seventeenth-century embroideries and samplers as smaller motifs, together with numerous other insects popularly taken from contemporary pattern books.

It is difficult to find a quality possessed by the scorpion that is worthy of imitation, although

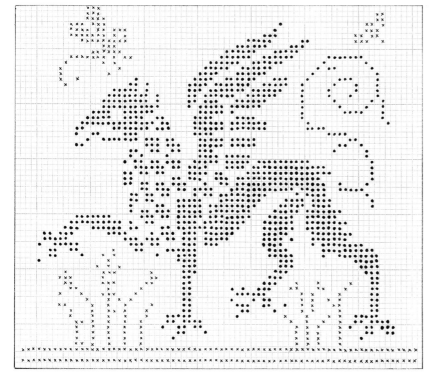

*GRIFFIN*

the following comment was provided by one herald:

> Pierius in his hieroglyphicks saith, that if a man stricken with a scorpion sit upon an Asse, his pain shall passe out of him into the Asse, which shall be tormented for him. In my opinion he that believe this, is the creature that must be ridden in this case.

The bee was praised for its admirable policy and for the regiment of its commonwealth, both at war and in peace. The sense of duty of the sovereign bee and its subjects was also to be admired. The bee was considered to be of great virtue, providing both honey for pleasure and wax for thrift and was hence used as a symbol of industriousness.

The toad signified a 'hasty and choleric man, easily stirred up to anger, being naturally prone to himself having an unbred poison from his birth'. In art, the toad symbolised death.

The dolphin indicated both strength and speed but could also signify an overheady and outrageous man. (Dolphins were believed to swim so fast that they often dashed themselves against the rocks because they could not stop in time.)

## TECHNIQUES AND MATERIALS

Today's heraldic embroidery is generally the province of professional embroiderers, notably the Royal School of Needlework. Amateurs rarely need, or wish, to embroider heraldic pieces. Creatures borne as motifs on coat-armour both in the past and in the present do, however, provide amateurs with a rich source of animal imagery and designs.

Throughout the centuries, almost every conceivable technique has been used and it would be impossible to describe all of them here. Instead, I would refer the reader to a number of books listed in the bibliography. Many animal motifs were worked simply with tent and cross stitches (see p37) and within designs which incorporated more complicated techniques such as metal-thread embroidery. Beginners would be wise to experiment with these simple stitches, and also with some laid and couched work (see p12) before trying the more complicated metal-thread techniques. Simpler raised work and applied motifs can be outlined with a line of dark stitches or couched cord or thread to give a greater definition, the accent being on the choice of materials rather than on the techniques.

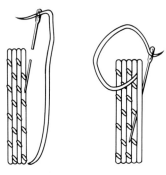

Roumanian couching

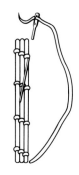

Bokhara couching

# CHAPTER 9

# SAMPLERS

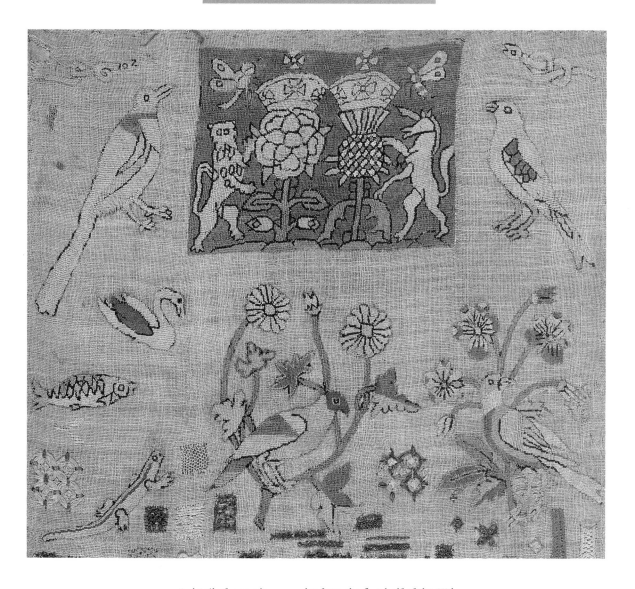

*A detail of a random sampler from the first half of the 17th century. A square panel at the top holds an heraldic design of the lion and the unicorn, the rose and the thistle, and a pair of dragonflies. Other motifs include several large birds, a pair of knotted snakes, a swan, a lizard, and a fish*
(Victoria and Albert Museum)

The earliest surviving samplers from the sixteenth and seventeenth centuries are believed to have been worked by adults solely for the purpose of recording individual motifs and patterns. During this period, printed patterns, although available, were still relatively scarce. Samplers also proved excellent practice grounds for experimentation with stitches and colours, and became so treasured that they were often bequeathed in wills and mentioned in inventories. These early pieces were made either as band samplers or as random (spot) samplers. Band samplers were long narrow lengths of loosely woven linen, embroidered with row upon row of repeating patterns, executed both in white work and coloured work. Random samplers were also long and narrow, with every valuable and available space densely filled with animal and plant motifs, as well as with samples of all-over repeating patterns.

Many of the animals that were embroidered on to samplers of the seventeenth century were heraldic in character. Animal designs were worked not only as attractive motifs but also as records and trial workings for subsequent use on heraldic embroideries, domestic furnishings and clothing of wealthier families. Smaller heraldic embroideries worked by amateurs included bags, purses and book-covers. Heraldic motifs are instantly recognisable by their formal presentations as they are identical to those creatures that were used as bearings on coat-armour. Fish were often depicted as an ancient Christian symbol of baptism and were shown erect. Frogs and toads that were embroidered with the backs of their heads showing were also heraldic, as were serpents shown knotted, or knowed, curling and standing erect on their tails.

The porcupine, squirrel, hedgehog and owl were also depicted on samplers. The owl was the attribute of Minerva, who herself personified wisdom. It was also used, however, to symbolise avarice and the devil. For heraldic purposes, the owl was used to signify watchfulness, vigilance, prudence and solitude. Heraldic intentions may also lie behind the inclusion of so many of the smaller creatures. Moths, dragonflies, beetles, worms, snails, grasshoppers and flies were not only worked prolifically on to Stuart embroideries, but they were also borne as motifs on seventeenth-century coat-armour.

The most popular of the heraldic motifs were horses, camels, lions, dogs, goats, sheep, peacocks and the mermaid. When used as a motif on coat-armour, the mermaid alluded to vanity. Firm belief in mermaids was held well into the seventeenth century and many stories and legends surrounded these fabulous marine creatures. The mermaid's upper half was an alluring young maiden and her lower half was the tail of a fish. Mermaids are closely allied to the sirens of Greek mythology who were said to lure sailors by their seductive singing so that ships sailed towards dangerous shores and foundered on the rocks. As in heraldic embroidery, on samplers the mermaid is generally shown seated, gazing at her reflection in the mirror she holds in one hand, while in the other she holds a comb. Great care was taken with details such as her hair, her face reflected in the mirror and the scales on her tail. Satin and back stitches were popularly used for embroidering these fabulous creatures.

The unicorn appears on random samplers as a spot motif and it was frequently included not only because it was a romantic and fanciful creature, but also because of its heraldic uses. The existence of this fabulous creature was first recorded by a Greek writer of the 4th century BC and it was said to have the head and body of a horse, the hind legs of an antelope, the tail of a lion and a long pointed horn growing from its forehead. The unicorn was usually pure white in colour and was often depicted with a goat's beard. The heraldic unicorn is usually shown as a horse, but with the legs and cloven hooves of a stag and with a twisted horn. Paired with the lion or with the ox, the significance of the unicorn takes on a different meaning.

The unicorn's horn was believed to possess magical powers. In antiquity, the unicorn was said to have purified poisoned springs by making the sign of the cross with its horn over the water. It was also believed that a drinking vessel made from the horn could dispel poison and prevent convulsions and falling sickness. The unicorn was fabled to have been so wild and elusive an animal that hunters were able to capture it only in the presence of a young virgin maiden. The unicorn was supposed to be irresistibly attracted to purity and chastity and hence a virgin maid was sent into the forest where she was first to attract the unicorn and then to tame him into submission. The hunters would then move in and capture the beast. In scenes of the hunting

of the unicorn, the creature is shown taking refuge in the lap of the virgin.

Jane Bostocke's sampler, the earliest surviving example, which was completed in 1598 and worked as a gift for her daughter Alice Lee, depicts a number of creatures. The sampler has been inscribed thus:

'ALICE LEE WAS BORNE THE 23 DAY OF NOVEMBER BEING TUESDAY IN THE AFTERNOON 1596.' The animal motifs worked on the top quarter of the sampler include a chained bear, a deer, a dog chewing its lead, a small heraldic lion and the owl in the vine and the pelican in her piety. The dog has been worked with two-sided Italian cross stitch while the remainder of the animals have been worked simply with cross stitch.

A number of animal motifs that appear on

*THE PELICAN IN HER PIETY*

seventeenth-century samplers hold religious significances. These include the Lamb of God, the pelican in her piety and the peacock, whose flesh it was believed did not putrefy. This belief, together with the annual renewal of its fabulous plumage, led to the representation of the peacock as an emblem of Christ, of the resurrection and of eternal life. The peacock has also been used as a symbol of pride, vainglory, envy and ostentation. In medieval times, knights took their oaths of allegiance with their hands placed on the sides of a stuffed peacock, the bird being used to symbolise knightly or kingly demeanour.

Depictions of doves drinking at a fountain signified eternal life, spiritual life and salvation.

*PEACOCK*

Birds embroidered on to Dutch samplers were worked with religious and symbolic intent as well as being attractive motifs. The cock motif (often a pair of birds) represented Christ as conqueror of the powers of darkness. The cock was also a symbol of penitence because St Peter first felt remorse at cock crow. The stork was representative of parental love and filial devotion.

The swan was depicted on English and Dutch samplers and was known as the bird of love which accompanied both Venus and Cupid. In Germany, the swan was considered a creature of the sun and the bringer of light and life. It symbolised a good death as people believed it sang sweetly as it died. The falcon signified pride and nobility, the goose stupidity, the parrot talkativeness and the duck marital fidelity.

The animals on seventeenth-century English samplers were repeated on other contemporary embroideries. The embroiderer would often use designs that she worked on to her sampler for larger pieces at a later date. Girls who produced stumpwork caskets and mirror frames would often embroider two samplers, one in white work and another in coloured work, before they attempted to embroider a casket.

Many of the design sources for motifs worked on to samplers were the same as for those on contemporary embroideries. These included publications such as *The Needle's Excellency*, written and compiled by John Taylor, and *A Schole-house for the Needle*, written by Richard Shoreleyker and published in 1624. The latter contained, among other patterns, 'sundry sortes of spots as Flowers, Birdes and fishes, etc. and will fitly serve to be wrought some with gould, some with silke, some with crewel in coullers: or otherwise at your pleasure'. A later publication, published by William Simpson in 1650, was *The Second Book of Flowers, Fruits, Beasts, Birds, and Flies exactly drawn.*

Books and pattern sheets offered for sale by Peter Stent included *One Book of Birds sitting on sprigs, One Book of Beasts*, and *Nine Plates of Emblems*, among what were described as 'Books for Drafts of Men, Birds, Beasts, Flowers, Fruits, Flyes and Fishes'.

Among the recognisable and more realistically worked species of birds were parrots or popinjays, falcons, blackbirds, magpies, robins, finches, kingfishers, ducks and geese. Some of these were

Butterflies, which remained popular motifs throughout the history of sampler making, symbolised, by the different stages of its life-cycle, the resurrected human soul, immortality and also pleasure and joy.

Samplers from Holland and Germany were overtly religious in their use of animal motifs. On German samplers, depictions of the pelican in her piety, Adam and Eve and the crucifixion were popular, together with spot motifs of wild animals and exotic birds which were worked with linen or silk thread on a linen ground in very fine cross stitch.

The animal motifs worked on to Dutch samplers as religious symbols were similar to their German counterparts. Animal motifs include a unicorn or a dog to represent faith, a phoenix, a bird in a cage or a bee to represent hope and a lamb, a lioness with her cubs, a pelican or a dove to represent charity.

On Dutch samplers, the hart signified a longing for Christ, although in more general terms it symbolised gentleness and pride as well as the hunt. The unicorn was a symbol of the Redeemer as the creature was believed to have the power of purifying poisoned springs by making the sign of the cross over them with its horn. A white unicorn which symbolised purity and chastity represented the Virgin Mary.

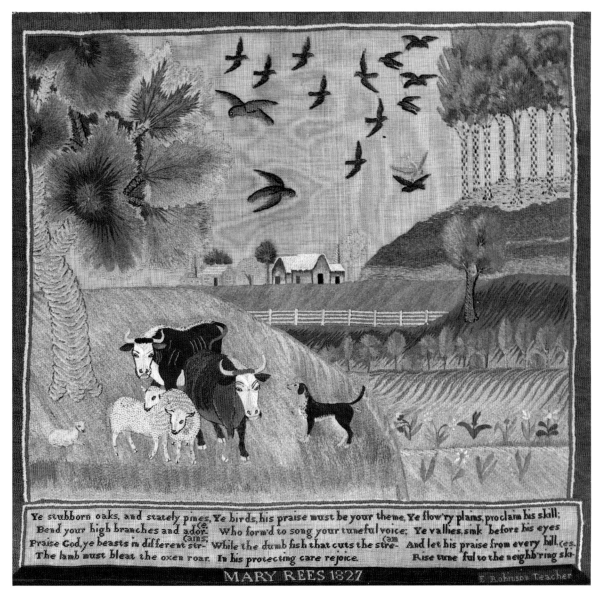

Ye stubborn oaks, and stately pines, Ye birds, his praise must be your theme, Ye flow'ry plains, proclaim his skill;
Bend your high branches and ador- Who form'd to song your tuneful voice; Ye vallies, sink before his eyes
Praise God, ye beasts in different str- While the dumb fish that cuts the stre- And let his praise from every hill,
The lamb must bleat the oxen roar. In his protecting care rejoice. Rise tune ful to the neighb'ring ski-

MARY REES 1827

E. Robinson Teacher

popularly shown holding sprigs or cherries in their beaks. The huge variety of recognisable insects and birds diminished towards the end of the seventeenth century, which became known as the golden age of sampler making. The standards of excellence began to decline at the end of this period and the vast repertoire of stitches dwindled significantly. On early samplers the range of stitches included Roumanian, Russian overcast, buttonhole, detached buttonhole, montenegrin cross, plaited braid, Italian cross, coral, speckling, guilloche, Algerian eye, tent and cross. Whitework samplers included the use of pulled work and cut and drawn work. By the eighteenth century, cross stitch was

*A needlework picture showing a barnyard scene worked by Mary Rees. It is dated 1827 and is thought to come from Pennsylvania. The stitches have been worked in a predominantly diagonal direction, particularly on the cattle and the chequered patterning on the tree trunks, which has given this piece its individuality. It is a striking piece of embroidery on which silk threads have been used for the majority of the work, while the sheep's fleeces have been embroidered with wool threads* (Colonial Williamsburg Foundation)

so widely used that it became known as the sampler stitch; other stitches included Algerian eye, rococo, Hungarian, a number of straight stitches and tent stitch. A few other stitches were used occasionally for working small areas.

# EIGHTEENTH- AND NINETEENTH-CENTURY SAMPLERS

The subjects and styles of embroideries from the eighteenth century were very different from those of the previous one. By now there were strong influences from Indian floral fabric and the highly fashionable chinoiserie, a trend that had started in the seventeenth century. Animal motifs had disappeared in preference to floral designs and most of the animals worked into compositions were purely incidental.

Samplers worked by children included classroom exercises, such as mathematical tables, rebus and map samplers. Many were embroidered entirely with rows worked repeatedly with alphabets and numerals.

By the eighteenth century, samplers had lost almost all practical value and were purely decorative. Their shape had become more square and the texts were generally surrounded by border patterns. Samplers were made to be framed and hung on the wall to display a child's achievement. Motifs became smaller, simpler and more stylised as the century progressed. Species of birds and dogs were in the main unrecognisable,

*Sampler worked by Laura Hyde, dated 13 June 1800, and featuring the American eagle and a zebra in panels at the top. The rest of the work shows scenes of the Bay of Bengal and of a visit by the wife of the American ambassador to a local harem* (Metropolitan Museum of Art)

but nevertheless possessed the charming qualities peculiar to cross-stitch samplers.

Eighteenth-century designs were formal, with well-ordered and balanced arrangements of motifs. Animals and birds were often placed in pairs facing each other or arranged symmetrically around the work. Discipline was the rule of the day, both in stitchery and in design.

Some samplers had landscapes embroidered across the lower portion of the work and depicted trees, houses, sheep, cattle, ducks and deer, echoing the idyllic and sometimes frivolous rural landscapes worked on many eighteenth-century embroidered pictures, panels and chair-seats and backs.

The United States of America produced some of the finest examples of pictorial samplers. Generally, these used wide borders to hold the main pictorial area of the design, an enclosed small central square being worked with alphabets, verses or inscriptions. The animals worked within the borders were mainly the domestic and rural varieties – dogs, birds, cattle, sheep and deer being the favourites. On Dorothy Ashton's sampler of 1764, a shepherd and shepherdess are seated within a rural landscape. A small cheetah in the background has been embroidered in a style usually attributed to the Sarah Stivour School of a later period. Long straight vertical stitches have been effectively couched down at intervals to create the spotted pattern on the leopard. The embroidery was worked with a shimmery, kinky silk that was home-dyed and widely used in America giving the piece an interesting textural quality. Other creatures and

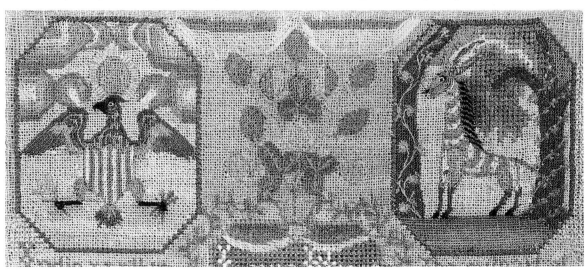

the figures were worked with straight stitches that varied in direction from vertical to diagonal.

An unusual woollen sampler from the eighteenth century depicts a dog chasing a hare and has been worked above a length of Florentine embroidery. This beautiful and highly individual sampler has been worked in bright colours. The design of a dog and a hare symbolises the chase – that is, good fleeing before evil. The fruiting tree between them is also an ancient, well-used and useful design element. The animals have been worked in tent stitch, outlined first with a dark coloured thread and filled in later.

## TECHNIQUES AND MATERIALS

Sixteenth- and seventeenth-century sampler makers had a large repertoire of stitches, such as cross, tent, Florentine, raised plaited braid, rococo, double running, Cretan, eyelet, Hungarian and chain, among others. Sampler makers used a range of different materials, including silks, linen and metal threads – popularly silver and silver gilt. Interwoven techniques and interlacing stitches, as well as pattern darning, and cut and drawn work with darned and detached fillings, were all popular techniques. White work, in which satin stitches were embroidered to make geometric patterns in counted-thread work, was another technique. Linen, with a relatively fine thread-count, was the principal fabric used for grounds. In the mid-seventeenth century, tammy, a fine woollen cloth, was popular and by the end of the century cotton was also in use.

Eighteenth-century sampler making employed fewer stitches than other embroidery styles of the period. These included such stitches as chain, feather, hollie point, running, cross, rice, tent, satin, back and Algerian eye. Couched work and pattern darning were employed in some sampler making. 'Stivour stitch' was peculiar to a group of American samplers and was worked with a crinkly silk thread. It was a long straight stitch worked diagonally to cover larger areas of backgrounds on pictorial samples. Some American samplers also made extensive use of both pattern darning, worked vertically, and of satin stitches. Many samplers were worked with free surface stitchery as opposed to counted threadwork.

Cross stitch, however, was the principal stitch used on eighteenth-century English samplers and this stitch became known as the sampler stitch. By the nineteenth century, the repertoire of stitches had decreased considerably to those of cross and tent, with a number of canvas-work stitches such as Hungarian, Florentine, satin and brick. Materials included silks on linen, but with the influence of Berlin woolwork, wool and canvas was the most popular combination. Beadwork, another popular technique at this time, was also worked on samplers.

## PRACTICAL APPLICATIONS

Samplers are very popular projects for today's embroiderers and are generally worked either for purely decorative purposes or as works celebrating special occasions, such as historical events, births, weddings, and so on. Sampler making is at its most valuable when used to record in detail personal, historical and social events. The inclusion of the worker's name and the date the work was started and finished is also important.

Try working your favourite animals into decorative borders, perhaps with your home as a centrepiece. If you live in the country, use farm animals and wild creatures, such as deer, badgers, game-birds and other familiar species of birds. Town dwellers have a different repertoire of creatures upon which to draw: pigeons, starlings, robins, house martins, family pets, mice, hedgehogs, squirrels and perhaps a scavenging fox.

You might like to embroider the animals entering Noah's ark, the creation, God naming the animals or classical subjects such as Orpheus charming the animals. You could also work a design depicting Adam and Eve in the Garden of Eden, and include the tree of knowledge, the serpent and wild and exotic animals. Popular animals such as cats, rabbits, ducks, geese, elephants, horses and donkeys would be appropriate on a sampler for the birth of a child. Favourite nursery-rhyme creatures could prove an attractive theme – 'The Cat and the Fiddle' or 'The Owl and the Pussycat', for example.

The charted designs from this book can be used for counted-thread work techniques, while for more freely worked surface stitchery, drawings can be used and transferred on to the ground using one of the methods described on p125.

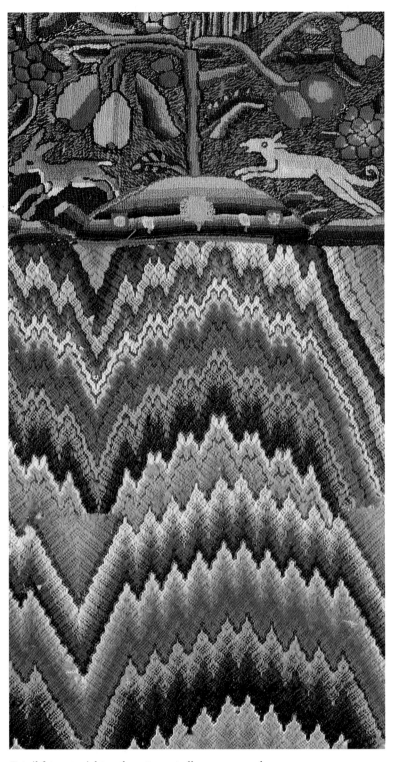

*Detail from an eighteenth-century woollen canvas-work sampler which is an unusual and individual embroidery. Above a length of brightly-coloured florentine patterning a depiction of the chase has been worked. The dog and the hare have been placed either side of a fruiting tree (National Museum of Scotland)*

# DARNING STITCHES

Double darning can be worked in an irregular way, but always it is worked in rows. Running stitches are worked across one row, generally with regular counted spaces between each stitch. The return row is worked by filling in the spaces left by the first row. Double darning is reversible. By arranging

**Double darning stitch**

**Rows of double darning stitch**

**Diagonal darning stitch**

the counted stitches and their positioning on each row, geometric patterns can be achieved such as columns of alternating colours, chevron, brick and diagonal patterns, and so on.

**Geometric darning patterns**

# DOROTHY DIXON'S SAMPLER

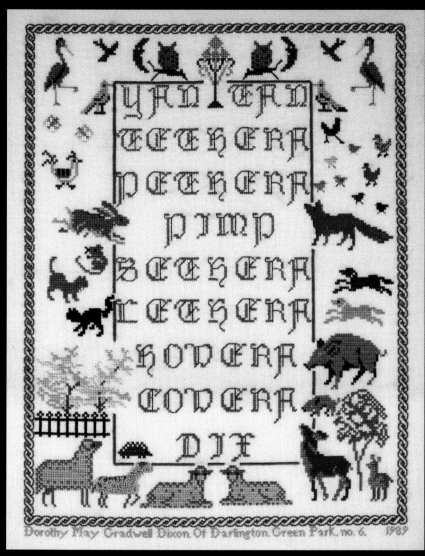

*Dorothy Dixon's Sampler* (Dorothy Dixon)

Dorothy Dixon's sampler is a highly individual and rather jolly example, worked whilst attending classes at Darlington Arts Centre. It records just one of the Yorkshire Dales' ancient sheep counting rhymes, using lovely old lettering surrounded by wide borders of favourite wild and domestic creatures. The colourful and lively collection here includes leaping dogs and prowling cats, grazing deer and swallows in flight. A pair of owls sit perched in branches surveying the whole scene, where many of the animals are shown breaking out of the borders into the centre panel.

Stranded cottons have been used on an even-weave cotton ground. The stitches are mainly cross stitch, with long-armed cross, satin stitch, trailing back stitch, whipped back stitch and French knots for the sheep – so it was an excellent way of learning some of the basic counted-thread work stitches.

# ANIMALS
## IN THE
## RURAL IDYLL

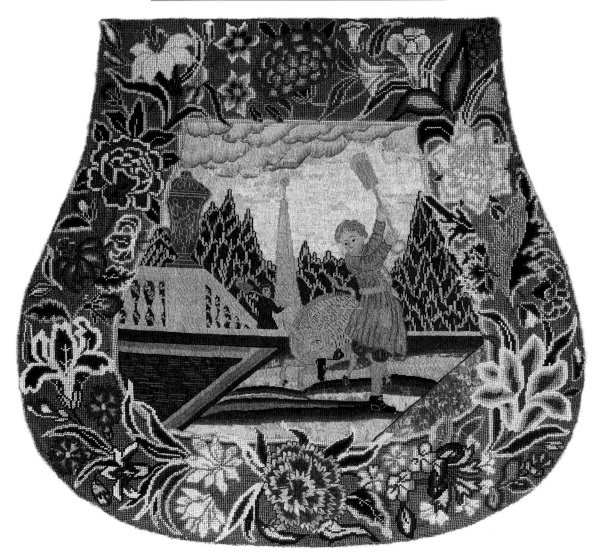

*Canvas-work chair seat showing the fable of the gardener
and his pet hog* (Victoria and Albert Museum)

By the beginning of the eighteenth century the number of amateur embroiderers had greatly increased. The genteel art of embroidery had become an occupation for women from the provinces as well as for those from wealthier families. The range of techniques also broadened to include knotting and quilting, pulled work, hollie point, tambour work, flowered muslin and white crewel embroidery. Crewel work with silks and metal-thread embroidery were popular, as was shaded work with silks and wools in long-and-short stitch.

The designers of woven silks, lace and tapestries who worked in France were the main source of inspiration for eighteenth-century embroiderers. Numerous professional embroiderers were employed in France to produce pieces for the court and for large houses throughout Europe. Floral designs dominated in what has been described as 'rampant naturalism' and flowers abounded on all the decorative arts.

Animal motifs were rarely embroidered during this period. On canvas work, embroidered animals appeared simply as carefully placed props in stylised settings. The eighteenth-century vision of the pastoral idyll reached new heights, with lords and ladies acting out rural tasks and masquerading as shepherds and shepherdesses.

This new Arcadia is epitomised by the following description, written by Thomas Whateley in 1770, of an ornamental farm in Surrey:

> With the beauties which enliven a garden are everywhere intermixed many properties of a farm; both the lawns are fed, and the lowing of herds, the bleating of sheep, and the tinkling of the bell-wether resounding all round the plantations; even the clucking of poultry is not omitted; for a menagerie of very simple design is placed near the gothic building; a small serpentine river is provided for the waterfowl, while the others stray among the flowering shrubs on the bank or straggle about on the neighbouring lawn . . . everywhere rich, and always agreeable.

The animal most frequently depicted on embroideries was the sheep, portrayed with clean, white, fluffy fleece. Charming little girls and demure young ladies are shown playing with their pet lambs in an idealised nursery-rhyme land. Although the portrayal of sheep in art had religious symbolism, their portrayal in eighteenth-century rural scenes represented innocence, playfulness and joy.

Eighteenth-century needlework pictures were generally embroidered with straight stitch, long-and-short stitch and satin stitch, worked with silk and chenille on silk grounds. Sheep were worked in knots, as was the foliage of trees. The faces and limbs of figures, and skies, were painted on to silk grounds with watercolours and the subjects were depicted in the same mood as those worked on to canvas-work pictures.

Chinoiserie was a development of crewel work, which had evolved directly from Elizabethan blackwork and monochrome embroideries, as well as being influenced by eastern styles. A dominant style, chinoiserie was in harmony with the flowing floral designs and elegant pastoral landscapes and vignettes of the time. Early eighteenth-century designs at first followed similar lines to those of seventeenth-century crewel work, depicting unlikely combinations of mythical, wild, domestic, and foreign beasts and birds in the foregrounds and skies. Later, wild beasts were rarely embroidered, although graceful and exotic birds frequently appeared amid flowers and foliage. The following description appears in a publication entitled *Wild Flowers and Birds as Seen on 18th Century Needlework*:

> . . . the popyngay, the mavys, partrige, pecocke, thrushe, nyghtyngale, larke, egle, dove, phenix, wren, the tyrtle trew, the hawke, the pelly cane, the swalowe, all singing in quaint blending of Latin and English the praises of God.

The technique of needle painting was developed during the eighteenth century. A group of women who produced embroidered copies of paintings by such influential artists as Gains-

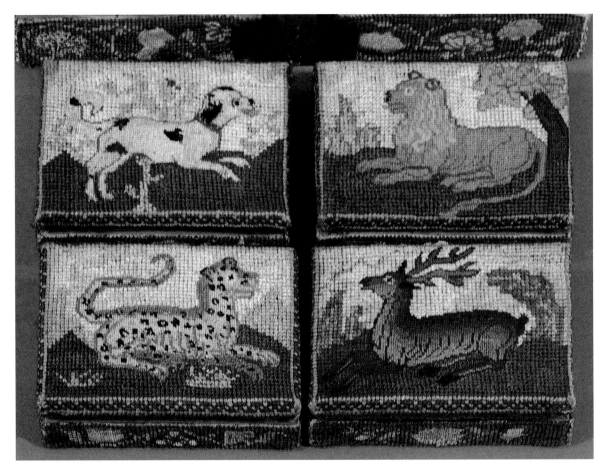

*A box covered with canvas-work with four drawers that bear a leopard, a dog, a lion and a stag. The box measures 5¼ × 7¾in (133 × 197mm) (Christie's)*

borough, Rubens and Stubbs, became famous for their much admired embroideries. Needle painting involved the use of long-and-short stitch worked in a wide range of colours and many different shades that imitated the painted brush-stroke.

During the eighteenth century, the most popular technique for the majority of furnishings, was canvas work. Items ranged from carpets, wall-panels and screens to chair-covers, cushions, card-table tops and canvas-work pictures. Popular designs sold by publishers were worked both in wools and silks. The magazine *Ladies*, which first appeared in 1749, also proved an important source of design.

Designs worked by amateur embroiderers retained their own peculiar styles and characteristics, and animals continued to be favourite subjects. While both amateur and professional embroiderers portrayed similar subjects, amateur embroideries of the period were reminiscent of primitive painting. They have immediacy and personality, the sentiments expressed being more important than scale, proportion or the standards of stitchery.

The four drawers illustrated come from an English embroidered box. On these have been embroidered four of the most popularly worked creatures of the seventeenth century. The spotted leopard, lion, dog and stag have been embroidered with petit point (in this case tent stitch over a single thread of the ground), while the background designs have been filled in with cross stitch worked over two threads. The acute shortage of space that demanded economy and simplicity of style, resulted in a piece that was well-designed and showed a good use of colour. Although the box cannot be said to be one of our greatest embroidered pieces, the four animal motifs have a special charm.

Numerous canvas-work furnishings, particularly embroidered chair-seats and backs, have

survived from this period. The embroidered chair-seat illustrated on p108 bears a design taken from an illustration by J. Wootten and William Kent (from Gay's *Fables*, first published in 1727) which shows the fable of 'The Gardener and the Hog'. Here the enraged gardener, who had made a good friend of the hog, has just found him eating his prize tulips. John Gay, poet, play-wright and author of *The Beggar's Opera*, dedicated his first volume of fables to 'a young prince' – the six-year-old Duke of Cumberland. Gay's *Fables* remained in print well into the nineteenth century.

The latter half of the century saw the making of new styles of delicate carved and gilded furniture, of Adam, Chippendale and Queen Anne chairs. The French woven tapestry and tent-stitch embroidered chair-coverings were replaced by figured silks, brocades and damasks. From 1770 onwards, canvas work suffered a decline which reached new lows during the Victorian period, (manifest in the production of Berlin woolwork). During the last decades of the eighteenth century, amateur embroiderers concentrated on needlework pictures and smaller items of furnishings.

## TECHNIQUES AND MATERIALS

The many different materials, threads and grounds used during the eighteenth century varied greatly and they were combined with almost every conceivable technique. New materials included ribbons, straw, quills, hair and small pieces of metal foil, all of which were introduced into designs to further embellish and add interesting textures. Metal-thread work was popular, especially on embroidered costumes, combined with silk stitchery. Yarns such as chenille added a further dimension. Grounds included silk, satin, linen, cotton, muslin and canvas.

Needlework pictures of flat silk and crewel embroidery entailed much use of fine silks in carefully shaded colours. Free surface stitchery made use of long-and-short stitches and satin stitch worked in a painterly way and on fine grounds of silk or satin. These techniques were often combined with the use of silver or silver-gilt thread and chenille, worked on floral designs in particular.

Chenille is a woven, tufted working thread which adds an additional and rich effect similar to the plush stitch which was so popular with the Victorians. It is well worth experimenting with, especially if you are working bird and animal designs, because it can be used to imitate fur or feathers. Chenille can be used as a working thread, with heavier weights being laid and couched to the ground.

Tambour embroidery was also popular during the eighteenth century, the ground being worked tightly stretched over a round frame. Chain stitch was created when a loop of the working thread was drawn from behind the ground through to the front with

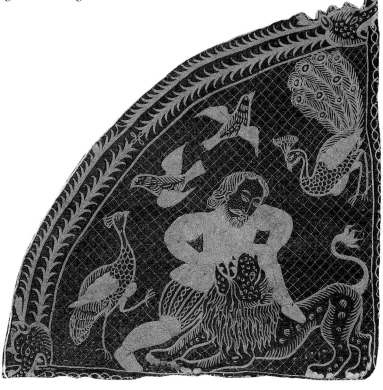

*A sixteenth-century coverlet depicting Hercules and the Nemean lion. It is an excellent example of chain stitch used both as an outline stitch and a filling. Running stitch has been used for the quilting and straight stitches as speckling for the faces. White cotton thread on a blue ground gives a striking effect when combined with the flowing lines of a well-drawn design.*

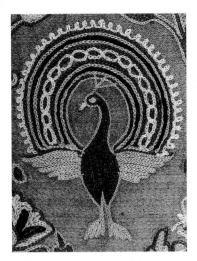

a fine hook; a second loop was drawn through the first loop, and so on. While a row of chain stitches was produced at the front of the work. on the reverse side a continuous line of back stitches was formed. The experienced hand worked at speed, the work progressing rapidly and forming neat flowing lines. Curving shapes were filled successfully with closely worked rows of stitches that followed the contours of the form and proved an excellent method for filling in animal designs.

Tambour embroidery may be worked on grounds which vary in weight from light net and muslin to satin, velvet and heavier linens such as those used for crewel work. Tambour hooks come in different sizes that are chosen to suit the weight of the grounds and working threads being used. Simple animal shapes would look very effective with outlines worked in chain stitch with cotton thread on net or muslin. Designs that were filled completely with stitchery and worked with the heavier crewel wools or linen in the manner of crewel work would also be effective. Tambouring is a technique well worth mastering, particularly because the work progresses quickly.

*An example of mochi work from Banni in Kutch, India. A green satin skirt has been embroidered with chain stitch in bright colours* (Rachel Kay Shuttleworth Collection)

Illustrated is an example of mochi work from Banni in Kutch, India. The tambour technique has been used to decorate the hem of the silk satin skirt with bright colours. Rows of heavily stylised repeating peacocks and flowers have been worked to a simple but effective and well-planned design. The use of card templates would be a suitable method for transferring the designs on to the ground. The various component shapes within the design could be cut out and drawn around separately, with as few as three shapes being required for the peacock. (The first wing should be turned over and the reverse side used for the second wing.)

A vast number of stitches can be used as fillings and those included here have the most interesting textural effects. It would be advisable to experiment with these using a variety of materials and grounds, as so many different effects can be produced. For free embroidery, the following stitches prove useful and effective for fillings: chain stitch, worked closely in rows; open Cretan, used as an outline stitch as well as a useful filling stitch; buttonhole; detached buttonhole; open buttonhole; knotted-buttonhole filling; buttonhole shading; hollie point; long-and-short, Roumanian couching; stem-stitch filling; satin-stitch shading; hollie stitch; trellis filling; plaited braid; speckling stitches, and numerous darning patterns.

Many different types of stitches, as well as couching, can be used for outlining animal motifs. Some experimentation with stitches and materials is required to find the desired effect. A few of the more interesting possible outline stitches are: back, running, buttonhole, chain, stem, outline, herringbone, pekinese, Roumanian, Vandyke, cross, long-armed cross and overcast.

Many stitches, such as whipped or threaded running, back, satin, stem, buttonhole, chain and satin stitch trailing, can be embellished further by whipping, or weaving, in a second thread (in the same or a contrasting colour or type of thread, for example metal threads), which adds further texture and weight to the finished work.

Knots, such as French and bullion, and pekin or coral stitch, were popularly used to imitate sheep's fleeces and the foliage of trees. Knotting involves the use of knotted thread that is couched to the ground, forming highly textured results. Knotting was a popular technique during the eighteenth century and was used to make furnishings, notably bedcovers. The technique involved winding linen thread on to a shuttle and knotting lengths at a time ready for sewing to the ground. The working of white thread on a white ground was a popular combination of materials.

The quite small repertoire of canvas-work stitches used by eighteenth-century embroiderers included tent stitch, with other stitches, such as Hungarian, cross and rococo, for textural contrast. Hungarian stitch is a simple canvas stitch which can be worked with two colours to create patterning. Rococo stitch was often used on geometric patterning and can be found on many seventeenth-century samplers. Initially, it is a complicated stitch to learn, but its highly textured appearance makes it an invaluable one and is especially effective as a filling stitch to create larger creatures. Rococo

is a canvas-work stitch that is worked on any ground on which the threads of the material can be counted and is particularly attractive when it is worked with finer threads on linen or cotton grounds that have a high thread count.

The following stitches were generally used as groundings: tent, cross, long-armed cross, two-sided Italian cross, eyelet, Algerian eye, Hungarian, plaited, Renaissance, rococo, velvet or plush or velvet stitch, knitting, plaited gobelin, trellis, Florentine, and arrangements of straight stitches, that is, brick, chevron patterns, and so on.

Several types of cross stitch exist. Animal motifs can be outlined with the popular basic cross stitch, each stitch being worked separately. When it is used to fill shapes or to cover areas of the ground, cross stitch can also be worked in rows. The first diagonal is worked on the first row across, the stitch being completed by the second diagonal that is worked on the return row. Other types of cross stitch that are useful for filling shapes include long-armed cross, montenegrin cross and two-sided Italian.

## THE FABLE OF THE FOX AND THE GOAT

## PRACTICAL APPLICATIONS

The practical applications of the different embroidery styles and techniques used during the eighteenth century are many and varied. Designs reflecting the romantic and pastoral vision of this period are perhaps best suited to embroidered canvas-work furnishings, such as cushions and pictures. The charted designs, line drawings and illustrations given in this book can be used for canvas-work embroideries. Designs may have to be enlarged or reduced to the required size before they are transferred to the ground ready for working (see p125).

Canvas-work chair-seats and backs can still be worked today – animal fables seem appropriate subjects, perhaps with carefully chosen and personally relevant stories. Canvas-work panels and pictures provide an area well suited for more pictorial landscapes. Such rural settings can include wild and domestic animals, from grazing sheep and cattle to rabbits, hens, chickens, ducks, geese, horses, deer and varieties of birds (flying or perched in trees). You could portray your own vision of the perfect rural idyll and include within the design favourite animals, birds, species of trees, flowers and plants. Mrs John Dower worked the illustrated needlework panel in 1974 in very much the same style as many sixteenth- and seventeenth-century canvas works. Her embroidery depicts a busy landscape of rolling hills, rural animals, and charming architectural features.

A single animal can be a valid design in itself, the background left plain or carefully framed within a patterned border. Textures can be created to represent each creature by using various materials and techniques. Canvas grounds, woollen threads and pile or loop stitches are excellent for sheep. For smoother-haired creatures, use shiny silks or cottons on a finely woven ground. The threads could be worked with surface stitchery in a more painterly manner in satin or long-and-short stitches and the ground need not be filled with stitchery. Other design elements, such as trees, flowering sprigs, the sun and the moon, clouds and birds flying in the sky, could be introduced as spot motifs around the ground.

*A canvas-work picture by Mrs John Dower at Wallington, Northumberland* National Trust

# RABBITS AND DOVES

These two designs have loosely been termed as 'folk' cross-stitch patterns. The birds are said to have come from South Germany. This combination of the two has been worked to suggest an Assisi design for a pillow cover, though they would also make an attractive cushion cover if worked in wool on a canvas ground. I have used an off-white even-weave linen (28 threads to the inch) with two strands of Coats stranded cotton, red 022. In Assisi work the shapes are voided, left unworked, whilst the background is filled with cross stitches. The shapes are outlined with back stitches, using just one strand of cotton.

*Rabbits and Doves* (Author)

# CHAPTER 11

# BERLIN WOOLWORK

The rapid decline in the standard of late eighteenth-century embroidery was caused in the main by the inevitable effects of the Industrial Revolution and the growth of the technique known as Berlin woolwork. It was a fashion which overshadowed almost all other styles of embroidery during the nineteenth century. Berlin woolwork became popular as one of the few acceptable occupations for the ever-increasing numbers of middle-class women. The production of mass-produced, relatively inexpensive printed and woven fabrics ended the traditional methods of working embroidered furnishings. Even machine-made lace was a relatively impressive imitation of the genuine article and the hand embroiderer was reduced to making smaller and more frivolous items.

The inclusion of novelty materials, such as beetle's wings, feathers, shells, fish-scales, ribbons, and so on, was also popular. Magazines and journals were largely responsible for the development of these fashions.

Traditionally, amateur embroiderers had referred to prints and engraved patterns as sources of designs, but the flood of printed, mass-produced, charted designs that were imported from Berlin at the beginning of the nineteenth century, meant that embroiderers no longer referred to their previous sources. Charted designs were intended for canvas-work embroidery and were first printed by L. W. Wittich in about 1810 and proved an instant success. By 1840, about fourteen thousand different designs, hand-coloured by poorly paid girls in the publishers' warehouses, were in circulation. Garish, brightly coloured wools, also from Berlin, were soon sharing the same amount of success and pop-

ularity. The invention of the new analine dyes brought new shades of pink, magenta, lime green and purple, which also became highly fashionable.

Berlin woolwork was a fashion which remained very popular for over half a century (from 1840). The method led to a decline in the standards of amateur embroiderers' techniques and design. The total repertoire of stitches fell almost to just two – tent and cross stitch. Mass-produced, coloured charts, combined with the supply of garish, brightly coloured wools, meant that the embroiderer no longer chose her own colours and this led to a decline in original embroidered works.

The illustrations of exotic foreign birds by John Gould, Audubon and Edward Lear were a source of inspiration for nineteenth-century designs. The embroidery which resulted from the publication of these artists' illustrations are probably the best examples of their day.

Bird's eyes were usually represented by glass eyes. Plush stitch was used to work plumage. Also known as Victorian tufting or pile stitch, plush stitch gave a highly textured, raised impression of velvet pile. Even animal fur was worked occasionally in this way, particularly on depictions of dogs. Plush stitches were used to work a Berlin woolwork embroidery entitled 'The Talisman' which depicted a scene from Scott's novel of that name.

Parrots and toucans were the most popular birds to be worked on to canvas-work embroideries, and the red and yellow macaw and salmon-crested cockatoo were also frequently worked. Birds were shown sitting on leafy branches or placed within wreaths of flowers. A

painting (1839) by Edwin Landseer inspired a design that depicted Queen Victoria's pet dogs, Islay and Tilco, a red macaw and two lovebirds. Other birds that were popularly embroidered include peacocks, humming birds and mallard ducks. Such brightly coloured birds were popular subjects for embroidery, not simply because many had become fashionable pets, but more importantly because the brightly coloured wools that were available were much favoured.

Sir Edwin Landseer's studies of animals were a source of inspiration for Berlin woolwork. One such embroidery depicts the Monarch of the Glen and his royal pets. Another Berlin woolwork embroidery, worked at Chatham in Kent and now at Maidstone Museum, depicts a large stag worked in the style of Landseer. Both the royal family and their pets were popular subjects and Dash, Queen Victoria's King Charles spaniel, was frequently depicted.

Cats were depicted on smaller designs and were shown sitting or lying on tasselled cushions. Cats and dogs depicted as family pets were included in portraits of young children, while

*A PAIR OF BIRDS*

foxes' heads were popular motifs that were worked on to men's slippers. Other items of furnishings subjected to Berlin woolwork designs included bell-pulls, curtain tie-backs, stools, cushions, tablecloths, firescreens and upholstered chairs. Cross- and tent-stitch rugs were also made. Patchwork rugs were later made from canvas-work squares and depicted various designs that were sewn together. A variety of designs showing animals, birds and floral designs of sprays and wreaths would be worked on to one rug. Cats, kittens, dogs, birds, a mouse and several fish, might all feature in one pattern. By the 1870s, geometric designs began to replace this type of design.

A number of simple woolwork designs in charted form are included here. The charts can be interpreted in a realistic manner and several shades and tones of different colours may be used. Choice of colour is, however, a matter of personal preference. It is also possible to hand-paint your own designs directly on to grounds with waterproof and smudge-proof colours, inks

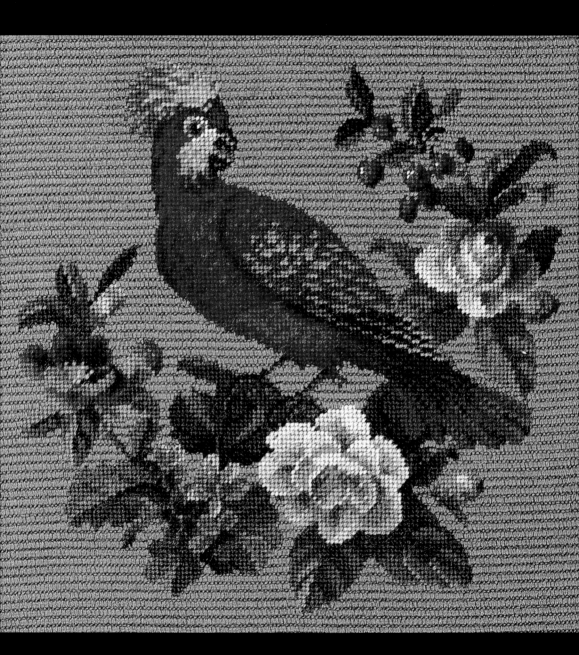

*Berlin Woolwork Bird* (Author)

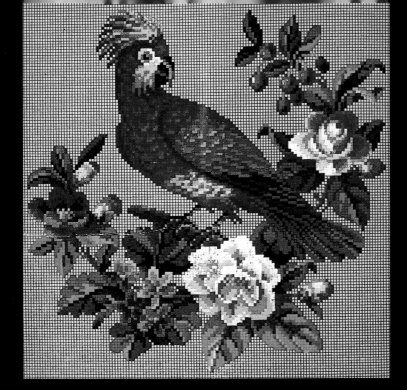

This has been worked from a rather fine Victorian design of an impossible species of 'parrot'. The coloured chart was printed by Hertz and Wagener in Berlin. There is quite an art to choosing the colours to achieve satisfactory effects of realism and shading.

The chart is shown here together with a list of colours. I have used a rather fine canvas of 18 holes to the inch, with two strands of Appleton's crewel wools in tent stitch – finished size, 8.5in (21.5cm) square. The background has been worked using rows of satin stitch (over two threads of the ground), outlined with rows of back stitches using just one strand of wool.

There is a wide range of canvas-work stitches which could be used instead; eg, satin-stitch diamonds or triangles, long-armed cross stitch, Hungarian stitch, plait stitch and eyelet. Heavier tapestry wools matched with a more open canvas would make a larger though perhaps cruder embroidery.

## COLOUR KEY

Body: reds, 505, 503, 448, 865

Wings: violet 105, 101; green 543; black 993; grey 922, 927

Tail: black 933; blue 929, 823, 821

Beak: black 993; grey 922, 927

Crest: yellow 692, 695, 697, 698

Pink flowers: 588, 505, 756, 755, 754, 753

White flower: 992, 201, 985, 581 (highlights in pure-white Madeira stranded silks, used whole)

Violets: 106, 105, 103, 101 (highlights in violet Madeira stranded silks 0807, used whole)

Violet leaves: 407, 406, 404, 403, 402, 401, 993

Leaves the top right: 584, 547, 545, 543, 542

Lower rose leaves: 348, 346, 344, 343, 341

Twigs, branches and veins: 696, 126, 581, 976

or thin paints. Realistically worked designs will require both experimentation and patience, probably with several reworkings. The grounds are generally filled in with a single colour, as they are for beadwork designs and motifs.

The practical applications for Berlin woolwork are the same today as they were during the Victorian period: pictures, bell-pulls, cushions, pelmets, curtain tie-backs and cross-stitch rugs and carpets. Patchwork rugs, with various animal and bird motifs are particularly suitable. Original designs may be hand-painted on to the canvas ground. Designs taken from other sources, such as line drawings and black-and-white illustrations, can be transferred on to the ground by means of one of the methods described on p125.

*The Chase tapestry, designed by Heywood Sumner in 1908 and woven by Martin, Glassbrook and Berry* (Chilcomb House)

## TECHNIQUES AND MATERIALS

The stitches used for Berlin woolwork embroideries were limited to mainly tent and cross stitches, with significant amounts of pile stitch for fur and plumage. A series of loops were worked into a foundation of cross stitches then cut and trimmed to the required length or 'height'. Here some impression can be given of shape and contours to create a sculptural effect. Leviathan stitch, or railway stitch, was also used to cover the ground quickly and was worked over four threads of the ground. Other stitches include continental and diagonal stitches, and other varieties of cross stitch.

Inexpensive wools of varying thicknesses were the threads most commonly in use, although silks were worked on fine canvas for smaller works and also for highlighting certain areas of designs, such as petals of flowers and parts of clothing. Beads, too, were used in the same ways. Chenille of two thicknesses was also popular.

In the Victorian period canvasses were available in a wide range of weights and materials, ranging from very fine, expensive silk types for smaller hand-painted designs, to cotton and jute types for larger pieces. The most popular canvas grounds had thread counts of between 11 and 37 threads per inch. Today, the range of canvasses is much smaller, although it

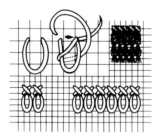

**Velvet or pile stitch**

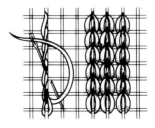

**Knitted stitch**

covers all possible needs adequately. Threads available through local shops are, however, limited and it is a good idea to write to either manufacturers or specialist suppliers for samples from all available ranges. Stranded wools that may be required for finer work are not always readily available and many shops sell only limited ranges of colours.

It is advisable to work on a frame because some distortion always occurs when the ground is constantly pulled to one side by the first stroke of each stitch (which should always be worked in the same direction). When the work is stretched tightly over a frame, the need to block the finished embroidery may be avoided and the task of mounting or making up is made much easier. If possible, the frame should be large enough to take the whole of the proposed embroidery which avoids the need to roll up the work. Blunt-ended crewel needles should be used so that you do not pierce either the thread or the ground, thus enabling the stitches to lie neatly.

# VICTORIAN CAT

This embroidery was inspired by a charming Victorian design published in the late nineteenth century, which looks very effective worked simply in just two colours. Other muted shades, such as rust or sage green, might also be rather attractive.

It has been worked on a double-mesh canvas of ten holes to the inch, using cross stitch and two strands of Appleton's crewel wool, blue 563, and off-white 991. The finished size is 8.5in (21.5cm) square.

Thicker tapestry wool on a more open canvas would also be attractive, and perhaps stronger. The finished panel is ideal for applying to a rich ground for a cushion cover.

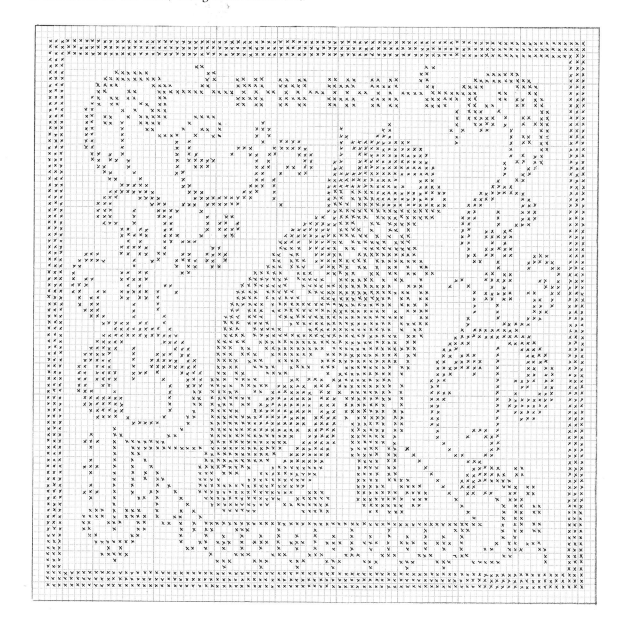

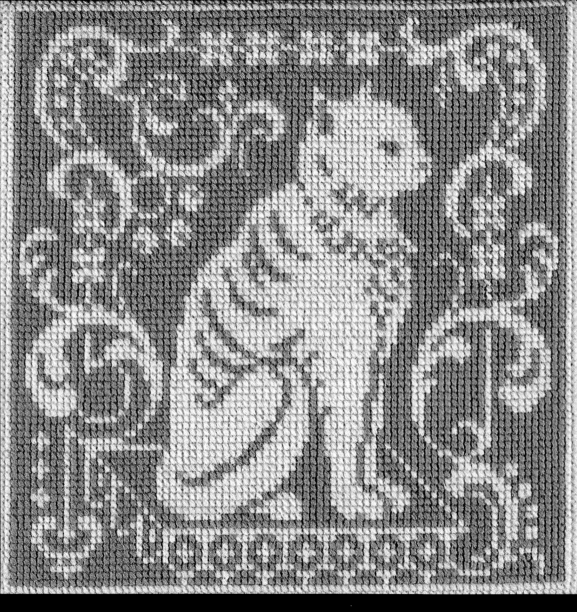

*Victorian Cat* (Author)

# SPANIEL

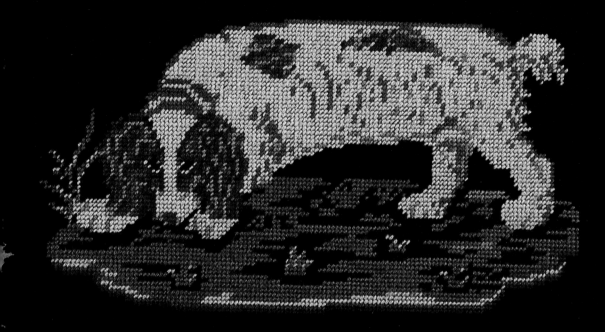

*Spaniel* (Author)

The spaniel is taken from a design worked at the turn of the century by a ship's carpenter, using wool on a coarse canvas ground. This version uses Coats tapisserie wool on a double mesh canvas of twelve holes to the inch – tent stitch throughout. The finished work measures 13 × 9in (33 × 23cm).

## COLOUR KEY

| | |
|---|---|
| * | Rust 0741 |
| + | Pink 3166 |
| z | Beige 0904 |
| ● | Brown 0420 |
| / | Sand 0713 |
| × | Green 0859 |
| e | Olive 0269 |
| . | Black 0403 |
| n | Brown 0378 |
| ○ | White 0390 |
| ■ | Pink 0503 |
| s | Cream 0388 |

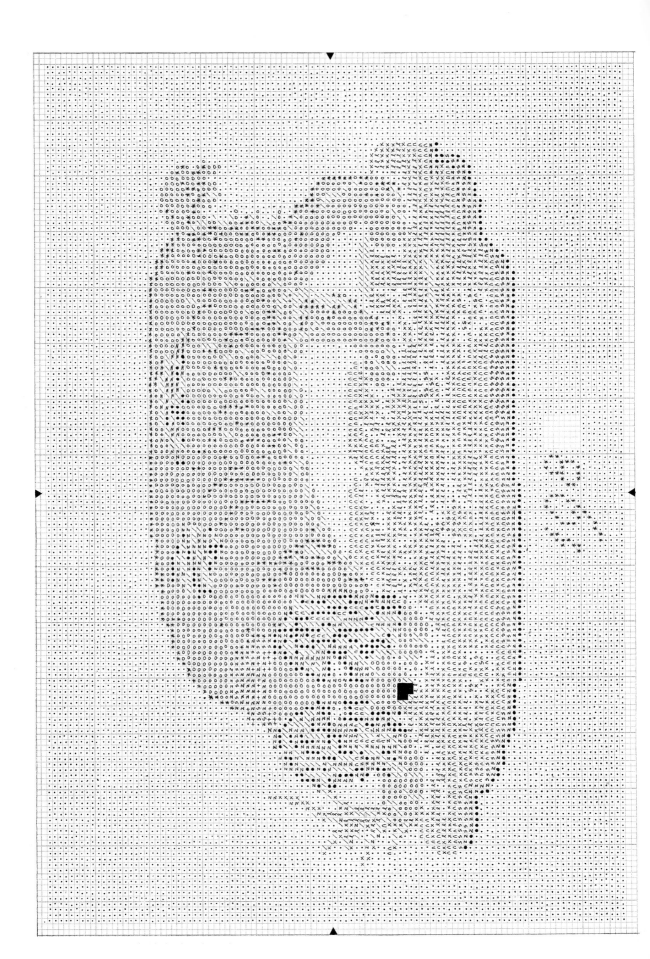

# APPENDIX

## PREPARATION OF GROUNDS FOR EMBROIDERY

The first stage in preparing the ground for embroidery is to produce a drawn design. If an existing design is to be used, a tracing can be made and the design transferred on to paper or thin card, depending on the method of transferral. It is essential that a good, clear, strong drawing is made at this stage.

The most exact method of enlarging a design is to make a photostat enlargement. This process can be repeated (enlarging the enlargement) until the required size is achieved. A tracing can then be made of the enlargement, referring to the original as a guide.

Other methods depend largely on the worker's ability to draw. One is the grid method. Draw a grid over the existing design and make a larger-scale grid on paper, card or tracing paper (use a smaller grid when reducing a design). Copy the drawing as it appears in each square of the grid on to the squares of the newly drawn grid.

Once the finished design has been drawn, transfer it to the ground fabric by using one of the following methods. (Remember that first the ground must be stretched taut and be taped to a firm surface.)

On fine fabrics, tape the tracing on to a bright window (or light-box) and then tape the ground over this. Enough light should shine through the tracing so that you can see the drawn lines through the ground. Trace the design on to the ground by means of the chosen medium. Another possibility is to use a glass table-top under which a lamp is placed so that the light shines through the table. Similarly, a well-defined drawing will show through the holes of a low-thread-count canvas that has been placed on top.

For more simple motifs, an easier method, which may need to be repeated, is to use templates that have been cut from thin card. The design must be drawn carefully on to the card and cut out. The resulting template can then be positioned on the ground and drawn around, using the chosen medium. Finer details can be drawn on to the ground afterwards.

The prick and pounce method involves making a line of pin-pricks on strong paper, along the drawn lines of the design. When pricking the holes, the paper should be placed over a soft folded blanket. The ground fabric is then taped firmly to a firm surface and the paper design is taped over this. A pounce (a fine muslin bag filled with pounce powder – usually charcoal powder, cinnamon or powdered chalk) is then either patted or rubbed gently in a circular motion over the pricked design. Small dots of powder are pushed through to the ground. This is a temporary line which must then be drawn over with a permanent medium.

The medium with which the design is actually drawn on to the ground depends largely on the intended embroidery techniques. Pencil should never be used because the ground and the working thread will become discoloured when the thread is pulled through the work. Non-waterproof ink and dressmakers' chalk must also be avoided. Prick-and-pounce lines can be painted over with a very fine sable brush and artists' waterproof inks, thin poster or gouache paints, but remember that any drawn lines must be fine enough to be covered by the stitchery.

For fine grounds and fine stitchery, lines can be drawn on to the ground by means of lines of tiny dots. China clay pencil can be used for canvas work where all the ground is to be covered, as can a waterproof felt pen. A dressmakers' carbon pencil, sharpened constantly so that it remains fine, can also be used to draw on to the ground, as can a fine waterproof felt-tipped pen.

In the past, black was the colour most commonly used to outline designs. In fact, a colour just slightly darker than that of the ground is often all that is necessary and is better suited to lighter styles of embroidery.

Whatever method is chosen, experimentation will be necessary and work can begin only after a few trials on spare samples of the chosen ground.

# BIBLIOGRAPHY

*Publications marked with an asterisk indicate possible sources of animal motifs and designs.*

Audsley, *Christian Symbolism* (1865)

*Baker, Muriel, and Lunt, Margaret, *Blue and White, The Cotton Embroideries of Rural China* (Sidgwick & Jackson, 1978)

Bath, V. C., *Needlework in America* (Mills & Boon, 1980)

Beck, Thomasina, *Embroidered Gardens* (Angus & Robertson, 1979)

*Brooke-Little, J. P., *An Heraldic Alphabet* (Mac-Donald, 1973)

Christie, A. G. I., *English Medieval Embroidery* (Oxford, 1938)

Christie, Mrs Archibald, *Samplers and Stitches* (B. T. Batsford, 1920)

Christies catalogue: *An Important Collection of Needle-work* (Christies, June 1987)

*Clark, Hugh, *Clark's Heraldry* (G. Bell & Sons, 1910)

Colby, Averil, *Samplers* (B. T. Batsford, 1964)

*Curious Woodcuts of Fanciful and Real Beasts* (Dover Publications, New York, 1971)

de Dillmont, T. H., *Encyclopedia of Needlework* (Simkin Marshall)

Edward, Joan, small books on the history of embroidery: *Berlin Work* (1980); *Blackwork* (1980); *Chronicle of Embroidery 1900–1950* (1981); *Gertrude Jekyll, Embroiderer, Gardener and Craftsman* (1981); *Sampler Making 1540–1940* (1983)

Fawdry, Marguerite, and Brown, Deborah, *The Book of Samplers* (Lutterworth Press, 1980)

*Freeman, R., *English Emblem Books* (Chatto & Windus, 1948)

*Gesner, Konrad, *Beasts and Animals in Decorative Woodcuts of the Renaissance* (Dover Publications, New York, 1983)

—.—., *Curious Woodcuts of Fanciful and Real Beasts* (Dover Publications, New York, 1971)

*Gierl, Irmgard, *Cross Stitch Patterns* (B. T. Batsford, 1977)

Gombrich, E. H., *A Sense of Order* (Phaidon, 1979)

—.—., *Symbolic Images* (Phaidon, 1972)

Gostlelow, Mary, *Blackwork* (B. T. Batsford, 1976)

*Guillim, John, *A Display of Heraldry* (1660)

Handford, S. A. (trans), *Fables of Aesop* (Penguin Books, 1954)

Huish, Marcus, *Samplers and Tapestry Embroideries* (Dover Publications, New York, 1970)

*Hundred Fables of La Fontaine, A* (Crown Publishers, New York, 1983)

King, Donald, *Samplers* (Victoria and Albert Museum, 1960)

Levey, Santina M., *Discovering Embroidery of the 19th Century* (Shire Publications, 1971)

*Meulenbelt-Nieuwburg, Albarta, *Embroidery Motifs from Dutch Samplers* (B. T. Batsford, 1974)

*Needle's Excellency, The, A Travelling Exhibition* (Victoria and Albert Museum, HMSO, 1973)

*Nevinson, J., *Peter Stent and John Overton, Publishers of Embroidery Designs*, Vol xxi, p279 (Opollo, 1936)

*Paradin, Claude, *Devices Heroiques* (Lyon, 1557)

Parry, Linda, *William Morris Textiles* (Weidenfeld and Nicolson, 1983)

*Picture Book of English Embroideries, A (Part III, Georgian)* (Victoria and Albert Museum, 1928)

Proctor, Molly G., *Victorian Canvas Work: Berlin Wool Work* (B. T. Batsford, 1972)

Rhodes, Mary, *The Batsford Book of Canvas Work* (B. T. Batsford, 1983)

*Royal School of Needlework Book of Needlework and Embroidery, The* (Collins, 1986)

*Sales Meyer, Franz, *Hand Book of Ornament* (Dover Publications, New York, 1957)

Sebba, Anne, *Samplers – Five Centuries of a Gentle Craft* (Weidenfeld & Nicolson, 1979)

Snook, Barbara, *Embroidery Stitches* (Dryad Press, 1963)

—.—., *English Embroidery* (Bell & Hyman, 1985)

Stevenson-Hobbs, Anne (ed), *Fables* (Victoria and Albert Museum, 1986)

Swain, Margaret, *The Needlework of Mary Queen of Scots* (Ruth Bean Publishers, 1986)

Swift, Gay, *The Batsford Encyclopedia of Embroidery Techniques* (B. T. Batsford, 1984)

Synge, Lanto, *Antique Needlework* (Blandford Press, 1983)

*Victorian needlepoint designs from *Godey's Lady's Book* and *Peterson's Magazine* (Dover Publications, New York, 1975)

*Vinciolo, Federico, *Renaissance Patterns for Lace, Embroidery and Needlepoint* (Dover Publications, New York, 1971)

Wade, N. Victoria, *The Basic Stitches of Embroidery* (Victoria and Albert Museum, 1966)

Wardle, Patricia, *Guide to English Embroidery* (Victoria and Albert Museum, 1970)

*White, T. H., *The Book of Beasts* (Alan Sutton, 1984)

Whiting, Gertrude, *Old Time Tools and Toys of Needle-work* (Dover Publications, New York, 1971)

*Whitney, Geoffrey, *A Choice of Emblems* (Leyden, 1986)

Wilson, David M., *The Bayeux Tapestry* (Thames & Hudson, 1986)

Wingfield-Digby, George, *Elizabethan Embroidery* (Faber & Faber, 1963)

*Wood-Krutch, Joseph *Herbal* (Woodcuts from Pierandrea Mattiolo's *Commentaries on the Six Books of Dioscorldes*, Prague, 1563) (Oxford, 1976)

Yates, Francis A., *The Volois Tapestries* (Routledge & Kegan Paul, 1975)

# INDEX

## ACKNOWLEDGEMENTS

I should like to thank all the staff at numerous photographic departments for giving their time and attention to often complicated details and enlargements, in particular to those at the Victoria and Albert Museum, the picture archives at the Bodleian Library and Joanna Hushagin at the Bowes Museum, Barnard Castle and Derek Seaward, who have organised much new photography for this book. My special thanks go to Joan for her long and hard work in typing the manuscript. I also thank all the patient and caring friends who have supported me and helped in many ways, especially Betty Swanwick ARA, Sheila, David, and both Jills and their families; and thanks to Doreen for her support and to Vivienne for her patience.

Finally, I am indebted to a number of books upon which I have drawn heavily, in particular *Hall's Dictionary of Subjects and Symbols in Art*; T. W. White's *The Book of Beasts*, and John Guillim's *A Display of Heraldry*.

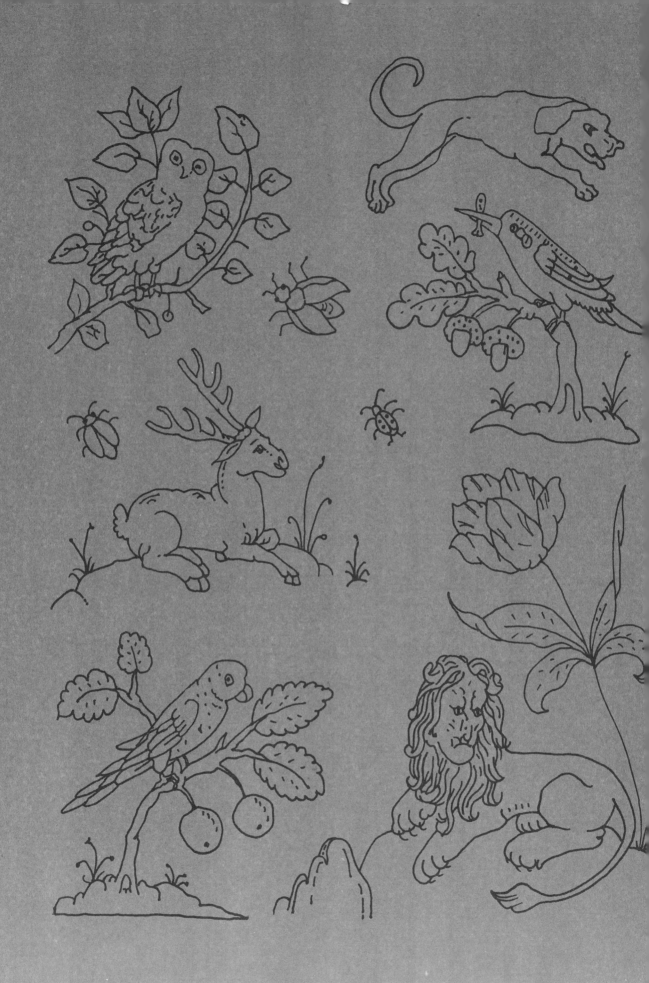